ITALIAN MAIOLICA
CATALOGUE OF THE COLLECTIONS

ITALIAN MAIOLICA
CATALOGUE OF THE COLLECTIONS

Catherine Hess

THE J. PAUL GETTY MUSEUM

MALIBU · CALIFORNIA

1988

© 1988 The J. Paul Getty Museum
17985 Pacific Coast Highway
Malibu, California 90265

Mailing address:
P.O. Box 2112
Santa Monica, California 90406

Christopher Hudson, Head of Publications
Andrea P. A. Belloli, Editor-in-Chief
Karen Jacobson, Manuscript Editor
Patrick Dooley, Designer
Karen Schmidt, Production Manager
Thea Piegdon, Production Artist
Elizabeth C. Burke, Photograph Coordinator
Jack Ross and Don Hull, Photographers

Typography by Wilsted & Taylor, Oakland, California
Color separations and duotones by Toppan Graphic Arts
Center/West
Printed by Dai Nippon Printing Co., LTD

LIBRARY OF CONGRESS CATALOGING-IN-PUBLICATION DATA
Hess, Catherine, 1957–
 Italian maiolica: catalogue of the collections /
 Catherine Hess. p. cm.
 Includes bibliographies.
 ISBN 0-89236-138-7
 1. Majolica, Italian—Catalogs. 2. Majolica, Renais-
sance—Italy—Catalogs. 3. Majolica—16th century—
Italy—Catalogs. 4. Majolica—California—Malibu—
Catalogs. 5. J. Paul Getty Museum—Catalogs.
I. J. Paul Getty Museum. II. Title. III. Series.
NK4315.H47 1988 738.3′7—dc19 88-17737

Cover: *A Candelieri* Plate. Venice, circa 1540–1560.
H: 5.7 cm (2¼ in.); Diam: 47.7 cm (18¾ in.). Malibu,
J. Paul Getty Museum 84.DE.120 (see no. 33).

CONTENTS

In memory

of

Jörg Rasmussen

FOREWORD

With each passing year, a visit to the Getty Museum has more surprises for the unwary. Until 1984 the visitor saw only antiquities, paintings, and decorative arts, for these had been the exclusive interests of J. Paul Getty and his Trustees. Since then the menu has been diversified, thanks to Mr. Getty's generous bequest and the decision to broaden the collection so that it could include sculpture and other European works of art outside the Museum's traditional territory of eighteenth-century France. Today's visitor, passing through a fair-sized vestibule connecting two paintings galleries, encounters a small collection of Italian maiolica that is, piece for piece, one of the finest in existence. Most of the important centers and styles are represented. The best pieces astonish the connoisseur as well as the layman, whether they are the robust early Florentine vessel with oak-leaf decoration (no. 7) or the suave Mannerist Venetian dish with grotesque ornament (no. 33).

With the exception of a small number of important pieces, most of our maiolica came to the Museum in 1984 as a single purchase, having been assembled by a talented collector in England. The Museum's then newly appointed curator of sculpture, Peter Fusco, had argued not only that the pieces were exceptionally fine and desirable but also that such a collection could hardly be put together again. Like another splendid collection—of European glass—purchased soon afterward, this was a chance that had to be taken. Events have proven our curator right.

Maiolica has many joys, as collectors have always known. It is an art of transformation—an almost alchemical conjuring of glistening solid form and vivid color out of ordinary elements. The concave walls of a bamboo container become the potter's *albarello*. The refined turnings and twistings of a goldsmith's pitcher are transformed into a robust vernacular vessel. Christ in the form of a half-length marble bust, austere in monochrome, is turned into a vivid likeness in bright colors. And the stories of the Old Testament and classical authors (including the *Metamorphoses* of Ovid), once visualized by painters and already transformed by printmakers, are given new life by the resourceful decorators of maiolica. For all its complexities, however, the best maiolica combines a harmony of shape, decoration, and color which vibrates in the heart today just as it must always have done.

This catalogue owes its existence to Peter Fusco's wisdom and taste. Fortunately, a part of his wisdom was to entrust work on the collection to Catherine Hess, Assistant Curator of Sculpture and Works of Art, a promising young scholar who has come to maturity with this project. I want to thank them and other staff members at the Museum whose efforts combined to produce this catalogue.

John Walsh
Director

ACKNOWLEDGMENTS

This catalogue, like many of the works it documents, was largely a collaborative effort. Much as alchemists, potters, glaze painters, workshop directors, and patrons worked together to foster advances in fifteenth- and sixteenth-century maiolica production, so have curators, art historians, and other scholars joined forces to bring this publication to fruition. I am greatly indebted to these collaborators for their gracious and generous assistance.

First I would like to thank Peter Fusco, Curator, Department of Sculpture and Works of Art, for his support throughout the project; after all, it is thanks to his vision that this collection of ceramics is now at the Museum. My interest in and excitement about Renaissance maiolica were stimulated by the late Jörg Rasmussen of the Museum für Kunst und Gewerbe, Hamburg, whose gentle direction was crucial in shaping the form and content of this catalogue. Rainer Zietz, the London-based dealer who gathered the majority of these wares, was an unfailing source of provocative and informative discussion. I would also like to thank him and his wife, Barbara, for their hospitality.

I am beholden to many other scholars whose contributions took various forms, including helping me gain access to—and often walking me through—public and private collections of Italian maiolica. They include John Mallet, Victoria and Albert Museum, London; Timothy Wilson, British Museum, London; Tjark Hausmann, Kunstgewerbemuseum, Berlin; Carmen Ravanelli Guidotti, Museo Internazionale delle Ceramiche, Faenza; Wendy Watson, Mount Holyoke College Art Museum, South Hadley, Massachusetts; Grazia Biscontini Ugolini, Castello Sforzesco, Milan; Caterina Marcantoni, formerly of the Museo Correr, Venice; Chantal Meslin-Perrier, Musée National de la Renaissance, Ecouen; Pierre Ennés, Musée du Louvre, Paris; Angelo Mazza and Massimo Medica, Museo Civico Medievale, Bologna; Guido Donatone, Centro Studi per la Storia della Ceramica Meridionale, Naples; and Timothy Schroder and Tina Oldknow, Los Angeles County Museum of Art.

Other scholars who have enhanced my research include Laurie Fusco, Senior Museum Lecturer; Marco Spallanzani, Istituto di Storia Economica, Università degli Studi, Florence; Alessandro Alinari, Florence; Gino Corti, Villa I Tatti, Florence; Claudio de Pompeis, Museo delle Genti d'Abruzzo, Pescara; Rudolf Drey, London; Richard Palmer, Wellcome Institute, London; Roger Price, Wellcome Museum of the History of Medicine, London; Hugo Blake, University of Lancaster; and Wesley Trimpi, Department of Classics, Stanford University.

My questions about the medium were untiringly answered by Roseline Delisle and Paul Mathieu, master ceramists in their own right. I am indebted to the designer of this publication, Patrick Dooley, and to Andrea P. A. Belloli, Mary Holtman, and Karen Schmidt, Department of Publications, for their fine work. Peggy Fogelman, Amy Lyford, and Nina Banna, Department of Sculpture and Works of Art, helped carry out the often tedious tasks of compiling, translating, and proofreading the material. I would also like to thank the manuscript editor, Karen Jacobson, for her unflagging patience and welcome suggestions. Finally, those closest to me, Laurence Frank and Bruce Kijewski, provided constant inspiration, intellectual and otherwise.

Catherine Hess
Assistant Curator, Department of Sculpture and Works of Art

LIST OF ABBREVIATIONS

In bibliographies and notes, frequently cited works have been identified by the following abbreviations:

Ballardini 1933–1938 G. Ballardini. *Corpus della maiolica italiana.* 2 vols. Rome, 1933–1938.

Ballardini 1975 G. Ballardini. *La maiolica italiana.* Faenza, 1975.

Bellini and Conti 1964 M. Bellini and G. Conti. *Maioliche italiane del rinascimento.* Milan, 1964.

Bode 1911 W. von Bode. *Die Anfänge der Majolikakunst in Toskana.* Berlin, 1911.

Bojani et al. 1985 G. C. Bojani, C. Ravanelli Guidotti, and A. Fanfani. *La Museo Internazionale delle Ceramiche in Faenza: La donazione Galeazzo Cora.* Milan, 1985.

Chompret 1949 J. Chompret. *Répertoire de la majolique italienne.* 2 vols. Paris, 1949.

Cora 1973 G. Cora. *Storia della maiolica di Firenze e del contado del XIV e del XV secolo.* 2 vols. Florence, 1973.

Cora and Fanfani 1982 G. Cora and A. Fanfani. *La maiolica di Cafaggiolo.* Florence, 1982.

Falke 1914–1923 O. von Falke. *Majolikasammlung Pringsheim in München.* 2 vols. The Hague, 1914–1923.

Giacomotti 1974 J. Giacomotti. *Catalogue des majoliques des musées nationaux.* Paris, 1974.

Hausmann 1972 T. Hausmann. *Majolika.* Berlin, 1972.

Kube 1976 A. N. Kube. *Italian Majolica: XV–XVII Centuries.* Moscow, 1976.

Liverani 1960 G. Liverani. *Five Centuries of Italian Majolica.* New York, 1960.

Martí 1944–1952 M. González Martí. *Cerámica del levante español.* 3 vols. Barcelona, 1944–1952.

Rackham 1940 B. Rackham. *Catalogue of Italian Maiolica.* 2 vols. London, 1940.

Rackham 1959 B. Rackham. *Islamic Pottery and Italian Maiolica.* London, 1959.

Valeri 1984 A. Moore Valeri. "Florentine '*Zaffera a Rilievo*' Maiolica: A New Look at the 'Oriental Influence.'" *Archeologia medievale* 11 (1984), pp. 477–500.

Wallis 1903 H. Wallis. *Oak-Leaf Jars: A Fifteenth Century Italian Ware Showing Moresco Influence.* London, 1903.

Watson 1986 W. Watson. *Italian Renaissance Maiolica from the William A. Clark Collection.* London, 1986.

Wilson 1987 T. Wilson. *Ceramic Art of the Italian Renaissance.* London, 1987.

INTRODUCTION

There were no mortal men until, with the consent of the goddess Athene, Prometheus, son of Iapetus, formed them in the likeness of gods. He used clay and water of Panopeus of Phocis, and Athene breathed life into them.

Hesiod, Theogony

And the Lord God formed man of the dust of the ground, and breathed into his nostrils the breath of life; and man became a living soul.

Genesis 2:7

Inexorable is . . . the generosity of the earth. Even omitting all of the benefits of the fruits, of wine, of apples, of herbs, of shrubs, of medicines and of metals, . . . only objects of terracotta . . . fulfill us, giving us the tiles for roofs, the bricks for walls, the receptacles for wine, the tubes for water and all of those objects which one makes on the wheel and forms with one's hands. For these reasons, Numa established as seventh college, that of the potters.

Pliny the Elder, Natural History

Ceramic objects have existed in many shapes and in many countries for thousands of years. Produced from earth mixed with water, dried by air, and baked by fire, they were regarded in ancient times as the embodiment of the four essential elements that made up the universe: earth, water, air, and fire. The rediscovery of the writings of Empedocles, Euclid, Pliny, and others in the Renaissance led to a revival of the notion that baked clay was a microcosm mirroring the macrocosm. The potter's seemingly divine act of using a medium representing the elements of the universe to create form from nonform helps account for the cross-cultural appeal of ceramic work, which long ago included not only utilitarian vessels but also votive offerings to the gods. More importantly, however, it is clay's ability to form functional objects that explains the long history and remarkably wide geographical and cultural dissemination of ceramic production.

This long history and wide dissemination can be attributed to three chief factors: first, the raw materials required—the different clays for the ceramic body, and the minerals, ash, and sand for glazes—are abundant and accessible; second, ceramic ware is easily shaped (by hand, on a wheel, or in a mold) and hardened (by drying or firing); and third, the objects produced are fundamentally utilitarian (see figs. 1, 2).

Ceramic wares have been produced in Italy since ancient times. The colonizing Greeks (ninth to eighth century B.C.) and the Etruscans (seventh to fifth century B.C.), for example, were able, even masterful ceramists. The development and efflorescence of tin-glazed earthenware, or maiolica, on the peninsula in the fourteenth, fifteenth, and sixteenth centuries mark a particularly rich chapter in this history. Certainly Italy's location in the Mediterranean basin, at the center of an area touched by

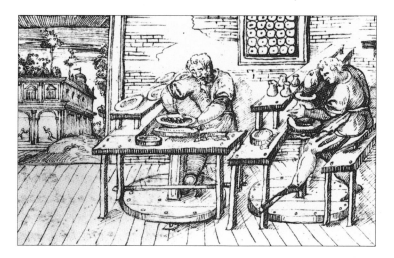

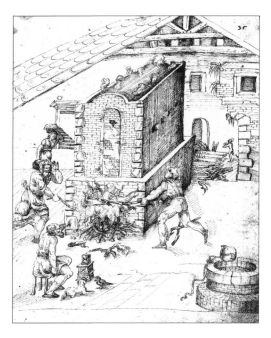

FIGURE 1. CIPRIANO PICCOLPASSO (Italian, 1524–1579). *Potters at Their Wheels (muodo di lavorar al torno)*. From *Li tre libri dell'arte del vasaio* (1557), fol. 16r. Drawing. London, Victoria and Albert Museum. Photo courtesy Board of Trustees, Victoria and Albert Museum.

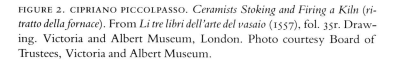

FIGURE 2. CIPRIANO PICCOLPASSO. *Ceramists Stoking and Firing a Kiln (ritratto della fornace)*. From *Li tre libri dell'arte del vasaio* (1557), fol. 35r. Drawing. Victoria and Albert Museum, London. Photo courtesy Board of Trustees, Victoria and Albert Museum.

diverse cultural influences—Byzantine, Islamic, and North African—helped determine not only the high level of technical virtuosity but also the beauty and variety that maiolica wares display.

The term *maiolica* can be traced either to the Balearic island of Majorca (Majolica), which served as an entrepôt for the Moresque lusterware bound for the Italian market in the fourteenth and fifteenth centuries (see fig. 3),[1] or to the Spanish name for luster products, *obra de málequa*.[2] Medieval potteries at Málaga (*málequa*) as well as at Murcia and Almería in the Moorish south were likely the first to produce ceramic lusters in Spain. Until the sixteenth century *maiolica* referred exclusively to wares decorated with iridescent lusters of Spanish or Islamic origin.[3] Only later did this term come to refer to the more common unlustered earthenware as well.

Tin glazes can likewise be traced to Spain from as early as A.D. 1000.[4] But around 1400, Ibn Ahmar's Nasrid kingdom, which had united Málaga with Murcia and Granada, became increasingly unstable, and Moorish masters were forced north to the more prosperous Valencian ceramic centers. They brought with them Islamic motifs and techniques that were then exported to Italy thanks to active trade and the migration of artisans between Spanish workshops and the burgeoning Italian centers of production. The same methods of transfer also served to introduce Persian, Egyptian, Turkish, and Chinese ceramics to Europe, but it was the pottery of Moorish Spain which, together with Arabic wares from northern Africa, exerted the strongest influence on early Italian maiolica.

By the late fifteenth century Italian importation of Hispano-Moresque ware had dwindled as Italian potters became adept in the tin-glazed medium. Italian tastes had also changed, and quintessentially Renaissance embellishments such as narrative elements supplanted the medieval and Islamic-inspired motifs still found on Spanish wares from the same period.

While retaining some of the original glazing techniques, Italian Renaissance maiolica featured distinctively Italian colors and ornamentation, as many of the Getty Museum's works illustrate. Moreover maiolica ware of the fifteenth and sixteenth centuries served a range of purposes that crossed social strata: from practical common-ware vessels to the decorative and occasionally propagandistic objects of the powerful. Initially, the shape and glaze of these wares followed their function as receptacles; later on, however, the shape and surface decoration became aesthetic concerns, taking on significance in and of themselves.

Thanks not only to advances in glazing and firing techniques and to developments in pictorial representation but also to active patronage that nurtured its progress, Italian maiolica of the Renaissance displays exceptionally brilliant and colorful surface decoration. This decoration was achieved by covering already fired earthenware with a primary *bianco* (white) glaze. With firing, this glaze became vitreous, establishing the appropriate opaque white ground for painted decoration. The *bianco* glaze was made up of a glassy lead oxide opacified by the addition of tin oxide (ashes) along with a silicate of potash from wine lees mixed with sand. Firing again in the kiln secured the painted pigments to this white ground. The innovation of adding tin not only enabled the potters to produce a pure white ground but also made the glazes more stable when fired; previously, the pigments had tended to run or blur. Maiolica painters often reserved the precious tin glazes for the front of a dish, where the glaze's brilliance and stability for painted decoration was more crucial, relegating the less precious lead glaze to the reverse side (see no. 22).

Late medieval maiolica displays a limited range of colors composed primarily of green from acetate or carbonate produced by the action of vinegar on copper, white from tin (though not used overall at this early date), and brown from manganese. Although rare, light blue and yellow also appear at this time.[5] By the early fourteenth century, especially in Emilia-Romagna and Tuscany, one finds the first known dark blue-glazed works of the Christian West.[6] By the mid-Quattrocento, Italian *vasai*, or potters, had developed a rich palette that included a deep blue from cobalt oxide mixed with quartz or sand, a more purple-colored manganese brown, and brilliant yellows and oranges from mixtures of antimony and ferric oxide. Although red occasionally appeared, no true red from vermilion was used before 1700, since this pigment proved too volatile to survive contemporary firing techniques.

The application of silver and copper oxides in a subsequent firing produced the gold, red, or pearly metallic reflections characteristic of lusterware. These oxides were sprinkled or painted in a thin wash onto the surfaces of the ceramics. Introducing smoke into the kiln during firing by narrowing the air inlets to the fire chamber and adding wet or resinous fuel (such as rosemary or juniper branches) removed the oxygen from the pigments, leaving the painted areas with a thin metal coat. When rubbed, these metal deposits produced the shimmering, iridescent surface characteristic of luster (see nos. 22, 23). Sometimes a final *coperta* (cover) glaze was applied, which functioned like a clear varnish, fusing the pigments and leaving a particularly shiny, jewellike surface. (A *coperta* is a type of *marzacotto* [cooked mixture] made by fusing sand with calcined wine lees.)

Maiolica painters needed a sure hand in applying pigments because once applied, they were partly absorbed into the porous clay body and could not be imperceptibly altered or erased. These artists also needed a thorough knowledge of the materials to ensure that the decoration desired became the decoration achieved, since pigments change color with firing. Luckily, painted maiolica decoration

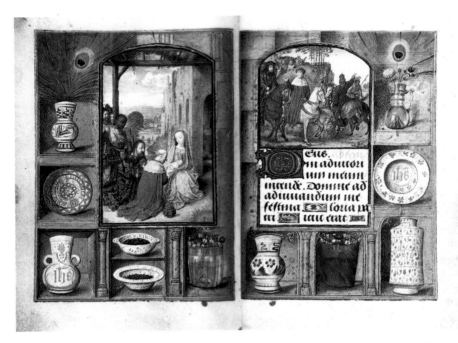

FIGURE 3. MASTER OF MARY OF BURGUNDY (French, active 1475–1490). Two miniatures from the Hours of Engelbert of Nassau, circa 1477–1490. Gold and tempera on vellum. Oxford, Bodleian Library Ms. Douce 219, fols. 145v–146r. Photo courtesy Bodleian Library. The ceramics depicted are either Hispano-Moresque or Hispano-Moresque-inspired wares.

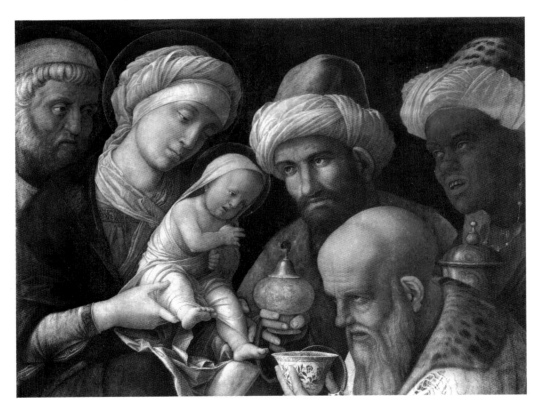

FIGURE 4. ANDREA MANTEGNA (Italian, circa 1431–1506). *Adoration of the Magi*, circa 1495–1505 (detail). Distemper on canvas, 48.5 × 65.6 cm (19⅛ × 25⅞ in.). Malibu, J. Paul Getty Museum 85.PA.417. The magus in the foreground offers his gift to the Christ child in a small blue-and-white bowl, an early example of Chinese porcelain imported to Europe.

has the great advantage of never dulling or darkening with age, unlike contemporaneous fresco or oil painting. Although limited by available materials and techniques, maiolica pigments thus provide some of the few examples of colors used in the Renaissance that have remained unchanged.

Fifteenth- and sixteenth-century alchemists and experts in such subjects as pyrotechnics, metallurgy, and mineralogy helped advance the techniques of maiolica production. Around the beginning of the sixteenth century, after Hispano-Moresque lusterware had been imported to Italy for several decades, Italian alchemists began to attempt to create a goldlike luster on maiolica. Present in every court, these alchemists understood not only the talismanic value of gold but also its appeal for their patrons. Of the house on Alcina's mythical island, Ludovico Ariosto wrote in the sixteenth century: "It seemed some alchemist did make this hold; / The walls seemed all of gold, but yet I trow / All is not gold that makes a golden show."[7] Scientific writers such as Vannoccio Biringuccio and Georg Agricola emphasized the power of fire.[8] Others explained how the "divine" properties of fire made possible the potters' gift of life (permanence) to earth (clay), much as the gods of the creation myths of the Mediterranean world gave life to man.

References to the divine and mythical nature of the ceramic craft are found in the most exhaustive and didactic sixteenth-century manual on ceramic production. Cavaliere Cipriano Piccolpasso of Castel Durante wrote *Li tre libri dell'arte del vasaio* at the suggestion of Cardinal François de Tournon when the cardinal was visiting Castel Durante as a guest of the duke of Urbino. Piccolpasso instructed novice potters to prepare and light the kiln fire "al far della luna . . . raccordandosi far sempre tutte le cose col nome di Jesu Cristo" (by the light of the moon . . . remembering to do all things in the name of Jesus Christ).[9]

Thanks to Piccolpasso, we are able to reconstruct contemporary methods of gathering and forming clay, making and applying glazes, and firing ceramic pieces. His manual recorded for the first time "tutti gli segreti de l'arte del vassaio . . . quello che gia tant'anni è stato ascosto" (all of the secrets of the potter's art . . . which have been kept hidden for many years).[10] Besides being hidden (*ascosto*), these secrets—the keys to success and fame—were jealously guarded as well. This explains why, despite the mobility of ceramists and their wares, one can often distinguish the methods, ceramic shapes, and decorative styles of different centers of production.

Some types of maiolica decoration became the specialties of the centers in which they were developed. In Tuscany, especially in the Florentine workshops of Giunta di Tugio (see nos. 7–9) and others, one finds *zaffera a rilievo* (relief-blue) decoration. The term *zaffera* derives from the Arabic *al-safra*, either meaning *brilliant*[11] or originating from the Arabic term for the cobalt mineral from which this pigment was made.[12] The artists used this cobalt pigment in impasto form, outlined with manganese brown, to paint motifs resembling oak leaves and berries, sometimes framing figural subjects and heraldic devices; they often painted this vitreous blue impasto so thickly that the decoration appears to be in relief (see no. 5).

The East influenced *alla porcellana* (porcelainlike) decoration through Persian designs, Turkish Iznik pottery, and especially Chinese porcelain of the Ming dynasty (1368–1644), which arrived in Italy in the fifteenth century (see fig. 4). This decoration imitated porcelain, with painted blue foliage and floral sprays on a white ground (see no. 21). Although popular as well in Tuscany and the Marches, *alla porcellana* embellishment became a specialty of Venetian workshops, probably because of the city's location on the Adriatic Sea, a strategic position for trade with the East.

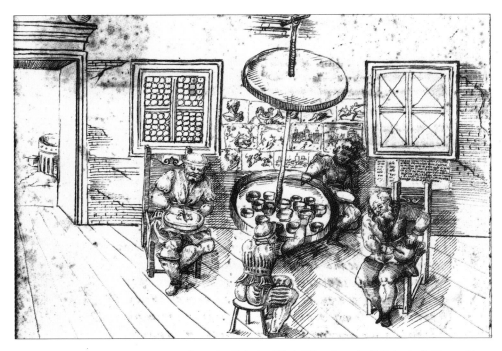

FIGURE 5. CIPRIANO PICCOLPASSO. *Ceramists Painting Their Wares* (*muodo di dipingiare*). From *Li tre libri dell'arte del vasaio* (1557), fol. 57v. Drawing. London, Victoria and Albert Museum. Photo courtesy Board of Trustees, Victoria and Albert Museum.

Bianco sopra bianco (white-on-white) decoration likewise displays delicate arabesque foliage and floral sprays (see no. 30). As Piccolpasso testified,[13] this decoration was common in pottery centers such as Urbino and neighboring Castel Durante (renamed Urbania under Pope Urban VIII, 1623–1644). The artists covered the ceramic surface with a slightly grayish ground to make their designs, traced in pure white, stand out.

Like *alla porcellana* motifs, *berettino* glazes may have originated in Venice as a result of Middle and Far Eastern influences. Ceramists achieved *berettino*'s characteristic lavender-gray color by mixing tin-white glaze with cobalt ore from the Orient. This delicate blue served as a ground on which they painted designs (primarily flowers, foliage, and grotesques[14]) in intense blue highlighted with thread-like bands of white (see nos. 26, 28). A similar *berettino* blue ground was also popular in Faenza and, later, in Liguria.

Around the beginning of the sixteenth century, painted figural and abstract decorations were equally popular on maiolica pieces produced in the rival centers of Deruta, Faenza, Florence, Gubbio, and Montelupo. Faenza—from which the term *faïence* is derived[15]—was one of the most influential of these centers and produced works that display an extremely varied palette, range of shapes, and decorative repertoire. By 1520, however, this balance between the figural and the abstract had been upset. Some painters at Faenza and Castel Durante and, later, Nicola da Urbino and Francesco Xanto Avelli at Urbino pioneered *istoriato*, or historiated, ware, on which painted "stories"—usually historical, religious, or mythological—cover most, if not all, of the surface (see no. 31). *Istoriato* painting thus shows the greatest influence of contemporary fresco and oil painting of the humanist tradition, particularly in the illusionistic representation of deep space.

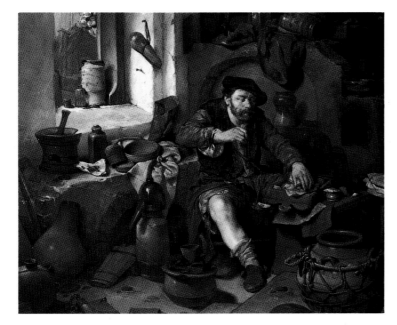 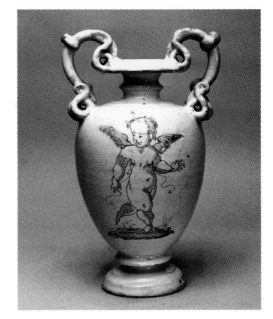

FIGURE 6. CORNELIS BEGA (Dutch, circa 1620–1664). *The Alchemist*, 1663 (detail). Oil on panel, 35.5 × 31.7 cm (14 × 12½ in.). Malibu, J. Paul Getty Museum 84.PB.56. An *albarello* covered with a swatch of leather, parchment, or fabric sits on the window ledge at the left.

FIGURE 7. Amphora with *Compendiario* Painting. Italian (Faenza), late sixteenth century. Tin-glazed earthenware, H: 22 cm (8 ¹¹⁄₁₆ in.); Diam (foot): 6.8 cm (2 ¹¹⁄₁₆ in.). Faenza, Museo Internazionale delle Ceramiche inv. 21159/c, Cora Donation. Photo courtesy Museo Internazionale delle Ceramiche.

In earlier maiolica forms one finds a union of shape, decoration, and use. In *istoriato* wares, however, the painted stories were of primary importance, which explains why much full-scale *istoriato* painting was executed on shallow, concave vessels whose surfaces were largely uninterrupted by rims, depressions, or molded designs. The shift in emphasis from functional ceramic receptacles to pictorial glazed surfaces is reflected not only in *istoriato* ware but also in maiolica plaques and *piatti da pompa* (show dishes), which were produced solely for display (see no. 22).

Prints and engravings proliferated in the mid-fifteenth century and brought once-esoteric imagery into popular use. Especially in the Marches of central Italy, maiolica painters used prints by German and Italian masters such as Martin Schongauer, Albrecht Dürer, and Marcantonio Raimondi as cartoons for their ceramic paintings (see nos. 30, 31, 34). They adapted the scenes and figures from the prints to the generally circular shapes of the ceramics and transferred the designs to the wares. From Piccolpasso we know that ceramists copied prints freehand (see fig. 5). Yet, since so many images appear repeatedly—and almost identically—on *istoriato* plates, it is also possible that painters used the cartoons as templates in order to copy more precisely the desired scenes and figures. They may have transferred these images by pricking the cartoons with small holes, through which a dark powder was forced onto the ceramic surface, or by painting one side of the cartoon with glaze and then pressing the wet pigment to the fired clay.

In addition to drawing on sources in the visual arts, maiolica painters also used the works of contemporary literary figures to ornament their wares. The inscriptions and mottoes often written on decorative banderoles painted across the front of vases, plates, and jugs were usually recordings of popular wisdom that frequently emphasized the clever turn of phrase. Famous contemporary writers

were sometimes engaged to invent these witticisms, causing Angelo Poliziano to complain in 1490 of those who wasted his time by employing him to compose "un motto . . . o un verso . . . o una impresa . . . pei i cocci di casa" (a motto . . . verse . . . or device . . . for household pots).[16] Though he lamented such attempts to display erudition, wit, and status by emblazoning even household crockery with witty mottoes and heraldic arms, the demand for the latest fashion and cleverest maxim nonetheless inspired innovations and increased competition among workshops.

In contrast to these innovations in decoration, pottery shapes continued to reflect late medieval forms well into the fifteenth and sixteenth centuries. Typical among these shapes, jugs, two-handled jars, *tondini*, and *albarelli* are represented in the Museum's collection. *Tondini* are small, rounded bowls with wide, flat rims (see nos. 21, 29). *Albarelli* are cylindrical storage jars most often used in the home and in pharmacies for conserving and transporting preparations in viscous, paste, or dry form, including pharmaceuticals as well as various nonmedicinal spices, herbs, dyes, and ointments (see nos. 6, 10–12, 14, 17, 24, 25). They were closed with a lid or with a piece of paper, parchment, or cloth tied around the top rim (see fig. 6). Their name probably derives from the Arabic *al-barani* or *al barril*, referring to containers used in the East to store drugs.[17]

During the second half of the sixteenth century there were significant changes in pottery shapes, reflecting a new interest in highly decorative, undulating forms. Toward the middle of this century, as pictorial maiolica decoration was passing from vogue, potters and painters began breaking up and rearranging into compartments both the ceramic surface and the painted decoration. Maiolica potters invented the *crespina*[18] form in imitation of highly valued metal repoussé vessels. These *crespine* were gadrooned (the rounded molding was decoratively notched), embossed, and molded in shell, mask, and other baroque shapes (see no. 27). One finds the ultimate expression of this fondness for irregular surfaces and surface decoration in the sculptural flasks, basins, vases, and wine coolers of the late sixteenth century as well as in the sketchy *compendiario* (shorthand) style of painting (see fig. 7). *Compendiario* painting—executed in a limited palette, often on wares with pure white grounds (called *bianchi di Faenza*, Faentine white wares)—also enabled workshops to turn out large numbers of finished pieces quickly and efficiently, to meet the demands of an ever-increasing market.

Although much of the maiolica that has survived intact consists of the masterpieces and luxury items that were carefully kept and displayed, the popular pieces that have endured help illuminate not only the vessels' significance but also the social practices with which they were associated. The study of maiolica, and of the minor arts in general, affords an opportunity to understand better the daily life of various social classes, since the objects were not destined solely for use by courtly patrons and the Church; the majority of maiolica was inexpensive ware intended for everyday use.

One gets an idea of the role of courtship, matrimony, and childbearing—and youth, beauty, hospitality, and decorum—in Renaissance life when one considers the often elaborate maiolica forms made to serve these social practices and honor these ideals. *Bella donna* (beautiful lady) plates and *coppe amatorie* (love cups) were often decorated with classicized busts of beautiful women or heroic men or with a lover's portrait accompanied by a name or love motto (see no. 22); *piatti da ballata* were used to offer sweets to houseguests; maiolica flasks, ewers, *rinfrescatoi* (coolers), and basins held scented water offered to guests to wash their hands and cooled wine glasses and bottles (see no. 34); and *tazze da impagliata* and *boli da puerpera* were vessels used by and given as gifts to pregnant women. The *impagliata* (named for the straw [*paglia*] beds on which women gave birth) and *puerpera* (mid-

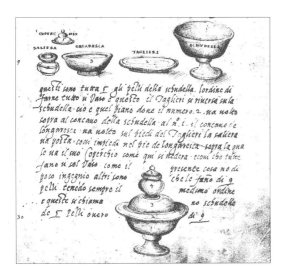

FIGURE 8. CIPRIANO PICCOLPASSO. *A Parturition Set* (*schudella di cinque pezzi*). Drawing. From *Li tre libri dell'arte del vasaio* (1557), fol. 11r. London, Victoria and Albert Museum. Photo courtesy Board of Trustees, Victoria and Albert Museum.

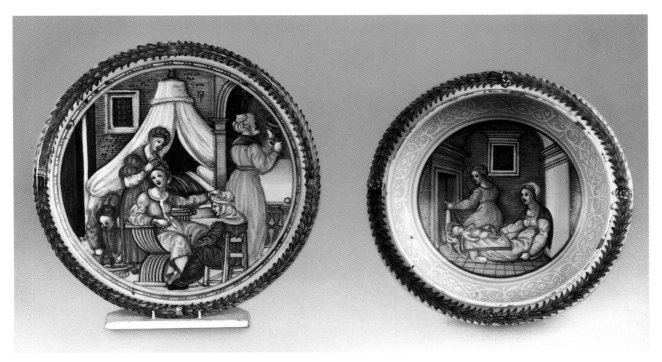

FIGURES 9a–b. Trencher (*Tagliere*) and Broth Bowl (*Scodella*) from a Parturition Set. Italian (Urbino), circa 1525–1530. Tin-glazed earthenware, H (bowl): 10 cm (3¹⁵⁄₁₆ in.); Diam: 23 cm (9 in.); Diam (trencher): 19 cm (7½ in.). London, Victoria and Albert Museum inv. 2258-1910. Photo courtesy Board of Trustees, Victoria and Albert Museum. The trencher served as a cover for the bowl. Scenes of childbirth decorate the painted interiors of both.

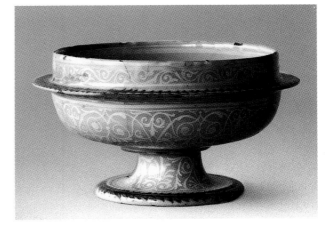

wife) dishes were often made as sets of up to nine pieces, including various bowls, a saltcellar, sometimes an eggcup, and a cover to be pieced together in the shape of a vase (see fig. 8). In these dishes women would be served special foods—chicken, broth, and soup—during pregnancy and parturition (see fig. 9).

In addition to its widespread domestic use, maiolica was avidly commissioned and collected by the upper classes. Pope Sixtus IV showed his high estimation of maiolica when he wrote to Costanza Sforza in 1478 that glazed ceramics were as precious as if they had been made of gold or silver.[19] Moreover Marchesa Isabella d'Este, Pope Julius II, Pope Leo X, Grand Duke Cosimo I de' Medici, Duke Guidobaldo da Montefeltro, and Duke Francesco Maria della Rovere all commissioned works by the foremost maiolica artists of their time. The maiolica vogue soon spread to other countries through gifts and foreign commissions; the households of Andreas Imhof in Nuremberg and Cardinal Duprat and Constable Anne de Montmorency in France all included pieces of Italian maiolica.

At least two objects in the Museum's collection have noble heritage: the Fontana basin (no. 34) likely originates from a ducal collection of Urbino, and the porcelain flask (no. 36) was executed for Grand Duke Francesco I de' Medici. Although unable to afford the most refined pieces by the most sought-after ceramists, families of lesser fame but surely of a certain affluence also commissioned and collected maiolica. Three of the Museum's maiolica objects (nos. 12, 23, 30) were either ordered by or given to the well-to-do families whose arms they bear.

The first attempts to identify and catalogue Italian Renaissance maiolica began in the nineteenth century. In 1873, for example, the collector and art historian Charles Drury Edward Fortnum published his extensive catalogue of Hispano-Moresque, Near Eastern, and Italian ceramics in the South Kensington Museum, London, which was followed in 1875 by his abridged handbook. It was not until after the turn of the century, however, that major studies classifying pieces according to date, type, and center of production were undertaken. These include Otto von Falke's 1907 handbook of the maiolica collection of the Berlin Kunstgewerbemuseum (Schlossmuseum) and Wilhelm von Bode's 1911 *Die Anfänge der Majolikakunst in Toskana*. In 1933 Bernard Rackham, then keeper of the department of ceramics at the Victoria and Albert Museum, completed his guide to the museum's collection of Italian maiolica, and seven years later he published a catalogue of the same collection. Also in 1933 Gaetano Ballardini, promoter of the Scuola della Ceramica and founder of the Museo Internazionale delle Ceramiche in his native Faenza, published the first volume of his *Corpus della maiolica italiana*. Giuseppe Liverani, Ballardini's successor at the Faenza museum, published his comprehensive *La maiolica italiana* in 1957.

The J. Paul Getty Museum's collection of maiolica, ranging in date from the early fifteenth to the eighteenth century, is composed of wares of outstanding quality and in fine condition and includes examples from most of the major pottery centers. A wide variety of maiolica forms and styles is represented. The collection includes popular, domestic objects as well as more luxurious items. It is no surprise that one can trace the provenance of a great number of these works to illustrious nineteenth- and twentieth-century collectors such as Charles Damiron of Lyons; Alfred Pringsheim of Munich; Wilhelm von Bode of Berlin; Robert Strauss of London; Alessandro Castellani of Rome; J. Pierpont Morgan of New York; and Baroness Marie-Hélène and Barons Adolphe, Maurice, Alphonse, Edouard, and Guy de Rothschild of Paris.

The present catalogue organizes this collection in a roughly chronological progression, accord-

ing to stylistic trends. These divisions do not, as one might fear, provide a false sense of order; governed to some extent by technical advances, a general course of stylistic development is indeed discernible. Coupled with, though somewhat subsumed under, the broad divisions is a breakdown of objects according to centers of production. Conveniently for purposes of classification, one can recognize a general shifting of dominance from one center to another; these shifts were dictated as much by changing political and economic circumstances as by fluctuating fashions and taste. Tuscan workshops flourished from roughly the Middle Ages to 1450, followed by Faentine workshops in the early Renaissance, and those of Cafaggiolo, Castel Durante, Deruta, Gubbio, Venice, and, above all, Urbino from 1520 on. Castelli d'Abruzzo, although active during the Renaissance, is here represented in its later period of maiolica production in the seventeenth and eighteenth centuries. At a time when porcelain had surpassed tin-glazed earthenware in popularity, potters at Castelli produced wares that constitute a final, supremely pictorial phase of this tin-glazed art. Framing this presentation of the Museum's maiolica collection are two fifteenth-century Spanish works and a late sixteenth-century porcelain flask, objects that exemplify the ceramic types that preceded and followed Italian maiolica of the Renaissance.

1. *Maiolica* specifically refers to tin-glazed earthenware dating from the Renaissance; *majolica* is an application of the original term to the colorful lead- and tin-glazed wares of the nineteenth century (R. Charleston, *World Ceramics* [London, 1975], p. 345).

2. A. Caiger-Smith, *Lustre Pottery* (London, 1985), p. 127. G. Ballardini reminds us, however, that by the middle of the thirteenth century *obra de málequa* (alternate spellings include *melica*, *melicha*, *maliqua*, and *malica*), though certainly referring to a place (Málaga), became a generic term for a process (luster) much as the French term *faïence* (from *Faenza*) was later applied to tin-glazed earthenware (" 'Obra de Malica' e ceramiche di Granada," *Faenza* 10, no. 3/4 [1922], p. 60).

3. See, for example, C. Piccolpasso, *The Three Books of the Potter's Art* (translation of *Li tre libri dell'arte del vasaio*), trans. and ed. R. Lightbown and A. Caiger-Smith, vol. 1 (1557; reprint, London, 1980), fols. 46v, 47r, 50r.

4. A. Caiger-Smith, *Tin-Glaze Pottery in Europe and the Islamic World* (London, 1973), p. 54, n. 3. Because these tin glazes could produce a particularly white surface, they were crucial to the development and appeal of lusterware. Fired on the more common lead-based glazes, luster appears dull, whereas it becomes fully brilliant when set off against a stabler and purer white ground.

5. A. Moore Valeri, "Il campanile di Giotto e le origini della maiolica blu in Toscana," *Faenza* 72, no. 5/6 (1987), p. 281.

6. This dark blue glaze was apparently made of copper in its oxidized form. For a more complete discussion of this early blue glaze, see ibid., pp. 281–288.

7. *Orlando Furioso*, 6.57.

8. See V. Biringuccio, *De la pirotechnia* (Venice, 1540); G. Agricola, *De re metallica* (Basel, 1556).

9. Piccolpasso (note 3), vol. 1, fol. 64v.

10. Ibid., Prologue.

11. "Dolce color d'oriental zaffiro [like the saffron flower]," as Dante writes in the *Purgatorio*, chap. 13, l. 1.

12. Liverani 1960, p. 21.

13. Piccolpasso (note 3), vol. 1, fol. 70r.

14. So called after the decorations in ancient Roman ruins that were believed to be grottoes, grotesque embellishment is characterized by fantastic and highly decorative combinations of animals and humans (for two different approaches to grotesque embellishment on maiolica, see nos. 33, 34).

15. This French term most often refers to French, German, and Scandinavian earthenware dating from the sixteenth century on. Faentine ceramics, particularly *bianchi di Faenza* and *compendiario* wares, were popular in sixteenth-century France, and this probably explains the origin of the term.

16. Bellini and Conti 1964, p. 27.

17. C. Piccolpasso, *Li tre libri dell'arte del vasaio*, ed. G. Conti (Florence, 1976), p. 219. Conti believes that these Eastern jars were originally made from sections of bamboo; this may help to explain the origin of the ceramic *albarello* shape.

18. From the Italian *crespa*, meaning wrinkle or ripple.

19. Bellini and Conti 1964, p. 21.

1 Tile Floor

Manises(?) (Spain), circa 1425–1450
Overall: 110×220 cm (42⅞×85¾ in.); square tiles: 11.2 to 12.4 cm (4⁷⁄₁₆ to 4⅞ in.); hexagonal tiles: 10.8 to 11.1×21 to 21.8 cm (4¼ to 4⅜ × 8¼ to 8⁹⁄₁₆ in.)
84.DE.747

THIS PAVEMENT CONSISTS OF INTERLINKED OCTAGO-nal units (*alfardon den mig*) composed of square tiles (*ra-joles*) with a coat of arms, surrounded by hexagonal tiles (*alfaradones*) with a motto on scrolls. Both types of tiles are painted with cobalt blue foliage (often called oak leaves on Florentine examples). The triangular fills (*ri-goletes de puntes*) may have been cut from old tiles at a later date. The coat of arms (barry of six argent and gules) is probably Tuscan, but the family to which it belongs has yet to be identified.

On the scrolls the mottoes *speratens* and *ne oblyer* ("have hope" and "do not forget"), possibly religious or family devices, are written in Gothic script. These mot-toes may be derived from an Old Catalan or Old French dialect.[1]

The floor's octagonal units composed of square and hexagonal tiles are characteristic of Spanish pavements, and the foliate pattern is typical of the ceramic centers of Manises, Paterna, and Valencia. Although the design of these tiles is certainly Spanish in origin, it is difficult to determine whether the floor was also manufactured in Spain. Valencian potters produced large quantities of similarly inscribed tiles as well as ceramic plates and ves-sels for Italian export in the fifteenth century.[2]

Matching hexagonal tiles inscribed *speratens* are in the Kunstgewerbemuseum, Berlin (inv. 01, 43c),[3] and the Musée National de Céramique, Sèvres (inv. MNC 8447), and one inscribed *ne oblyer* was formerly in the Robert Forrer collection, Zurich.[4] A matching square tile with shield is in the Museum Boymans-van Beuningen, Rot-terdam.[5] Similar, but not identical, individual tiles are in the Museo Nacional de Cerámica, Valencia; the Victoria and Albert Museum, London (inv. 607–610, 1893); the Museo Arqueológico Nacional, Madrid; the Museos d'Arte, Barcelona; the Hispanic Society of America, New York (inv. E712); the Art Institute of Chicago (inv. 1984.923); and the Museo Correr, Venice.[6] Comparable tiles can also be seen in the panel paintings of Jaime Hu-guet, Pedro Alemany, and Gabriel Guardia, Spanish art-ists active from the mid-fifteenth to the early sixteenth century.[7]

MARKS AND INSCRIPTIONS: On scrolls across the hex-agonal tiles, *speratens, ne oblyer*; on the square tiles, a coat of arms of barry of six argent and gules.

PROVENANCE: Grassi collection, Florence, before 1920; [Ruth Blumka, New York].

EXHIBITIONS: *Beyond Nobility: Art for the Private Citizen in the Early Renaissance*, Allentown Art Museum, Sep-tember 1980–January 1981, no. 122.

BIBLIOGRAPHY: A. Berendsen et al., *Tiles* (London, 1967), p. 76; E. Callmann, *Beyond Nobility: Art for the Pri-vate Citizen in the Early Renaissance*, exh. cat. (Allentown Art Museum, 1980), pp. 115–116.

CONDITION: Surface chips; numerous abraded areas.

1. G. Corti suggested this derivation in correspondence with the author, January 25, 1985.
2. Hausmann 1972, p. 50, no. 32. A. W. Frothingham, in "Va-lencian Lusterware with Italian Coats of Arms in the Collection of the Hispanic Society of America," *Faenza* 39, no. 3/5 (1953), p. 92, mentions Ferrarese notarial records of 1442 listing nu-merous Valencian ceramics that had been carried to Italy on Majorcan ships.
3. Hausmann 1972, p. 50, no. 32.
4. R. Forrer, *Geschichte der europäischen Fliessen-Keramik* (Stras-bourg, 1901), pl. 38.
5. Berendsen et al. 1967, facing p. 76.
6. For an examination of these Correr tiles, see M. González Martí, "Azulejos valenzianos exportados a Italia," *Faenza* 34, no. 4/6 (1948), pp. 91–92, pl. 22a; E. Concina, "Documenti ed appunti per la pavimentazione Giustinian ad *azulejos* valen-ziani," *Faenza* 61, no. 4/5 (1975), pp. 80–82. Produced in Va-lencia for the church of Sant'Elena, Venice, these tiles are fur-ther evidence of the active artistic exchange between Italy and Spain in the fifteenth century. The hexagonal *azulejos*, inscribed *Justiniano*, and the square units, decorated with a crowned ea-gle, may have been ordered by Francesco Giustinian to embel-lish the tomb of his father, Giovanni, in Sant'Elena. In light of archival documents, Concina has suggested dating these tiles soon after 1460 (p. 82).
7. For examples, see J. A. de Lasarte, *Jaime Huguet* (Madrid, 1955), figs. 38, 48; A. L. Mayer, *Geschichte der spanischen Malerei* (Leipzig, 1922), pl. 73; C. R. Post, *A History of Spanish Painting* (Cambridge, 1938), vol. 7, pt. 1, fig. 116.

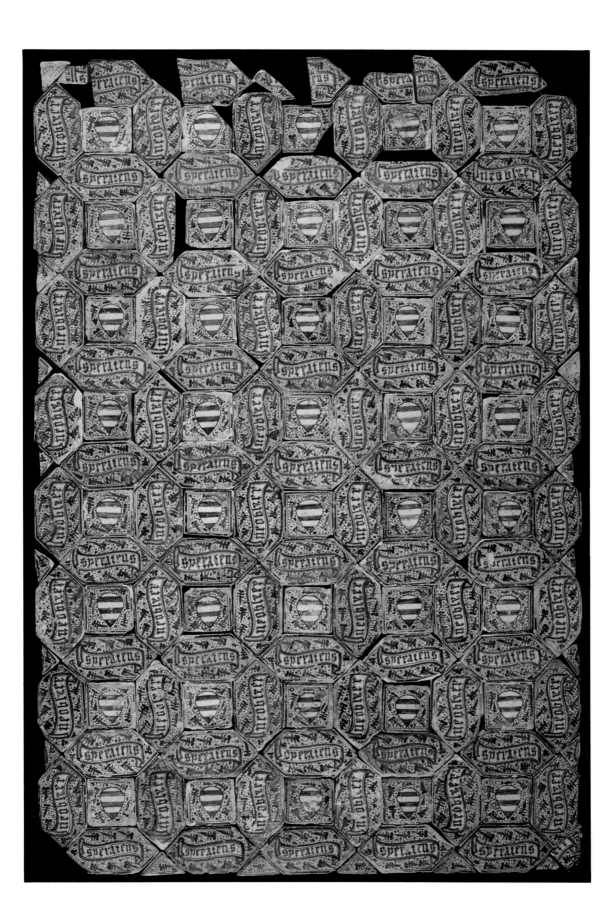

2 Hispano-Moresque Deep Dish (Brasero)

Valencia (Spain), mid-fifteenth century
H: 10.8 cm (4¼ in.); Diam: 49.5 cm (19½ in.)
85.DE.441

THIS DEEP DISH HAS A FLAT BASE, NEARLY VERTICAL sides sloping slightly outward, and a flat rim. The painted decoration is executed in cobalt blue pigment and copper red luster; Spanish Moors had mastered the metallic luster technique by the eleventh century, and by 1415 Málagan and Murcian potters had brought this technique to the Valencian region.[1]

The center of the obverse is inscribed *IHS* (Jesus Hominum Salvator). Saint Bernard of Siena, who died in 1444, would hold up this monogram for veneration at the end of his sermons, and it came to be associated with the saint and his missionary work. After his canonization in 1450, the monogram began to appear on works of art, thus substantiating the dating of this piece to midcentury.

The deep dish is further embellished with a radiating leaf pattern that extends over the rim and down the sides of the exterior; the reverse displays alternating wide and narrow concentric bands. The decoration of three-part leaves with tendrils from which spring small flowers with petals of varying number is occasionally identified as bryony leaves (a tendril-bearing vine of the gourd family),[2] parsley leaves (*hoja de perejil*),[3] or *fiordaliso* (normally translated as fleur-de-lis but also commonly used to indicate a small carnation).[4] One finds this leaf-spray embellishment in various configurations on Hispano-Moresque wares of the second and third quarters of the fifteenth century.[5] This foliate motif spread from Spain to Italy and became popular on Italian wares toward the end of the century.[6] Works decorated in this manner were also favored and collected in France, where this leaf-spray motif is referred to as *feuillages pers* (greenish blue foliage), and are included in important inventories such as that of King René of Anjou.[7]

This type of Valencian deep dish was often used as a serving trencher, although its large scale, elaborate decoration, and excellent state of preservation suggest that the Museum's dish was intended for display, perhaps on a credenza. Similar dishes with leaf-spray embellishment and the San Bernardino monogram, many of which are *braseros* and display concentric bands on the reverse, include those in the Kunstmuseum, Düsseldorf;[8] formerly in the Bak collection, New York;[9] formerly in the

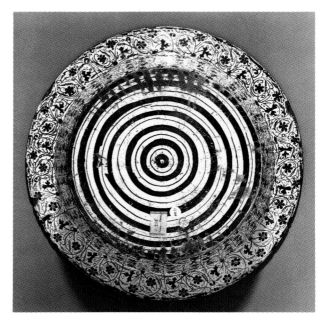

No. 2, reverse

Vieweg collection, Brunswick;[10] in the Musée du Louvre, Paris (inv. OA 1223, 1224, 4029, 4032); in the Museo Nazionale, Palazzo del Bargello, Florence;[11] formerly in the M. Boy collection, Paris;[12] in the Victoria and Albert Museum, London;[13] formerly in the Emile Gaillard collection, Paris;[14] in the Hispanic Society of America, New York;[15] in the Toledo Museum of Art;[16] in the González Martí collection, Valencia;[17] and formerly in the Francis Wilson Mark collection, Palma de Mallorca and London.[18]

MARKS AND INSCRIPTIONS: On obverse, in center, *IHS*.

PROVENANCE: [Leonardo Lapiccirella, Florence]; sold, Christie's, London, July 1, 1985, lot 270; [Rainer Zietz, Ltd., London].

EXHIBITIONS: None.

BIBLIOGRAPHY: G. Conti, *L'arte della maiolica in Italia* (Milan, 1973), pl. 8; *Apollo*, no. 122 (1985), p. 405, no. 5.

CONDITION: Some minor chips and glaze faults.

1. A. Lane, "Early Hispano-Moresque Pottery," *Burlington Magazine* 88 (October 1946), pp. 251–252.
2. See, for example, A. W. Frothingham, *Catalogue of Hispano-Moresque Pottery* (New York, 1936), p. 158; idem, *Lustreware of Spain* (New York, 1951), p. 139.
3. See Martí 1944–1952, vol. 1, pp. 459ff.
4. *Fiordaliso* may indeed be the most acceptable name for this

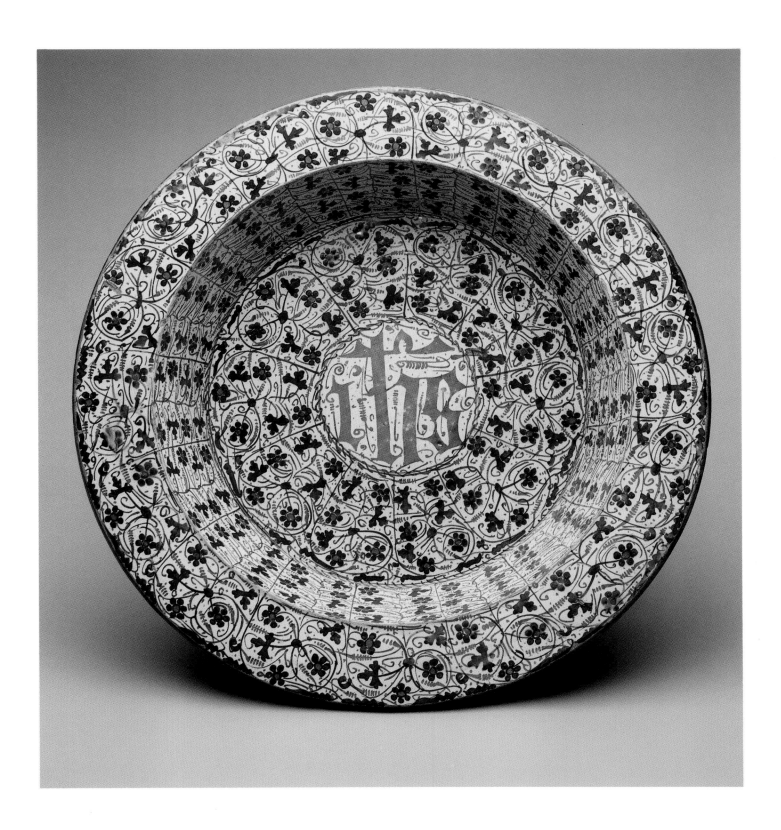

decoration, since it appears (as *fioralixi*) in contemporary inventories (M. Spallanzani, "Maioliche di Valenza e di Montelupo in una casa pisana del 1480," *Faenza* 72, no. 3/4 [1986], pp. 164–170). Moreover these inventories were concerned with listing works so that they could be readily identified; one can understand why the name of a common and easily recognizable flower such as the carnation might have been used to describe this decoration.

5. E. A. Barber, *Hispano-Moresque Pottery* (New York, 1915), p. 34.

6. See, for example, Bojani et al. 1985, p. 188, no. 467.

7. J. Hayward and T. Husband, *The Secular Spirit: Life and Art at the End of the Middle Ages* (New York, 1975), p. 53.

8. *Kunstmuseum Düsseldorf: Eine Auswahl* (Düsseldorf, 1962), p. 266, no. 892, fig. 104.

9. *A Highly Important Collection of Early Italian Maiolica Formed by Dr. Bak of New York*, sale cat., Sotheby's, New York, December 7, 1965, lot 2.

10. *Vieweg Collection, Brunswick*, sale cat., Rudolph Lepke, Berlin, March 18, 1930, lot 147.

11. G. Conti, *Catalogo delle maioliche: Museo Nazionale di Firenze, Palazzo del Bargello* (Florence, 1971), no. 517; idem, *L'arte della maiolica in Italia*, 2nd edn. (Milan, 1980), pl. 68.

12. *Objets d'art . . . composant la collection de feu M. Boy*, sale cat., Galerie Georges Petit, Paris, May 15–24, 1905, lot 53.

13. J. A. de Lasarte, *Ars hispaniae*, vol. 10 (Madrid, 1952), p. 68, fig. 155.

14. *Objets d'art . . . composant la collection Emile Gaillard*, sale cat., Gaillard home, Paris, June 8–16, 1904, p. 85, no. 406.

15. Frothingham, *Lustreware* (note 2), pp. 136, 138–139, figs. 98, 99.

16. *Museum News* (Toledo Museum of Art) 5, no. 3 (1962), p. 58.

17. Martí 1944–1952, vol. 1, p. 461, pl. 17, fig. 565.

18. W. G. Blaikie Murdoch, "Pottery and Porcelain: Mr. Francis W. Mark's Collection of Hispano-Moresque Pottery," *Connoisseur* 63 (August 1922), p. 201, no. 5.

3 Jug with Pecking Bird (Boccale)

Tuscany, early fifteenth century
H: 25 cm (9⅞ in.); Diam (at lip): 9.5 cm (3¾ in.); max.
W: 16.2 cm (6⅜ in.)
84.DE.95

THIS JUG IS FORMED OF AN OVOID BODY, STRAP handle, flared rim, and pinched spout. It is a simple yet remarkably elegant piece because of its gently attenuated shape and strongly rendered surface decoration. A long-beaked bird stands on the ground line, from which sprouts foliage, against a background of berries and dots in copper green and manganese brown pigments. The interior is lead glazed.

The oldest piece of maiolica in the Museum's collection, this jug corresponds to the archaic style, according to G. Ballardini's classification.[1] This style prevailed from roughly the thirteenth to the beginning of the fifteenth century and is generally characterized by simple motifs—initials, coats of arms, stylized animals—painted in copper green outlined in manganese brown. Like the present work, archaic-style maiolica jugs from Tuscany as well as from surrounding regions commonly display a guilloche pattern encircling the neck and parallel lines dividing the piece into decorative panels.[2]

Also popular was the motif of a single bird, often portrayed pecking at a berry or leaf, adorning the body of a jug or jar.[3] In reference to a Faentine example decorated with this motif, Ballardini has suggested that this pecking bird (becca l'uva) may allude to the name of a prominent family of the area.[4] Both the rather thickly painted green glaze and the appearance of berries and lobed leaves relate this decoration to the zaffera a rilievo (relief-blue) embellishment popular in Tuscany primarily in the second quarter of the fifteenth century (see nos. 5–9).[5] Indeed the connections between earlier archaic ceramics and zaffera a rilievo products may be more direct than initially thought. Traditionally, all ceramics of the relief-blue typology were dated to the fifteenth century.[6] Recent archaeological excavations in Tuscany have unearthed zaffera wares together with fourteenth-century archaic types, however, so that one can be certain that zaffera works were already being produced in the second half of the fourteenth century.[7] Consequently, and as this jug demonstrates, relief-blue decorations do not represent as great a departure from earlier decorative types as was previously believed.[8]

Once thought to be derived directly from Islamic and Islamic-inspired ceramic decoration,[9] the stylized animal designs—including lions, hares, leopards, and dogs as well as birds—on Italian wares appear to have been based instead on Florentine textiles and other decorative arts of the fourteenth and fifteenth centuries. These Florentine products in turn appear to have been influenced by Islamic motifs originating in the Eastern Mediterranean.[10] Maiolica decoration therefore may display Islamic motifs that were indirectly transmitted to the ceramic medium through other Renaissance Italian decorative arts.

MARKS AND INSCRIPTIONS: None.

PROVENANCE: Private collection, The Netherlands; [Rainer Zietz, Ltd., London].

EXHIBITIONS: None.

BIBLIOGRAPHY: None.

CONDITION: A chip in the base, and minor chips on the handle and rim; what appear to be three chips around the central section are actually areas of the clay body on which deposits of calcined lime or other impurities have expanded and "popped out," or exploded, during firing.

1. See Ballardini 1933–1938, vol. 1, *Le maioliche datate fino al 1530*, pp. 13–14; for a helpful schema, see vol. 2, *Le maioliche datate dal 1531–1535*, p. 10. Based on classifications of ancient pottery, Ballardini's categories are organized according to the wares' decorative glaze motifs. Although scholars have become increasingly aware of the importance of such factors as object shape as well as clay body and glaze composition in grouping maiolica wares, Ballardini's classification remains helpful in establishing a basic chronology of maiolica decoration. More recently, G. Cora established nineteen major categories of early Italian maiolica which vary only slightly from Ballardini's schema (Cora 1973, vol. 1, p. 33). One must remember, however, that while useful, the conventionalized terms employed by Ballardini and others can prove misleading, especially when used to identify the subjects of decorative motifs. A. Moore Valeri has pointed out, for example, that the "Persian palmette" bears no resemblance to a palmette and that in the Near East the "peacock-feather" motif originally had no connection with peacocks, symbolizing instead the rising sun (Valeri 1984, pp. 490–491, n. 62).
2. For other examples, see Cora 1973, vol. 2, figs. 6c, 8a–b, 11, 13a, 31a–d, 32, 33, 310a–c, 313a–d, 318b.
3. See ibid., figs. 8a–b, 44c, 51a, 64b, 65a–c, 69a, 69c, 69d, 70a–c, 71a–c, 137a, 138a, 309a–c.
4. Ballardini 1975, p. 49.
5. One knows of works decorated with typical relief-blue leaves, dots, and animals painted in a thin copper green glaze, as on this jug, instead of the much more common thick cobalt pigment (Giacomotti 1974, pp. 10–11, fig. 28). Cora 1973, vol.

2, pl. 21a, reproduces an early fifteenth-century Florentine fragment displaying similarly shaped and outlined leaves, also painted in copper green.

6. According to Cora's classification of early Florentine ceramics, *zaffera a rilievo* (his group V) dates from circa 1410–1450 and *zaffera diluita* (his group VI) dates from circa 1410–1480 (Cora 1973, vol. 1, pp. 73–83).

7. Valeri 1984, pp. 477–478.

8. Compare, for example, a mid-fifteenth-century archaic jug decorated with leaves in copper green glaze from Viterbo (L. Galeazzo and G. Valentini, *Maioliche arcaiche e rinascimentali in raccolta privata* [Foligno, 1975], pp. 108–109) and a Tuscan jug with similar decoration but in *zaffera diluita* (Bojani et al. 1985, no. 706). For a similar *boccale* with a "pecking bird" but painted in relief cobalt blue, see Cora 1973, vol. 2, pls. 64b, 65a–c.

9. For examples of Islamic animal motifs, see E. Kühnel, *The Minor Arts of Islam* (New York, 1971), figs. 51, 84, 88, 90; idem, *Beiträge zur Kunst des Islam* (Leipzig, 1925), pl. 99. For bird motifs on Hispano-Moresque works, see Martí 1944–1952, vols. 1, figs. 150, 153, 183, 192, 277, 280, 356, 459, 494–496, 538, 612, 631, 640, 648–652, 700; 2, pp. 472–478; 3, figs. 556–563, 668, 670, 678–680, 689–691.

10. First discussed in H. Wallis, *The Oriental Influence on the Ceramic Art of the Italian Renaissance* (London, 1900), pp. ix–xxx; most recently examined in M. Spallanzani, *Ceramiche orientali a Firenze nel rinascimento* (Florence, 1978), pp. 100–102; Valeri 1984, pp. 477–500.

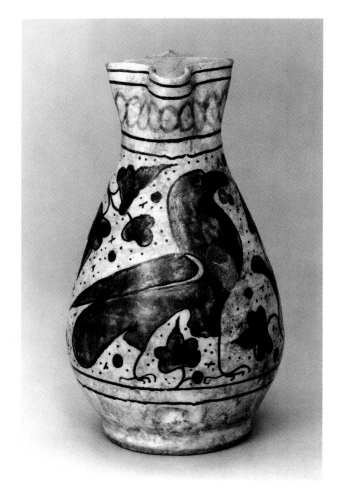

No. 3, alternate view

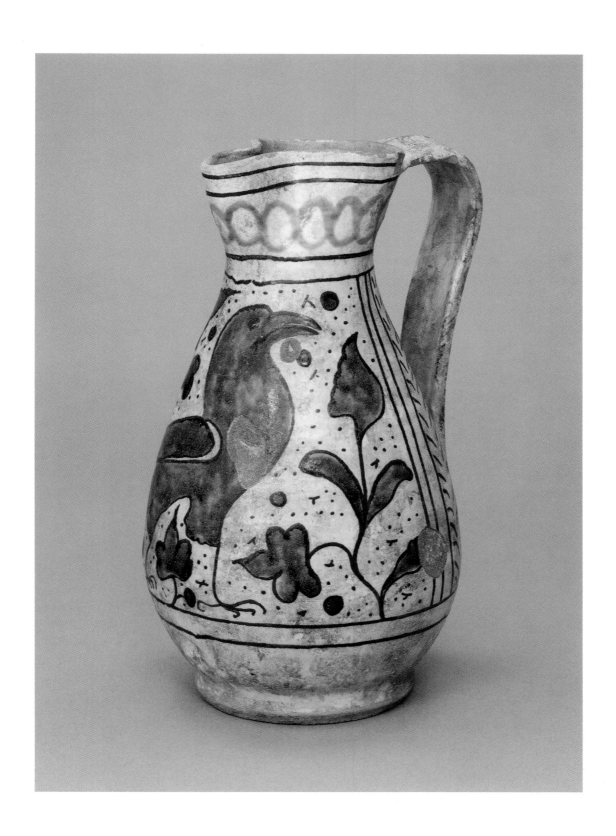

4 *Dish* (Bacino)

Florence, circa 1425–1440
H: 4.4 cm (1 3/4 in.); Diam: 25.3 cm (9 15/16 in.)
84.DE.94

THIS MODEST DISH displays sophisticated geometric and vegetal glaze decoration in green, ocher, and pale brownish purple. The radiating sections of scalelike ornamentation around the rim, slanting "shuttle" pattern alternating with wavy lines around the deep well border, and curvilinear pattern in the well all complement the object's simple shape. Moreover this dish is one of the rare early, undoubtedly functional pieces that have remained intact. Although unembellished, the reverse shows traces of lead and tin glazes.

This work belongs to the green family, the first phase of the severe style, which dates from roughly 1425 to 1450 and includes ceramic products decorated mainly with a copper green pigment.[1] This style differs from the earlier archaic style not only in its emphasis on more animated and varied decorative motifs but also in the use of new pigments—such as ocher, blue, yellow, and a more purple-tinted manganese brown—accompanying the traditional copper green.

Dating from around 1420 to the turn of the century, the severe style marks an important development in maiolica embellishment, since for the first time new designs drawn from a variety of media (such as textiles, architectural decoration, manuscript illumination, and ceramics), originating in centers outside the peninsula (such as Spain and the Near East), strongly influenced Italian maiolica glaze motifs. In addition to the green family, the severe style included such diverse types of glaze decoration as *zaffera a rilievo*, Italo-Moresque, Gothic-floral, peacock feather, Persian palmette, and *alla porcellana*.

Influenced by Islamic metalwork designs, this dish's well displays looped scrolls and leaf sprigs that emanate from a cruciform motif and gracefully feed into a band around the well, all reserved on a hatched ground. Not only do identical looped scrolls appear over and over again on Islamic metalwork objects,[2] but the hatched ground strongly resembles the background "filler" used to set off metalwork motifs by means of hatching or punching.[3] This same filler ground, against which the main decoration is reserved, appears on Islamic ceramics,[4] suggesting that they also served to transmit Islamic motifs to Italy.

Similar decoration, particularly of the well and well

No. 4, reverse

border, is found on Tuscan maiolica fragments of the late fourteenth and early fifteenth centuries.[5] A related Florentine deep dish from the first half of the fifteenth century was formerly in the Wilhelm von Bode collection, Berlin, and is now in the Fitzwilliam Museum, Cambridge.[6] Like the Getty Museum's *bacino*, a jug from Montalcino of the mid-fourteenth century displays a looped scroll on a hatched background.[7] Although apparently derived from the same sources, the looped scroll on the jug is abruptly cut off by the border lines; the jug's glaze painter, from the more provincial center of Montalcino, apparently did not understand the flowing nature of the scroll motif displayed by the Museum's dish.

The variety of this *bacino*'s decorative motifs and the use of an ocher glaze suggest this work was executed after the first decades of the fifteenth century; its decoration, however, is not as innovative as that on works of the midcentury.[8]

MARKS AND INSCRIPTIONS: None.

PROVENANCE: A. Pringsheim, Munich; E. R. Paget, London; A. Kauffmann, London; [Rainer Zietz, Ltd., London].

EXHIBITIONS: None.

BIBLIOGRAPHY: Falke 1914–1923, vol. 1, p. 4, fig. 4; Cora 1973, vol. 2, no. 50d, pl. 50.

CONDITION: Some areas of overpainting from rim to rim across the center of the dish and on the rim; a glaze fault and a few glaze chips around the rim.

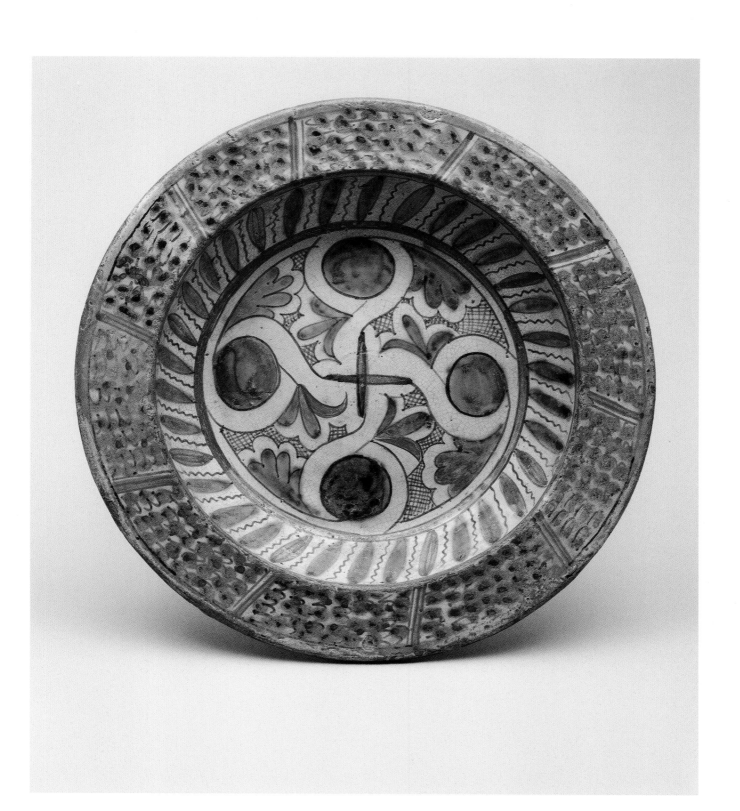

1. Ballardini 1975, pp. 49–51.

2. See, for example, A. Grohmann, "Die Bronzeschale M.388-1911 im Victoria and Albert Museum," in *Aus der Welt der islamischen Kunst* (Berlin, 1959), figs. 4, 5; E. Baer, *Metalwork in Medieval Islamic Art* (Albany, 1983), figs. 112, 117, 173, 176, 178, 180, 184, 213; E. Atil et al., *Islamic Metalwork in the Freer Gallery of Art* (Washington, D.C., 1985), no. 19.

3. A few examples among many can be found in Baer (note 2), fig. 183; Atil et al. (note 2), no. 26, fig. 64. For examples of this hatchwork motif on other early Italian ceramics, see L. Galeazzi and G. Valentini, *Maioliche arcaiche e rinascimentali in raccolta privata* (Foligno, 1975), pp. 17, 20; E. Callmann, *Beyond Nobility: Art for the Private Citizen in the Early Renaissance*, exh. cat. (Allentown Art Museum, 1981), nos. 120, 121.

4. See, for example, R. Charleston, *World Ceramics* (London, 1968), p. 70, nos. 204, 205.

5. See Cora 1973, vol. 2, figs. 24b, 28a; Rackham 1940, vols. 1, p. 20, no. 76; 2, pl. 5.

6. Bode 1911, p. 13; B. Rackham, *Catalogue of the Glaisher Collection of Pottery and Porcelain in the Fitzwilliam Museum* (Cambridge, 1935), no. 2164; Cora 1973, vol. 2, no. 50c.

7. Galeazzi and Valentini (note 3), p. 20.

8. See, for example, Cora 1973, vol. 2, pl. 53.

5 Two-Handled "Oak-Leaf" Drug Jar (Orciuolo Biansato)

Florence, circa 1420–1440
H: 31.1 cm (12¼ in.); Diam (at lip): 14.3 cm (5⅝ in.);
max. W: 29.8 cm (11¾ in.)
85.DE.56

THIS LARGE TWO-HANDLED DRUG JAR IS OF AN exceptionally bold and rare shape: it has a broad, almost cylindrical body with a tall neck, high foot, and ribbed, outward-jutting handles. The center of each side displays a three-runged ladder surmounted by a cross framed on one side by two birds, sometimes identified as peacocks,[1] and on the other side by two human-faced birds, or harpies. The surface is further decorated with leaves and dots (often called *bacche*, "berries"). This decoration is painted in an exceptionally thick, cobalt blue impasto (*zaffera a rilievo*) outlined in and scattered with touches of manganese purple on a pinkish white ground. Vertical patterns in manganese purple of double dashes between three parallel stripes border each side of the jar's body. The interior is tin glazed.

The leaf decoration on this jar is one of the first decorative typologies to be recognized and discussed as a coherent group.[2] In 1898 W. von Bode first described this decoration as *pastoser Blaudekor* (blue impasto decoration),[3] and five years later H. Wallis identified the motif as oak leaves.[4] T. Hausmann, however, has described the painted decoration as grape leaves.[5] According to Hausmann, this type of ornamentation was adapted in Florence from Hispano-Moresque ceramic decoration of vines and feathered leaves, which, when painted with the Florentine thick blue impasto, became simplified to resemble oak leaves. The Hispano-Moresque deep dish in the Museum's collection (no. 2), for example, displays this type of Spanish ceramic decoration, especially prevalent in Valencia. Recent scholarship, however, favors identification of the foliage as oak leaves and questions its derivation from Hispano-Moresque sources.[6]

Below each handle is a *P*, possibly intertwined with a backward *C*, which may be the mark of the Florentine workshop of Piero di Mazeo and company, active at the time the jug was made. Di Mazeo (born 1377/87 in Bacchereto) worked as a ceramist in his hometown before moving to nearby Florence, where he became head of an important workshop together with two partners and a group of craftsmen, many of whom also came from Bacchereto. One potter, Antonio di Branca, was a native of Viterbo and is known to have worked in di Mazeo's workshop around 1427 "for a few years at least."[7] Di Branca's presence in di Mazeo's workshop may explain the unusual presence of harpies—more common on works from centers such as Orvieto and Viterbo—on this jar of almost certain Florentine origin.[8] The harpy was a monster said to torment misers and was commonly used during the Renaissance as a symbol for avarice. It is uncertain whether the harpies here are invested with this meaning. They might have served as admonitory emblems referring to the generosity of the hospital for which this drug jar was made. Harpies also decorate a Florentine drug jar formerly in the Wilhelm von Bode collection, Berlin,[9] and another in the Musée du Louvre, Paris (inv. OA 3982).[10] A further example of a two-handled drug jar displaying symmetrically placed, striped birds is in the Museo Nazionale, Palazzo del Bargello, Florence.[11]

A three-runged ladder surmounted by a cross is the emblem of the Sienese Santa Maria della Scala hospital. This emblem refers to the hospital's location in front of the steps (*scala*) of the city's cathedral. Santa Maria della Scala was primarily a foundling hospital.[12] Established around the tenth century, the hospital later became so important that it opened branches outside Siena. On May 17, 1316, the Florentine town council authorized the opening of a branch in the Tuscan capital on what was to be called Via della Scala. The Florentine branch became prominent, maintaining almost complete autonomy until 1535, when it was combined with the Florentine Ospedale degli Innocenti.[13] Since all Tuscan branches of the Santa Maria della Scala hospital apparently used the cross-and-ladder emblem, one cannot be certain for which branch the present jar was produced. Maiolica products displaying the emblem include mid-fifteenth-century two-handled drug jars[14] and mid-sixteenth-century dishes.[15]

MARKS AND INSCRIPTIONS: On each side, a three-runged ladder surmounted by a cross; below each handle, *P*, possibly intertwined with backward *C*.

PROVENANCE: Wilhelm von Bode, Berlin; Glogowski, Berlin (sold, Sotheby's, London, June 8, 1932, lot 58); August Lederer, Vienna; Erich Lederer, Geneva.

EXHIBITIONS: None.

BIBLIOGRAPHY: Wallis 1903, pp. 9 (fig. 7), 35; Bode 1911, pl. 14; Chompret 1949, vol. 2, fig. 648; Cora 1973, vols. 1, p. 76; 2, pls. 61, 62, 63c; G. Conti, *L'arte della maiolica in Italia*, 2nd edn. (Milan, 1980), pls. 45, 46; Valeri 1984, fig. 4b.

CONDITION: Previously broken and repaired; some overpainting, particularly around the lip and neck on the left of the side with birds and on the right-hand bird; approximately three-quarters of the glaze on the top rim has worn off.

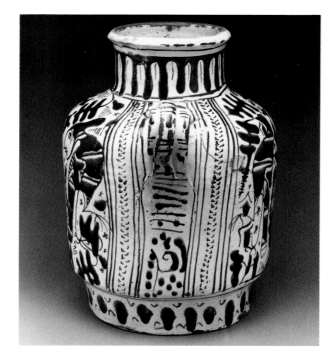

No. 5, alternate view

1. Bojani et al. 1985, vol. 1, nos. 181, 222, 225, 707.
2. This type of embellishment is alternately known as *pastoser Blau, zaffera a rilievo*, relief-blue, or oak-leaf decoration.
3. See W. von Bode, "Altflorentiner Majoliken," in *Ausstellung von Kunstwerken des Mittelalters und der Renaissance*, exh. cat. (Kunstgeschichtliche Gesellschaft, Berlin, 1899).
4. Wallis 1903, p. xx. Although quite different in appearance from relief-blue pieces, the reverse of an unusual basin in the Corcoran Gallery of Art, Washington, D.C. (inv. 26.315), and an octofoil bowl in the Los Angeles County Museum of Art (the authenticity of which is currently being investigated) clearly display oak leaves with acorns (inv. 46.16.2; Watson 1986, no. 5, and Valeri 1984, p. 492, fig. 10, respectively); whether these oak leaves can be related to the Florentine *zaffera* motifs has not yet been fully examined.
5. Hausmann 1972, p. 96.
6. Valeri 1984, pp. 490–493.
7. Cora 1973, vol. 1, p. 76.
8. Ibid., pp. 61, 67, 76.
9. Wallis 1903, p. 22, fig. 20; Chompret 1949, vol. 2, fig. 635; Bode 1911, p. 14 (right); *A Highly Important Collection of Early Italian Maiolica Formed by Dr. Bak of New York*, sale cat., Sotheby's, New York, December 7, 1965, lot 19.
10. Giacomotti 1974, pp. 12–13, no. 30.
11. Cora 1973, vol. 2, fig. 68; G. Conti, *Catalogo delle maioliche: Museo Nazionale di Firenze, Palazzo del Bargello* (Florence, 1971), no. 509.
12. K. Park, *Doctors and Medicine in Early Renaissance Florence* (Princeton, 1985), p. 104, n. 60.
13. Cora 1973, vol. 1, p. 76.
14. Ibid., vol. 2, figs. 91, 92c.
15. See Ballardini 1933–1938, vol. 1, nos. 64–67; Rackham 1940, vol. 1, nos. 642, 643.

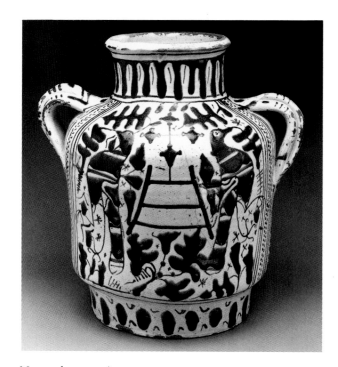

No. 5, alternate view

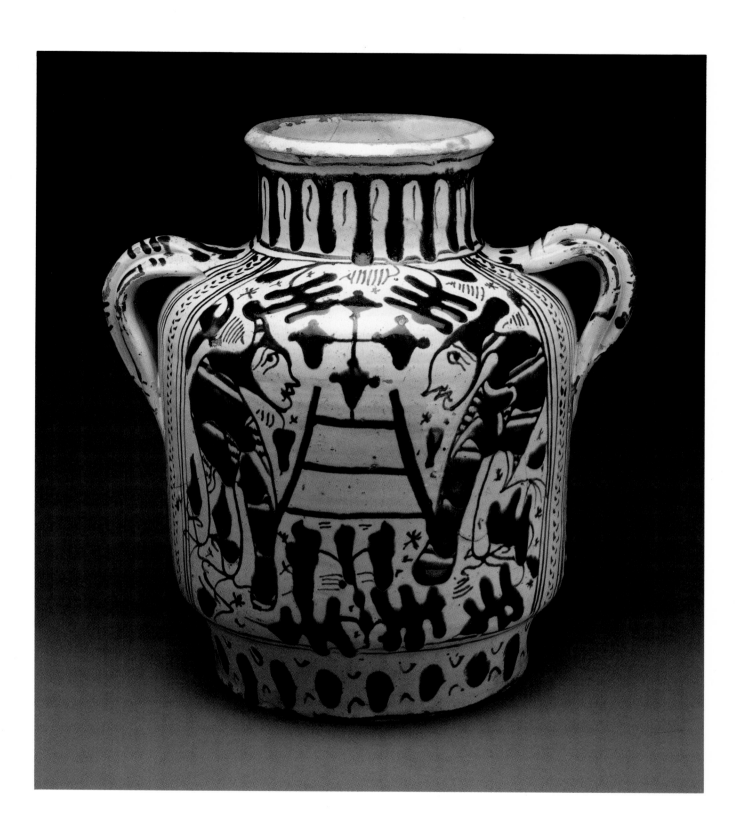

6 Cylindrical "Oak-Leaf" Jar (Albarello)

Florence, circa 1420–1440
H: 16.5 cm (6½ in.); Diam (at lip): 9.7 cm (3¹³⁄₁₆ in.); max.
Diam: 12.2 cm (4¹³⁄₁₆ in.)
85.DE.57

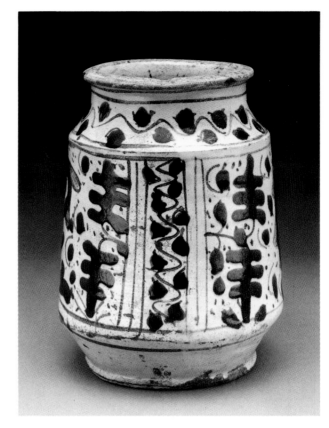

No. 6, alternate view

THIS ESSENTIALLY CYLINDRICAL VESSEL, THOUGH slightly wider at the base, is characteristic of the *albarello* form. The surface is painted with a vertically placed fish on either side surrounded by leaves and dots (or "berries") in a thick cobalt blue impasto (*zaffera a rilievo*) outlined in manganese purple on a pinkish white ground. The background is scattered with manganese dots and curved lines that echo the dot shapes. Down one side and around the rim, wavy manganese lines are punctuated by blue dots. The interior is tin glazed. The vessel's small size suggests that it must be a *quartuccio*, or quarter measure.

Although commonly thought to be of Hispano-Moresque derivation, this fish motif appears to be derived instead from archaic maiolica prototypes that may in turn have been based on Islamic models.[1] A drug jar in a private Florentine collection which displays a horizontally placed fish may be one of the few maiolica objects with this motif that directly relate to Hispano-Moresque or Near Eastern types.[2] The fish motif in the more common vertical position is found on other early Florentine jars, although of the two-handled form, also with oak-leaf and berry embellishment.[3]

MARKS AND INSCRIPTIONS: None.

PROVENANCE: Ugo Grassi, Florence; August Lederer, Vienna; Erich Lederer, Geneva.

EXHIBITIONS: None.

BIBLIOGRAPHY: J. Rothenstein, "Shorter Notices: Two Pieces of Italian Pottery," *Burlington Magazine* 85 (August 1944), p. 205, pl. C; Cora 1973, vols. 1, p. 78; 2, fig. 83c; G. Conti, *L'arte della maiolica in Italia*, 2nd edn. (Milan, 1980), no. 48.

CONDITION: Minor chips and overpainting on the rim.

1. Valeri 1984, pp. 478, 480–481, n. 24.
2. Cora 1973, vol. 2, fig. 82; Valeri, pp. 480, n. 24; 494, n. 85.
3. For other examples, see Cora 1973, vol. 2, figs. 83a–b, 84a–c, pl. 85; Wallis 1903, p. 32, fig. 30. For examples on archaic maiolica, see Cora 1973, vol. 2, pls. 14a, 16a, 17a, 20.

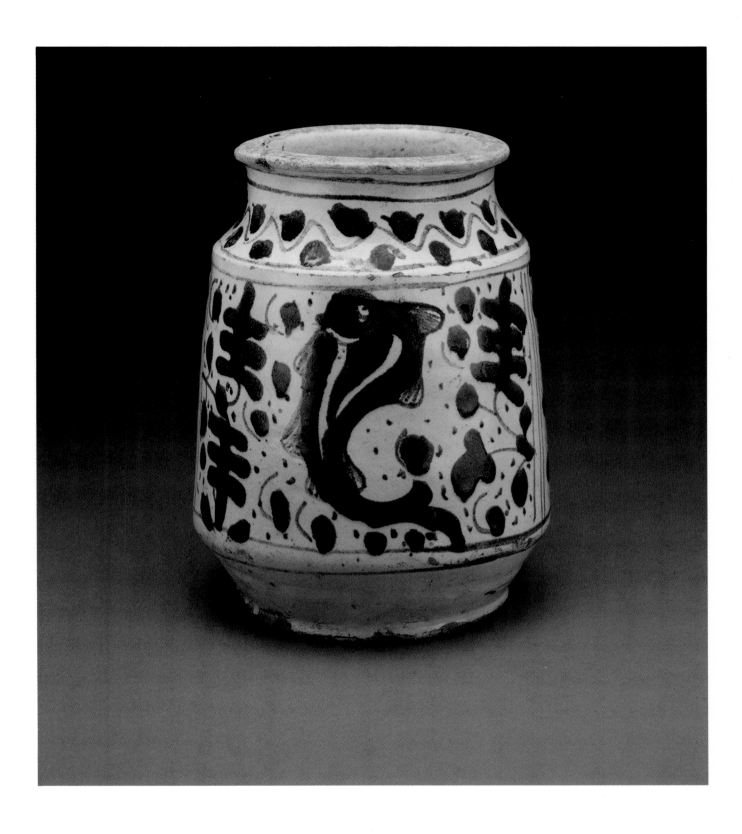

7 Two-Handled "Oak-Leaf" Jar (Orciuolo Biansato)

Florence, circa 1425–1450
H: 39.4 cm (15½ in.); Diam (at lip): 19.3 cm (7⅝ in.);
max. W: 40 cm (15¾ in.)
84.DE.97

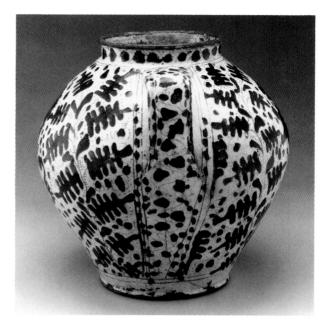

No. 7, alternate view

THIS TWO-HANDLED JAR IS THE LARGEST KNOWN VES-
sel of its kind. Its high-shouldered, ovoid body is em-
bellished on each side with a rampant lion among dots
(or "berries") and branches of leaves in a thin blue im-
pasto outlined in and surrounded by dashes and wavy
lines in manganese purple. The thin impasto, or *zaffera
diluita*, is a somewhat later and rarer type of decoration
than the thicker *zaffera a rilievo*.[1] The short neck and strap
handles are likewise painted with blue dots and man-
ganese lines on a thin bluish white ground. The interior
is glazed but much abraded.

This piece displays a painted asterisk below each
handle, which may serve a purely ornamental function,
since asterisks were a common decorative motif.[2] Be-
cause the areas below handles on jugs and jars are con-
ventionally inscribed with makers' marks, however, it
seems more likely that the asterisks on this work indicate
a given workshop. G. Cora has identified the six-pointed
asterisk on this drug jar as the mark of the workshop of
Giunta di Tugio (circa 1382–circa 1450), the most im-
portant maiolica ceramist of his time in Florence.[3] Di
Tugio, youngest son of Tugio di Giunta, was born in
Bacchereto, like his father and other fifteenth-century
ceramists who became active in Florence (such as Piero
di Mazeo[4]). Di Tugio was trained in his father's work-
shop, which he took over at the time of the latter's death
around 1419 and managed for the next thirty years. Ac-
cording to documents, by 1417 di Tugio was a member
of the council of the *oliandoli*, or oil merchants.[5]

Lions frequently embellish *zaffera a rilievo* ceramics
and are particularly appropriate as a Florentine motif,
since they probably refer to that city's lion emblem, or
marzocco. Since the lion was also popular on wares from
Valencian centers such as Paterna and Manises,[6] it is com-
monly thought to be of Hispano-Moresque origin, al-
though recent scholarship suggests that it derived instead
from Italian heraldry or archaic ceramics.[7] The white
starlike disk on the lion's chest, a design whose signifi-
cance has yet to be explained, appears on Hispano-Mor-
esque works[8] and may have been transferred to Italian ce-
ramics with the influx of Spanish wares in the fifteenth
century. This design also appears on animals embellish-

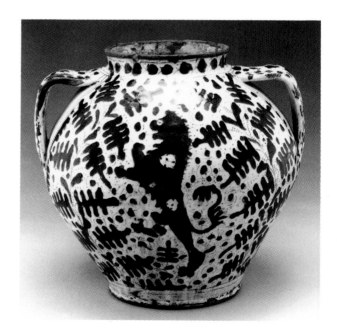

No. 7, alternate view

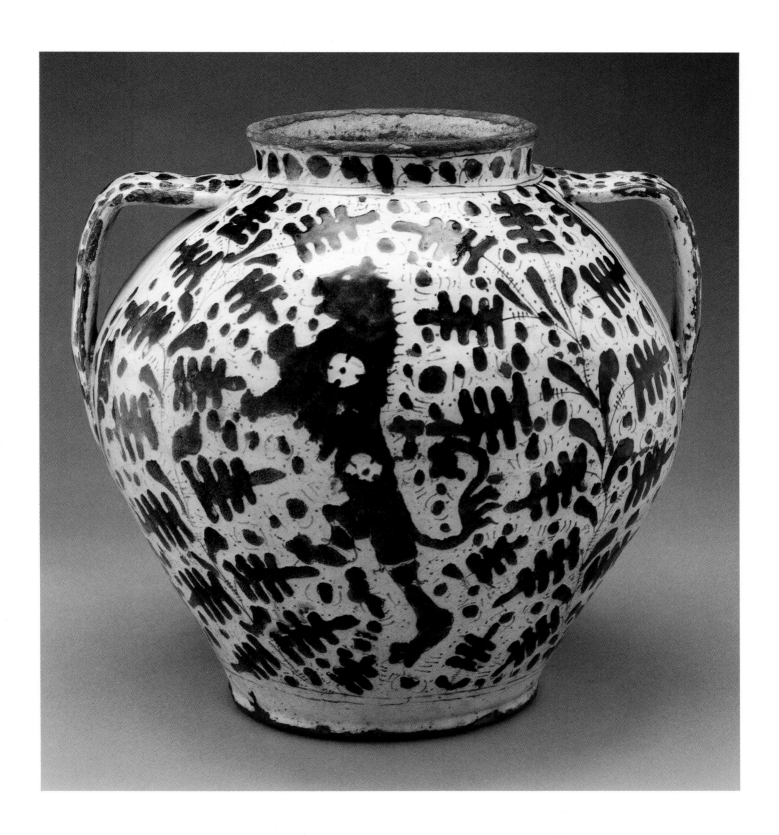

ing contemporary and earlier fabrics, and these fabrics, possibly themselves influenced by Spanish or Near Eastern prototypes, may have served as the source for the ceramic designs.[9]

Other Florentine two-handled jars with leaves and rampant lions include those in the British Museum, London (inv. 1903,5-15,1);[10] in the Kunstgewerbemuseum, Berlin (inv. 85,621);[11] in the Fitzwilliam Museum, Cambridge (inv. C76-1961, C77-1961);[12] in the Musée National de Céramique, Sèvres (inv. 5292);[13] in the Roche maiolica drug jar collection, Basel;[14] in the collection of the princes of Liechtenstein, Vaduz (inv. 1267);[15] formerly in the Otto Beit collection, London;[16] formerly in the Damiron collection, Lyons;[17] and in the Wadsworth Atheneum, Hartford (inv. 1917.433). The British Museum also has a large *albarello* with a rampant lion (inv. MLA 1898, 5-23, 1).[18] The most similarly shaped large two-handled jar—with high shoulder accentuated by the handles—is in the British Museum (inv. MLA 1902, 4-24, 1).[19]

MARKS AND INSCRIPTIONS: Below each handle, a six-pointed asterisk.

PROVENANCE: Contini-Bonacossi, Florence; [Nella Longari, Milan]; [Rainer Zietz, Ltd., London].

EXHIBITIONS: None.

BIBLIOGRAPHY: Cora 1973, vols. 1, pp. 83, 457; 2, pl. 112.

CONDITION: A crack runs from under one handle to the base; two small losses in the neck are filled and painted; small chips around the rim and along the handles.

1. Cora 1973, pp. 82–83; A. Moore Valeri, however, has suggested that the chronology of *zaffera* works might be better determined by the existence or lack of Italo-Moresque influence rather than by the thickness or dilution of the cobalt glaze (Valeri 1984, p. 496, n. 102).

2. For other examples, see Cora 1973, vol. 2, figs. 142a–b.

3. Cora 1973, vols. 1, p. 39, n. 12; 2, pl. 350 (M222, M223).

4. For a discussion of this artist, see entry no. 5 above.

5. Cora 1973, vol. 1, p. 55, n. 1.

6. For examples, see Martí 1944–1952, vols. 1, figs. 290, 329, 641; 2, figs. 342, 644, 680, 681, 699, 799, 801–804, 942; 3, figs. 551–554.

7. Valeri 1984, p. 478, n. 7.

8. See Martí 1944–1952, vols. 1, figs. 276, 278, 279, 282; 3, fig. 575.

9. See, for example, a thirteenth-century Sicilian altar frontal with embroidered leopards, parrots, and griffins in A. Santangelo, *Tessuti d'arte italiani: Dal XII al XVIII secolo* (Milan, 1959), pl. 4. As on numerous examples of textiles, moreover, the an-

imals here are symmetrically displayed, much in the same way that animal motifs are painted facing one another or addorsed on oak-leaf jars; see also Valeri 1984, p. 480, figs. 4–6. For a discussion of the importance of textiles as transmitters of Islamic designs to Italy, see M. Spallanzani, *Ceramiche orientali a Firenze nel rinascimento* (Florence, 1978), pp. 101–102.

10. See Wallis 1903, p. 23, fig. 21; Cora 1973, vol. 2, fig. 81b; Wilson 1987, no. 20.

11. Hausmann 1972, pp. 94–96, no. 71.

12. Bellini and Conti 1964, p. 61.

13. Cora 1973, vol. 2, fig. 79c; Chompret 1949, vol. 2, p. 80, fig. 636; Giacomotti 1974, pp. 12–13, no. 34.

14. Cora 1973, vol. 2, fig. 80b.

15. Ibid., fig. 81a; H. Bossert, *Geschichte des Kunstgewerbes* (Berlin, 1935), p. 17; E. Hannover, *Pottery and Porcelain* (London, 1925), vol. 1, p. 100, fig. 112; Wallis 1903, fig. 32.

16. Cora 1973, vol. 2, fig. 81c; B. Rackham, "Italian Majolica," in *Catalogue of Pottery and Porcelain: Otto Beit Collection* (London, 1916), pp. 76–77, no. 740.

17. *A Very Choice Collection of Old Italian Maiolica, the Property of M. Damiron, Lyons*, sale cat., Sotheby's, London, June 16, 1938, lot 73, p. 75.

18. Cora 1973, vol. 2, figs. 80a, 80c; Wilson 1987, no. 23.

19. Bode 1911, ill. p. 18; Cora 1973, vol. 2, fig. 57c; Wilson 1987, no. 21.

8 Two-Handled "Oak-Leaf" Drug Jar (Orciuolo Biansato)

Florence, circa 1431
H: 25 cm (9⅞ in.); Diam (at lip): 12.5 cm (4¹⁵⁄₁₆ in.); max.
W: 24.5 cm (9⅝ in.)
84.DE.98

THE BODY OF THIS TWO-HANDLED OVIFORM DRUG JAR is covered with a yellowish white tin-glaze ground decorated with branches of leaves in cobalt blue impasto, framing on each side a running saddleback boar, also in blue. Blue dots (or "berries") and manganese purple lines further embellish the body, neck, and ribbed strap handles. The impasto decoration is outlined in manganese purple. The interior is tin glazed.

A copper green and manganese purple crutch, emblem of the Florentine Santa Maria Nuova hospital, is painted on each of the two handles, and the areas below each handle bear six-pointed asterisks, the mark of Giunta di Tugio's workshop in Florence.[1] Around 1431 di Tugio apparently altered the asterisk mark inherited from his father's workshop by surrounding it with dots.[2] With their addition, the asterisk mark began to resemble a flower, as is the case on this drug jar, which therefore must have been executed around this time.

Also used as a motif on Spanish ceramics,[3] the saddleback boar on this vessel might have been part of the coat of arms or device of a family that had supported the Florentine hospital in some way.[4] The image is so generalized, however, that it seems more likely that the boar was used for decorative effect, possibly referring either to one of the animal's many symbolic qualities—as one of the four heraldic beasts of the hunt, it represents speed and ferocity—or to a scene from Greco-Roman mythology.[5] One finds similar wild boars on maiolica jugs and ceramic fragments;[6] this animal can be seen as a heraldic emblem on a Florentine jug of the third quarter of the fifteenth century[7] as well as on an early sixteenth-century maiolica plate from Gubbio in the Victoria and Albert Museum, London (inv. 1725-1855);[8] neither coat of arms has been identified.

In the early Middle Ages hospitals were simple hospices set up outside cities to offer food and lodging to pilgrims and travelers. The Santa Maria Nuova hospital, by the mid-fourteenth century the largest in Florence, was the first hospital in that city dedicated primarily to caring for the sick. From documents such as the hospital's account books and Matteo Villani's *Cronica,* we know that Santa Maria Nuova supplied high-quality medical care to a wide cross section of Florence's population while concentrating on the needs of the poor.[9]

This pharmaceutical jar is one of a large number of drug containers that the hospital ordered from the di Tugio workshop. Documents relating to this commission describe payments made by the hospital between 1430 and 1431 for nearly one thousand *albarelli, orciuoli,* and other *vaselli.*[10] This important commission was decisive for the workshop, as it undoubtedly served to increase not only di Tugio's wealth but also his reputation.

Including the Getty Musuem's piece, approximately twenty drug jars with the Santa Maria Nuova crutch emblem are known, and it seems likely that many, if not all, of them were produced as part of the 1431 di Tugio commission. They include one decorated with eagles formerly in the Stieglitz Museum, Saint Petersburg, now in the State Hermitage, Leningrad (inv. F-3118);[11] two—one with birds, the other with fish—in the Musée du Louvre, Paris (inv. OA 6304, OA 6305);[12] another with fish formerly in the Oppenheimer collection, London;[13] a third with fish in a private collection, Florence;[14] a drug jar with a rampant lion in the National Gallery of Victoria, Melbourne (inv. 3649.3);[15] two—one with rabbits, the other with fleurs-de-lis—in the Victoria and Albert Museum, London (inv. 389-1889, C.2063-1910);[16] another with fleurs-de-lis formerly in the Glogowsky collection, Berlin;[17] a third with fleurs-de-lis in the Museo Nazionale di Capodimonte, Naples;[18] one with geometric decoration formerly in the A. von Beckerath collection, Berlin;[19] one with cranes in the Metropolitan Museum of Art, New York;[20] one with leaf decoration in the Museum of Fine Arts, Boston (inv. 23.268); one with San Bernardino monograms in the Museo Internazionale delle Ceramiche, Faenza (inv. 21054/c);[21] one with crowns in the collection of the princes of Liechtenstein, Vaduz (inv. 1269);[22] another with crowns in a private collection, Milan;[23] one with profile portraits of a bearded man wearing a pointed cap and a woman wearing a plumed hat in the Cleveland Museum of Art (inv. 43.54);[24] and one with curly-haired figures in profile formerly in the Volpi collection, Florence.[25] Cora also mentions, but does not reproduce, a drug jar from this same Santa Maria Nuova group, also formerly in the Volpi collection.[26] Two further drug jars with the crutch emblem of the Santa Maria Nuova hospital but of slightly different shape and with simplified leaf decoration were sold at auction in Paris.[27] Maiolica jugs and jars bearing the same crutch emblem were also produced for the Santa Maria Nuova hospital in the sixteenth and seventeenth centuries.[28]

MARKS AND INSCRIPTIONS: On each strap handle, a copper green and manganese purple crutch; below each handle, a six-pointed asterisk surrounded by dots.

PROVENANCE: Sir Thomas Ingilby, Bt., North Yorkshire[29] (withdrawn, Sotheby's, London, July 2, 1974, lot 261; sold, Sotheby's, London, April 14, 1981, lot 13); [Rainer Zietz, Ltd., London].

EXHIBITIONS: None.

BIBLIOGRAPHY: G. Norman, "Documented History Helps Jar to Make Fifty-Six Thousand Pounds," *Times* (London), April 15, 1981; J. Cuadrado, "Prized Pottery Triumphs of the Italian Renaissance," *Architectural Digest* 41 (February 1984), p. 127.

CONDITION: A crack runs from the base to the top of one of the handles on one side; there are minor chips on the handles and in the glaze of the body.

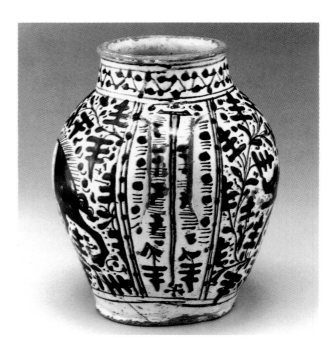

No. 8, alternate view

1. Cora 1973, vols. 1, p. 39, n. 12; 2, pl. 350 (M225); see entry no. 7 above.
2. Ibid., vol. 1, p. 80.
3. For examples, see Martí 1944–1952, vols. 2, fig. 673; 3, fig. 575.
4. Professor M. Spallanzani, Florence, has brought it to my attention that such Florentine families as the Foresi, Iacopi, Porcellini, and Veneri included boars or pigs on their coats of arms.
5. The Calydonian boar hunt, for example, was a popular subject for *istoriato* scenes (see Liverani 1960, fig. 26); a plate from Deruta of circa 1530 also displays a wild-boar hunt (with saddleback boar), allegorically interpreted as one of Hercules' labors (G. Conti, ed., *Una collezione di maioliche del rinascimento* [Milan, 1984], no. 24).
6. See Cora 1973, vol. 2, figs. 37, 166c, 188c, 196b; O. von Falke, *Die Majolikasammlung Adolf von Beckerath*, sale cat., Rudolph Lepke, Berlin, November 4, 1913, lots 79, 81, 82.
7. Falke (note 6), lot 80.
8. Rackham 1940, vols. 1, no. 656; 2, pl. 103.
9. K. Park, *Doctors and Medicine in Early Renaissance Florence* (Princeton, 1985), pp. 102–103, 106.
10. Cora 1973, vol. 1, p. 273 (document reprod. in vol. 2, pl. 360b).
11. Kube 1976, no. 1; Bode 1911, p. 19.
12. Giacomotti 1974, nos. 31, 32.
13. *Highly Important Collection of Italian Majolica . . .* , sale cat. (H. Oppenheimer collection), Christie's, London, July 15, 1936, lot 2; Cora 1973, vol. 2, fig. 84a.
14. Cora 1973, vol. 2, pl. 85.
15. *Highly Important Collection . . .* (note 13), lot 1; M. Legge, in A. Brody et al., *Decorative Arts from the Collections of the National Gallery of Victoria* (Melbourne, 1980), pp. 14–15.
16. Rackham 1940, vols. 1, nos. 38, 39; 2, pl. 9.
17. Cora 1973, vol. 2, fig. 88a.
18. Ibid., fig. 89a.
19. Bode 1911, p. 18, pl. 19; Wallis 1903, p. 8; Falke (note 6), no. 23.
20. Falke 1914–1923, vol. 1, no. 4, pl. 3; G. Szabó, *The Robert Lehman Collection* (New York, 1975), no. 143.
21. Bojani et al. 1985, no. 425; Cora 1973, vol. 2, pl. 95.
22. Cora 1973, vol. 2, fig. 90c (as "formerly Liechtenstein collection [?]"); Bode 1911, p. 14 (center).
23. Cora 1973, vol. 1, p. 78; this drug jar is mentioned but not reproduced.
24. Ibid., vol. 2, figs. 55a–b; E. P. Pillsbury, *Florence and the Arts: Five Centuries of Patronage* (Cleveland, 1971), no. 93.
25. Ibid., vol. 2, fig. 55c.
26. Ibid., vol. 1, p. 80.
27. *Objets de haute curiosité provenant de la collection du Dr. J. Chompret*, sale cat., Hôtel Drouot, December 15, 1976, lot 23.
28. Cora and Fanfani 1982, no. 2; Bojani et al. 1985, no. 577.
29. According to Norman (1981), the jar had been in the Ingilby family since the eighteenth century.

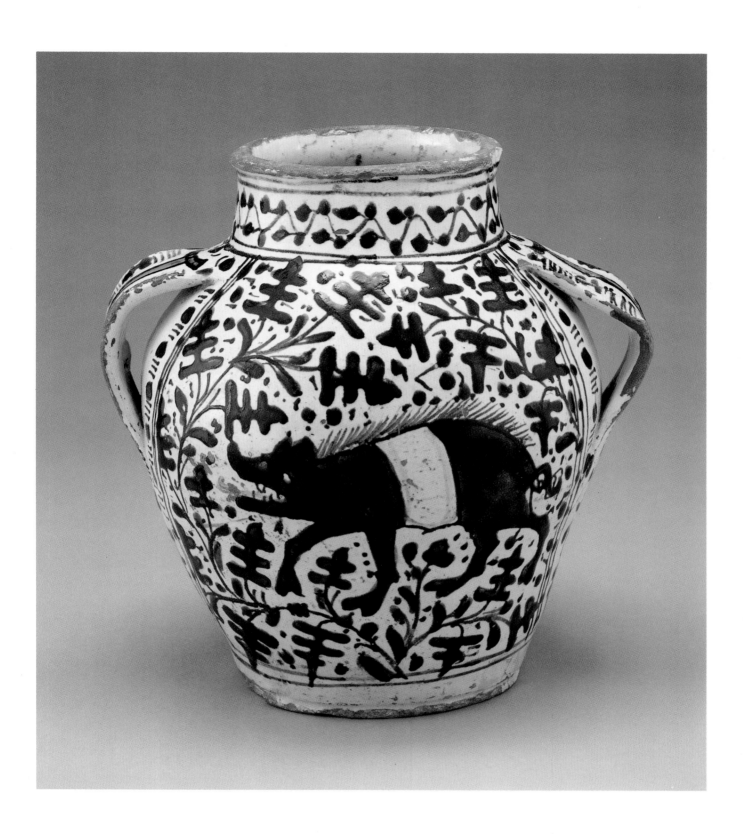

9 *Two-Handled Jar* (Orciuolo Biansato)

Florence, circa 1431–1450
H: 16.5 cm (6½ in.); Diam (at lip): 10.5 cm (4⅛ in.); max.
W: 17.8 cm (7 in.)
85.DE.58

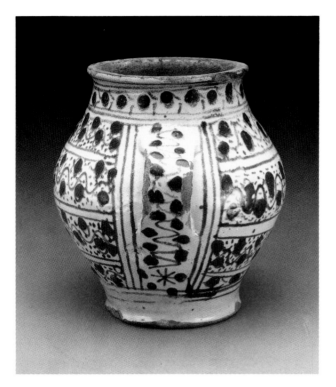

No. 9, alternate view

THIS OVIFORM TWO-HANDLED VESSEL DISPLAYS ON each side four horizontal zones delineated by manganese purple lines. These zones display wavy manganese purple lines and a double row of cobalt blue dots (or "berries") set into the curves on a ground of small manganese dots. The interior is lead glazed. The area below each strap handle bears a six-pointed asterisk mark surrounded by dots, attributed to the Florentine workshop of Giunta di Tugio.[1]

Other examples of *zaffera a rilievo* jugs and two-handled jars display similar repetitive, almost geometric decoration (including dots, dashes, wedge shapes, and patterns of "big drops"—*a goccioloni*—of glaze), rather than the more common leaf embellishment.[2]

MARKS AND INSCRIPTIONS: Below each handle, a six-pointed asterisk surrounded by dots.

PROVENANCE: Stefano Bardini, Florence; Elie Volpi, Florence (sold, Jandolo and Tavazzi, Rome, April 25–May 3, 1910, lot 777); Dr. Bak, New York (sold, Sotheby's, New York, December 7, 1965, lot 15); August Lederer, Vienna; Erich Lederer, Geneva.

EXHIBITIONS: None.

BIBLIOGRAPHY: Sale cat., Lempertz, Cologne, May 6, 1953, p. 56, no. 414, pl. 44; Cora 1973, vols. 1, p. 80; 2, fig. 107b.

CONDITION: Two chips in the rim, chips along the handles, and a number of blind cracks in the body.

1. For more on this mark, see Cora 1973, vols. 1, p. 39, n. 12; 2, pl. 350 (M225); see also entry no. 8 above.
2. For examples, see Cora 1973, vol. 2, figs. 99c, 101c, 102a–c, 103a, 103c, 104a–b, 106, 107a, 107c; sale cat., Semenzato, Florence, November 11, 1987, lot 290. A. Moore Valeri has suggested that the *a goccioloni* pattern on Florentine *zaffera* wares relates to contemporary textiles, costume, or heraldry; instead of representing "big drops," it may be derived from the medieval vair, or squirrel pelt, which commonly served to line cloaks and appears as a motif on furriers' coats of arms (1984, pp. 486–487).

10 Cylindrical Jar (Albarello)

Florentine area, mid-fifteenth century
H: 18.1 cm (7 1/8 in.); Diam (at lip): 9.5 cm (3 3/4 in.); max.
W: 13 cm (5 1/8 in.)
84.DE.96

THE CYLINDRICAL SHAPE, WAISTED NECK, AND TAPER-ing foot of this piece are typical of the *albarello* form. The small handle is an unusual addition whose function has yet to be explained. It may have been used to suspend the piece for storage or possibly to tie together a group of similar drug jars on a shelf. Marks, perhaps graduations, have been scratched on the underside of the unglazed bottom, although it is uncertain whether these were inscribed at the time the jar was made or at a later date. The blue glaze decoration is divided into horizontal bands following the object's shape: scrolls around the neck; a scroll and stylized leaf design around the shoulder and on the handle;[1] a wavy line with stylized leaves around the curved section above the unglazed foot; and hatched fields and knotwork within a pattern of angular, discontinuous lines around the body. The interior is tin glazed.

The angular line decoration on the exterior was inspired by Kufic script, an early form of the Arabic alphabet. Kufic calligraphy was known throughout Spain and Italy thanks to the spread of small and easily transportable goods—such as textiles,[2] leatherwork, and coffers as well as ceramics—decorated with the script. Especially in Tuscany Kufic designs had a strong influence, and there are Kufic inscriptions in paintings by important Tuscan artists from the late thirteenth to the late fifteenth century, such as Duccio, Fra Angelico, Gentile da Fabriano, Filippo Lippi, and Domenico Ghirlandaio.[3]

One finds an interesting mixture of Near and Far Eastern influences on this small jar. The scroll design around its neck and shoulder can also be found on Islamic works,[4] although it may originally have been derived from a Far Eastern source.[5] The knotwork on the jar's body, commonly found on pots from Málaga and Manises, can also be traced to Moorish and Near Eastern sources.[6] The hatchwork fields around the jar's body recall the background patterns that were used to fill in the areas around raised decoration on Islamic metalwork.[7] Although originally meant to be read as background, these rectangular hatched areas appear instead to protrude from the body of the jar.

Because of the large quantity of Hispano-Moresque ceramics arriving in Italy by the fourteenth and fifteenth centuries, Spanish rather than Islamic products were

No. 10, underside

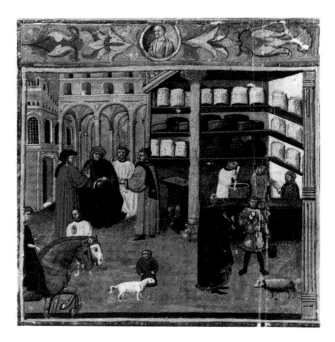

An Apothecary's Shop. From Avicenna, *Canon.* Northern Italy, circa 1440 (detail). Tempera on vellum. Bologna, Biblioteca Universitaria Ms. 2197, fol. 38v. Photo courtesy Biblioteca Universitaria. *Albarelli* decorated with Kufic script line the shelves at the right.

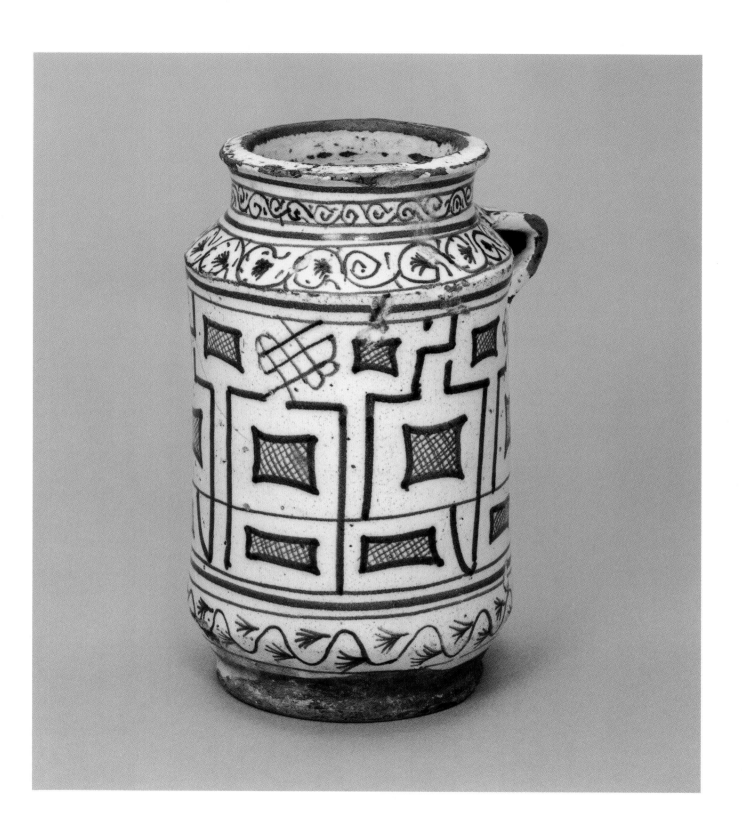

largely responsible for the spread of Near Eastern decoration to that country. The Islamic-inspired ornamentation on the vessel under discussion was probably influenced less by patterns on Spanish jars than by the blue decoration on a type of early fifteenth-century tile from Manises, however.[8]

In addition to this jar, there are approximately twenty known *albarelli* of very similar form and decoration, only three of which include a small, single handle: one in the Victoria and Albert Museum, London (inv. 1150-1904);[9] a second formerly in the Della Gherardesca collection, Bolgheri;[10] and a third sold at auction in Milan.[11] Examples without handles include those in the Victoria and Albert Museum (inv. 1143-1904, 1147-1904, 372-1889);[12] in the Museo Internazionale della Ceramiche, Faenza (inv. 21100/c, 21058/c);[13] in the Kunstgewerbemuseum, Berlin (inv. 14, 63);[14] in the Musée National de Céramique, Sèvres (inv. 22667);[15] formerly in the Ducrot collection, Paris;[16] in the Arturo Castiglioni collection, Trieste;[17] two in Florence: one in the Museo Nazionale, Palazzo del Bargello (inv. 13795), and another in a private collection;[18] in the Museo Nazionale di Capodimonte, Naples (inv. 46);[19] in the Roche maiolica drug jar collection, Basel;[20] and two pieces in the pharmacy of the Minorite brothers at San Romano Valdarno, near Pisa.[21] One finds an *albarello* of similar form, with the unusual single handle but with different surface decoration, in the Victoria and Albert Museum (inv. 1131-1904).[22] The Getty Museum's example is the most adroitly formed and decorated of this group.

MARKS AND INSCRIPTIONS: On underside, inscribed marks (graduations?).

PROVENANCE: Dr. J. Chompret, Paris (sold, Hôtel Drouot, Paris, December 15, 1976, lot 19); [Rainer Zietz, Ltd., London].

EXHIBITIONS: None.

BIBLIOGRAPHY: Hôtel Drouot, Paris, December 15, 1976, lot 19.

CONDITION: A hairline crack opposite the handle that runs from the lip down the neck and then forks; minor chips at the lip, handle, and base.

1. The scrollwork around the neck and above the shoulder is nearly identical to, and apparently derived from, the Chinese "classic scroll" motif used as border decoration primarily on porcelain from the Yuan (1271–1368) and Ming (1368–1644) dynasties. See, for example, R. Krahl, *Chinese Ceramics in the Topkapi Saray Museum* (London, 1986), vol. 2, nos. 571, 581,

583, 586, 593, 595. For another example on Italian maiolica, see J. Carswell, *Blue and White: Chinese Porcelain and Its Impact on the Western World*, exh. cat. (David and Alfred Smart Gallery, University of Chicago, 1985), p. 150, no. 90.

2. Islamic fabrics, desired for their rich decoration, were imported into Italy in large quantities in the fifteenth century and likely served as a primary source for ceramic embellishment, including Kufic patterns (R. Lightbown, "L'esotismo," in G. Bollati and P. Fossati, eds., *Storia dell'arte italiana*, pt. 3, vol. 3 [Turin, 1980], pp. 449–455).

3. For a discussion of this phenomenon, see G. Soulier, "Les caractères coufiques dans la peinture toscane," *Gazette des beaux-arts* 5, no. 9 (1924), pp. 347–358.

4. See, for example, a blue, black, and white *albarello* of the first half of the fifteenth century from Damascus in the Musée des Arts Décoratifs, Paris (reprod. in M. Spallanzani, *Ceramiche orientali a Firenze nel rinascimento* [Florence, 1978], pl. 1). Although this work was likely produced for the Florentine market, aside from the shield with fleur-de-lis, its painted motifs are Near Eastern.

5. See above (note 1).

6. A. Caiger-Smith, *Tin-Glaze Pottery in Europe and the Islamic World* (London, 1973), p. 59. For examples of this knotwork design on Islamic metalwork, see A. Grohmann, "Die Bronzeschale M.388-1911 im Victoria and Albert Museum," in *Aus der Welt der islamischen Kunst* (Berlin, 1959), figs. 4–9; E. Baer, *Metalwork in Medieval Islamic Art* (Albany, 1983), fig. 180. For this pattern on Hispano-Moresque ceramics, see Martí 1944–1952, vol. 2, figs. 472, 473; Caiger-Smith (1973), fig. 10.

7. See entry no. 4 above.

8. Hausmann 1972, no. 76; for further examples, see Martí 1944–1952, vol. 3, pl. 4, figs. 90–94, 142, 174.

9. Rackham 1940, vols. 1, no. 52; 2, pl. 12.

10. Cora 1973, vol. 2, fig. 131c.

11. Sale cat., Finarte, Milan, November 21–22, 1963, lot 141, pl. 75.

12. Rackham 1940, vols. 1, nos. 51, 68, 70; 2, pls. 12, 13.

13. Bojani et al. 1985, nos. 436, 437.

14. Hausmann 1972, no. 76.

15. Giacomotti 1974, no. 54.

16. G. Ballardini, *Le maioliche della collezione Ducrot* (Milan, [193-]), pl. 3, nos. 5, 6; Chompret 1949, vol. 2, nos. 655, 656; sale cat., Sotheby's, London, April 23, 1974, lot 38; sale cat., Semenzato, Florence, November 11, 1987, lot 319.

17. A. Castiglioni, "La farmacia italiana del quattrocento nella storia dell'arte ceramica," *Faenza* 10, no. 3/4 (1922), pl. 8c.

18. G. Conti, *Catalogo delle maioliche: Museo Nazionale di Firenze, Palazzo del Bargello* (Florence, 1971), no. 339; Cora 1973, vol. 2, no. 132b.

19. Museo e Gallerie Nazionali di Capodimonte, *La donazione Mario de Ciccio* (Naples, 1958), p. 23, no. 46.

20. H. E. Thomann, "Die 'Roche'-Apotheken-fayencensammlung," *Mitteilungsblatt, Keramik-Freunde der Schweiz*, no. 58/59 (1962), pl. 8.

21. C. Pedrazzini, *La farmacia storica ed artistica italiana* (Milan, 1934), p. 147.

22. H. Wallis, *The Albarello* (London, 1904), fig. 23; Rackham 1940, vols. 1, no. 56; 2, pl. 11.

11 *Cylindrical Jar* (Albarello)

Florentine area, circa 1440–1450
H: 18.6 cm (7⁵⁄₁₆ in.); Diam (at rim): 10.5 cm (4⅛ in.);
max. Diam: 11.8 cm (4⅝ in.)
84.DE.100

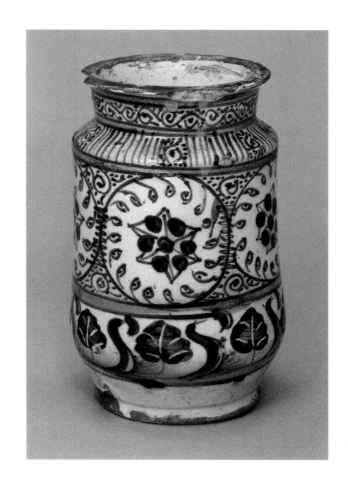

THIS *ALBARELLO* WITH WAISTED NECK AND TAPERING foot is divided into horizontal zones by light yellowish green bands outlined in grayish blue. The wide zone around the body displays a series of stylized flowers enclosed in circles and surrounded by foliate scrolls. This area is bordered below by incised flat leaves—sometimes called *foglie di gelso*, or mulberry leaves[1]—alternating with curved ones in manganese purple and cobalt blue. Blue foliate scrolls interspersed with parallel lines ornament the shoulder, and additional foliate scrolls run around the neck.[2]

For essentially functional maiolica objects such as this drug jar, efficiency of production was a prime concern. Apparently painted in haste, this work affords one the opportunity to view the artist's hand in its painted decoration. For the green stripes the artist dipped the brush once into the glaze, placed the pigment-laden brush on the body, and as the jar was turned, the color became depleted, leaving a much lighter green where the end of the stripe meets the beginning. In addition the artist painted the rosette motifs without considering the size of the piece, so that the last rosette was forced to fit into the remaining space and as a result appears more oval than round.

The incised flat-leaf motif in the lower section is derived from Hispano-Moresque designs[3] that spread to Italy, becoming particularly popular in and around Florence.[4] Similar rosette motifs also appear on Hispano-Moresque works, and the Italian designs may be derived from, or at least have been influenced by, that source.[5] It is equally likely, however, that such a generalized motif was developed independently in Italy. Other jars produced in the area of Florence display similar floral medallions surrounded by foliate scrolls[6] as well as the Hispano-Moresque-inspired incised leaves.[7] Most of these works can be dated to the second half of the fifteenth century, although the rather archaic quality of this jar's decoration suggests that it was executed shortly before midcentury.

MARKS AND INSCRIPTIONS: None.

PROVENANCE: Sold, Sotheby's, London, November 22, 1983, lot 194; [Rainer Zietz, Ltd., London].

EXHIBITIONS: None.

BIBLIOGRAPHY: Sotheby's, London, November 22, 1983, lot 194.

CONDITION: Chips on the rim and a minor crack through the body, with overpainting.

1. G. Conti, *L'arte della maiolica in Italia*, 2nd edn. (Milan, 1980), pl. 70.
2. For other examples of this scroll motif, derived from the Chinese "classic scroll," see entry no. 10 above, esp. n. 1.
3. See A. W. Frothingham, *Lustreware of Spain* (New York, 1951), figs. 85, 87.
4. See, for example, Rackham 1940, vol. 2, nos. 67, pl. 11; 80, pl. 13.
5. See, for example, Frothingham (note 3), figs. 70–72.
6. For examples, see Cora 1973, vol. 2, pl. 133, figs. 134a–b, 135a–b, 136c, 137a–c, 138a–c, 139a–c, 142a–c, 145; Bode 1911, pl. 20.
7. See Chompret 1949, vol. 2, fig. 663; Cora 1973, vol. 2, figs. 178a–b, 179, 181a–c.

12 Two-Handled Armorial Jar (Albarello Biansato)

Florentine area or Umbria, circa 1450–1500
H: 22.2 cm (8¾ in.); Diam (at rim): 11.4 cm (4½ in.);
max. W: 23.4 cm (9³⁄₁₆ in.)
84.DE.99

THIS VESSEL IS OF A GENTLY WAISTED, CYLINDRICAL form with a tall, perpendicular rim and two rope-twist handles that terminate in deep indentations. The body is divided into decorative panels that display on one side a blue and ocher *testa di cavallo* (horse's head, so called because of its shape) shield against a light copper green half-circle below blue tendrils and dots. The colors that could be fired on maiolica in the fifteenth century were limited to shades of blue, green, ocher, and purple. It is therefore difficult, if not impossible, to identify simple coats of arms that do not have specific distinguishing features. Although the horizontal stripes on this jar are painted in ocher and blue, these pigments may stand for any alternating light and dark colors, and thus this shield could belong to any one of a number of prominent contemporary families. For example a plate from Deruta formerly in the Adda collection, Paris, displays an apparently identical shield that Rackham identified as the Baglioni coat of arms.[1] He reproduced another similarly striped coat of arms on a Hispano-Moresque plate from Manises, also formerly in the Adda collection, which he believed to be comparable to the arms of the Pagoni of Venice, and the Origo of Milan.[2] A two-handled *albarello* attributed to Faenza in the Musée du Louvre, Paris (inv. OA 3983), that is similar to the Getty Museum's jar likewise displays an ocher and blue *testa di cavallo* coat of arms, which, according to Giacomotti, could belong to any one of a number of Italian families, such as the Giustiniani of Venice or the Fabbrini of Florence.[3] If the Museum's jar was made in Tuscany, its *testa di cavallo* shield (a common Tuscan form) might more reasonably be connected with a family from that region.[4]

On the other side of this jar, stylized leaves, tendrils, and dots frame the inscription *AMA.DIO* (love God).[5] A diagonal dash pattern in blue ornaments the base, a triangular motif of splayed blue lines decorates the shoulder, and an ocher zigzag between blue stripes embellishes the rim. The interior is unglazed.

This work belongs to the second phase of the severe style, often referred to as the Gothic-floral family because central Italian ceramists drew not only on Islamic motifs but also on European Gothic ornament (in architecture

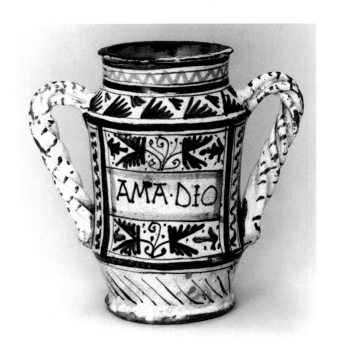

No. 12, alternate view

and miniature illumination, for example) to decorate their works.[6] Typical of Gothic-floral-family maiolica, which flourished from roughly 1460 to 1490,[7] are a number of jars whose handles were formed by twisting ropes of clay. Although the form of this jar and its glaze color and decoration are traditionally considered more characteristic of Florentine products,[8] similar works are also commonly attributed to Faenza.[9] The similarity of certain Florentine and Faentine ceramics in this early period is testament to the influences traveling between these two centers as well as to the common "language" of ceramic form and decoration that extended throughout central Italy. It is also possible that this jar was produced by a Faentine potter working in Florence, or vice versa.[10]

Most recently it has been established that objects with rope-twist handles and decorated with the same zigzag, tendril, dot, and splayed-line motifs displayed on this jar were also produced in Umbria, specifically Deruta.[11] If this work was indeed produced in an Umbrian center, its shield likely belongs to the Baglioni family of Perugia, a scant fifteen kilometers to the north of Deruta.[12]

MARKS AND INSCRIPTIONS: On one side, *AMA.DIO.*

PROVENANCE: A. Pringsheim, Munich (sold, Sotheby's, London, June 7, 1939, lot 3); [Alfred Spero, London]; [Rainer Zietz, Ltd., London].

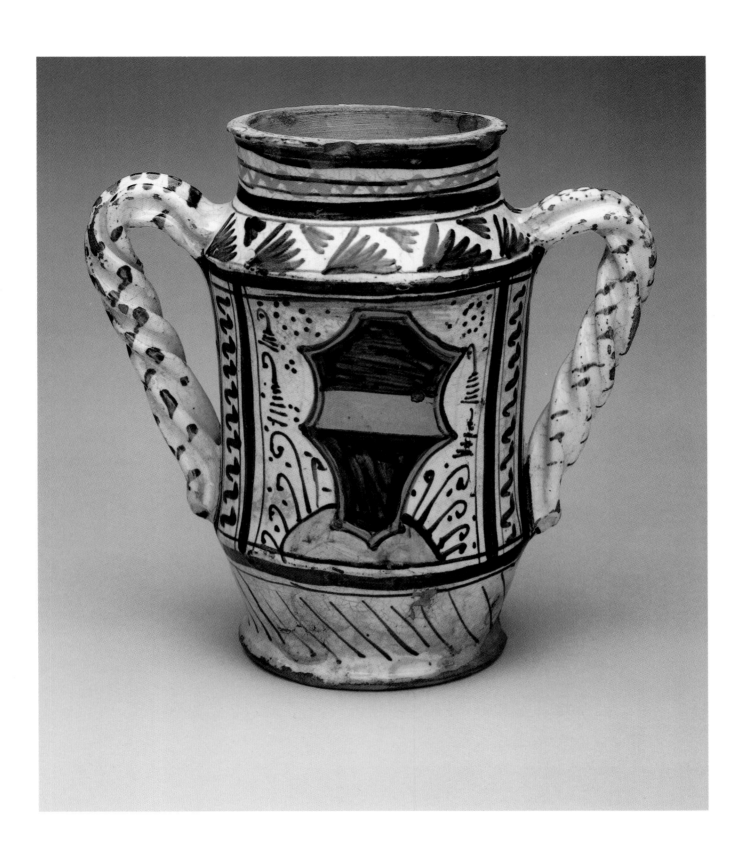

EXHIBITIONS: None.

BIBLIOGRAPHY: Falke 1914–1923, vol. 1, no. 11, pl. 8 (attributed to Siena or Florence of circa 1480); Bellini and Conti 1964, p. 89, fig. A (attributed to Faenza of circa 1470).

CONDITION: Glaze chips on the handles, body, and rim; loose glaze on the lower left of the shield side near the base due to soluble-salt damage; a hairline crack in the neck on the reverse.

1. Rackham 1959, no. 343, pl. 148b; another plate from Deruta with a similar shield, possibly from the same service, sold at Galerie Georges Petit, Paris, May 9–10, 1927, lot 27 (reprod. upside down in sale cat.); J.-B. Rietstap, in *Armorial général* (Gouda, 1884; reprint, Baltimore, 1972), p. 98, locates the family in Verona; V. Rolland, in *Illustrations to the Armorial Général by Rietstap* (1903; reprint, Baltimore, 1967), pl. 106b, locates the family in Perugia.

2. Rackham 1959, p. 62, no. 263, pl. 105.

3. Giacomotti 1974, no. 91.

4. Research conducted in the Archivio di Stato, Florence (ms. 473, Priorista Mariani, Carte Pucci, Carte Ceramelli Papiani); Biblioteca Nazionale Centrale, Florence (Poligrafo Gargani, Carte Passerini); and Kunsthistorisches Institut, Florence (mss. of heraldry collections) by M. Spallanzani, an expert in both Tuscan heraldry and early maiolica, has revealed such candidates as the Florentine Fabbrini, Marignoli, Bagnesi, Biligardi, and Soldi families. Both the Fabbrini family arms (ASF, ms. 473) and the shield displayed on the present jar are *azure à fess d'or* (blue with a broad, horizontal band in gold); the Fabbrini shield, however, exhibits a small snail in the upper band, a detail the ceramic painter might understandably have omitted when attempting to render the design in thick glazes.

5. C. Ravanelli Guidotti, in *Ceramiche occidentali del Museo Civico Medievale di Bologna* (Bologna, 1985), p. 95, no. 69, discusses A. Luce Lenzi's analysis of the original oral proverb or prayer on which this inscription is based ("Ama Dio e non fallire . . . ," *Nuèter* 1 [June 1982], pp. 22ff.). This proverb, which begins "Ama Dio e non fallire / fai del bene e lascia dire / lascia dir lasciar chi vole / ama Dio di buon cuore . . ." (Love God and do not fail / do good deeds and let it be said / let it be said by anyone / love God with a good heart . . .), was evidently widely known in sixteenth-century Italy.

6. Liverani 1960, p. 22.

7. Ballardini 1975, p. 53.

8. For examples, see O. von Falke, *Die Majolikasammlung Adolf von Beckerath*, sale cat., Rudolph Lepke, Berlin, November 4, 1913, lots 66, 76; Cora 1973, vol. 2, figs. 206a–c, 207b–c, 208a, 208c, 209b, 212a; Bojani et al. 1985, figs. 447–449; sale cat., Christie's, London, October 3, 1983, lot 238; sale cat., Christie's, London, December 3, 1984, lot 465; *The Robert Strauss Collection of Italian Maiolica*, sale cat., Christie's, London, June 21, 1976, lot 6; sale cat., Sotheby's, Florence, May 16, 1978, lot 79; sale cat., Sotheby's, London, April 14, 1981, lot 14; sale cat., Sotheby's, London, April 23, 1974, lot 24.

9. See Chompret 1949, vol. 2, figs. 372–375; Giacomotti 1974, nos. 87, 88, 91–93.

10. One might well question the logic behind such an exchange of ceramists; certainly there was no lack of talent, supplies, or active potteries in these two cities just seventy kilometers from each other. Documentary sources, however, attest to just this kind of exchange, of craftsmen as well as their products, which was probably determined as much by economic factors as by the quest for new talent and novel styles. Although these sources date from the late fifteenth and sixteenth centuries, they do not exclude the possibility of earlier exchanges (see, for example, G. Ballardini, "Maiolicari faentini e urbinati a Firenze," *Faenza* 10, no. 3/4 [1922], pp. 144–147).

11. G. Busti and F. Cocchi, "Prime considerazioni su alcuni frammenti da scavo in Deruta," *Faenza* 73, no. 1/3 (1987), pp. 14–20; see pl. 5c.

12. See above (note 1).

13 Jug with Bust Medallion (Brocca)

Florentine area, circa 1450–1500
H: 34.6 cm (13⅝ in.); Diam (at rim): 9.8 cm (3⅞ in.);
max. W: 33 cm (13 in.)
84.DE.101

THIS IS A LARGE OVIFORM JUG WITH A WIDE STRAP handle, small mouth and neck, and long spout projecting almost horizontally from the upper body. H. P. Fourest believes the form to be archaic of the Orvieto style.[1]

Because of its characteristic decoration, this piece can be identified as an early example of the Gothic-floral family dating from roughly 1460 to 1490 (see no. 12). The area below the spout is decorated with a bust in blue and olive green reserved against a background of stylized, feathered leaves, all enclosed in a circular band of copper green dots and heavily applied manganese pigment incised with scrolls linking circles. The subject of the portrait appears to be a man, since his style of dress, with full sleeves and turned-back collar, and long hair were typical of mid-fifteenth-century masculine fashion. Wide Gothic scrolling leaves (a cartoccio) in dark and light blue, manganese purple, and green surround the circular band. The handle and rear third of this vessel are undecorated. The interior is lead glazed.

Only two other jugs of this shape are known, one in the Musée National de Céramique, Sèvres (inv. 21915),[2] and another formerly in the Damiron collection, Lyons.[3] Both of these works are smaller than the Getty's piece. Although the former is attributed to Faenza or Tuscany and the latter to Faenza, and a cartoccio leaf decoration is occasionally found framing portrait busts on Faentine products,[4] this jug is almost certainly of Florentine origin because of the similarity between its painted decoration and that of numerous Florentine examples.

Although occasionally found on Faentine examples,[5] identical inscribed decoration in thick manganese pigment appears most commonly on drug jars described as Tuscan, specifically from Montelupo or Florence.[6] Very similar Gothic leaf motifs are common on Florentine works,[7] for example, a jug formerly in the Figdor collection, Vienna,[8] and one in the Kunstgewerbemuseum, Berlin (inv. 43,9),[9] both of which are particularly close to the Getty Museum's jug. The shape of the Berlin jug, moreover, strongly suggests a Florentine attribution; large jugs were a specialty of Tuscan, especially Florentine, ceramic workshops beginning in the late Middle Ages, and wide, flat strap handles are common

on Florentine *zaffera a rilievo* jars. In addition the pinkish buff color of this jug's clay body might substantiate a Florentine attribution, since Tuscan clays in general have a more reddish cast than the lighter, more cream-colored clays of the Faentine region.[10]

MARKS AND INSCRIPTIONS: None.

PROVENANCE: Savile family, Rufford Abbey, Nottingham (sold, Christie's, London, October 11–20, 1938, lot 879); [Alfred Spero, London];[11] sold, Sotheby's, London, December 4, 1956, lot 24; Robert Strauss, London (sold, Christie's, London, June 21, 1976, lot 7); [Rainer Zietz, Ltd., London].

EXHIBITIONS: None.

BIBLIOGRAPHY: *Christie's Review of the Season* (London, 1976), p. 394; H. Morley-Fletcher and R. McIlroy, *Christie's Pictorial History of European Pottery* (Englewood Cliffs, N.J., 1984), p. 26, fig. 3.

CONDITION: Touched-in glaze chips on the left side of the bust near the foliate scrolls; filling and repainting at the top and bottom of spout; repainting around the incised circles on the left side and on the area of hair below the chin; some extensive repainting of the blue leaf decoration on the left side near the top.

1. H. P. Fourest, "En avant-propos sur la majolique italienne," *Cahiers de la céramique, de verre et des arts du feu*, no. 25 (1962), p. 13. Orvieto ware is so called because green and brown archaic maiolica has long been associated with the Orvieto district, just north of Viterbo.
2. F. Duret-Robert, "Faenza," *Connaissance des arts*, no. 254 (1973), pp. 129–134, no. 2; Giacomotti 1974, no. 69.
3. Sale cat., Sotheby's, London, November, 22, 1983, lot 206.
4. Chompret 1949, vol. 2, figs. 348, 349, 351, 386; Giacomotti 1974, nos. 94, 95, 99.
5. Kube 1976, no. 3.
6. See A. V. B. Norman, *Catalogue of Ceramics I: The Wallace Collection* (London, 1976), nos. C80, C81; Cora 1973, vol. 2, fig. 209a; sale cat., Semenzato Nuova Geri Srl, Milan, November 5, 1986, lot 74.
7. See Cora 1973, vol. 2, nos. 210a, 210c, 211b–c, 219a, 219c.
8. Ibid., no. 210b; Bode 1911, pl. 29.
9. Hausmann 1972, no. 80.
10. Generalizations about the colors of ceramic bodies must, however, be considered with caution. Not only is it impossible to attribute with certainty a given clay color to a specific region, but areas of unglazed ceramic bodies become darker with handling. The superficial appearance of fired clay can therefore be misleading.
11. According to J. V. G. Mallet, correspondence with the author, November 1987.

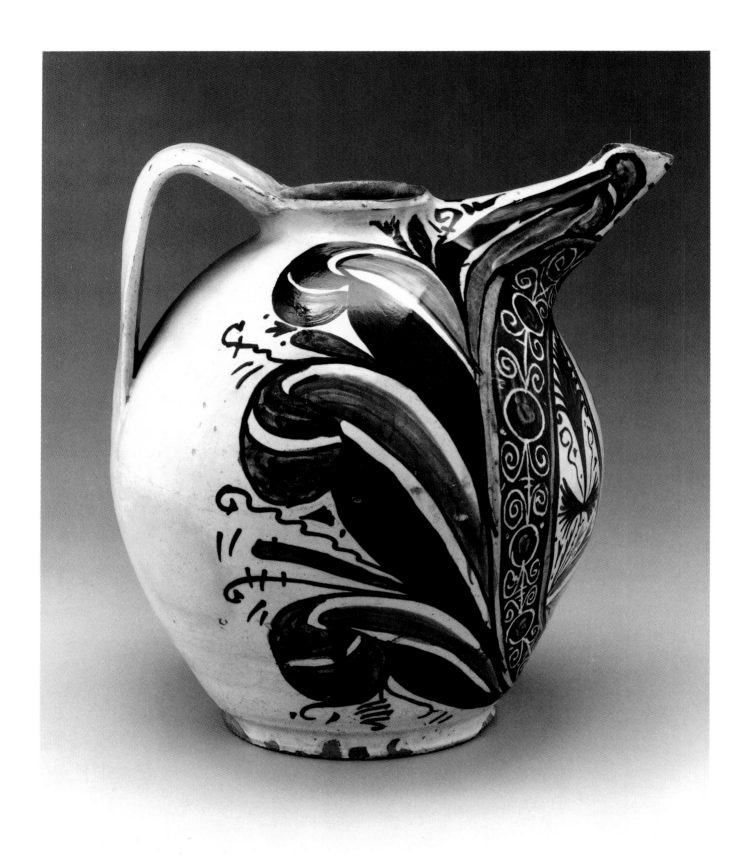

No. 13, alternate view

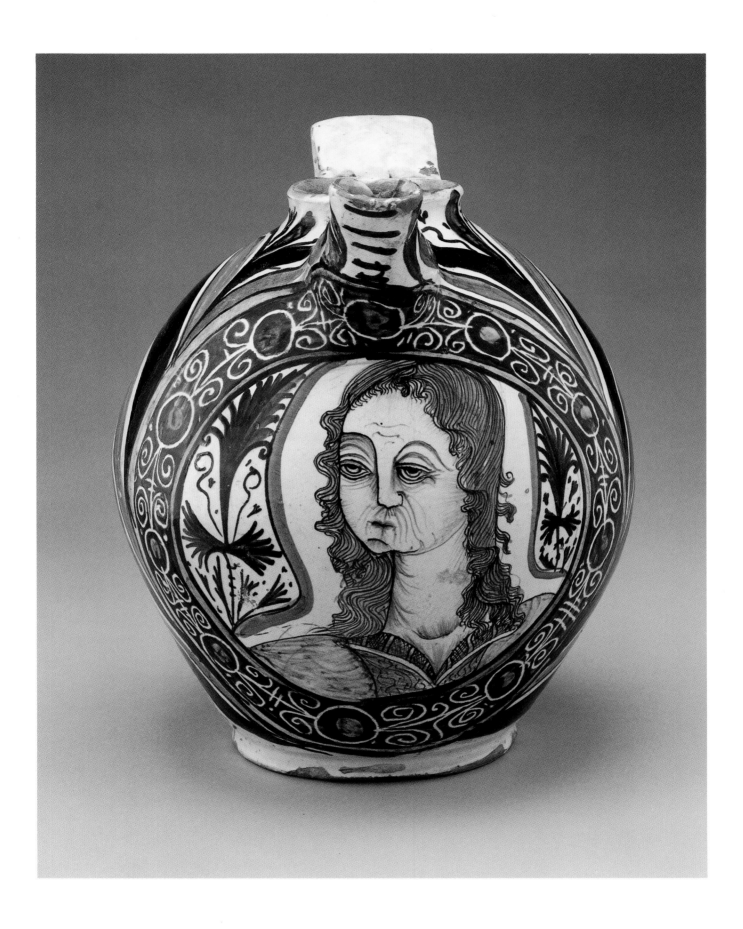

14 Two-Handled Cylindrical Jar (Albarello Biansato)

Faenza, circa 1460–1480
H: 22.9 cm (9 in.); Diam (at lip): 11.2 cm (4⁷⁄₁₆ in.); max.
W: 23.8 cm (9³⁄₈ in.)
84.DE.102

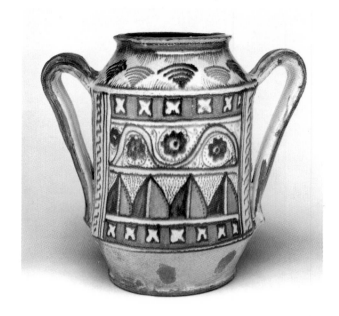

No. 14, alternate view

THIS GENTLY WAISTED JAR WITH TWO RIBBED HAN-dles is painted on one side with the profile bust of a young man in a feathered hat bordered by unusually slender scrolling foliage, and on the other with a geometric X pattern, flowers, and stylized leaves in horizontal sections. The decoration on both sides is painted in panels bordered by a vertical braid design. The high shoulder displays a stylized motif reminiscent of so-called San Bernardino rays. These rays were painted around the sacred monogram IHS on the tablet exhibited by Saint Bernard of Siena to promote devotion to the Holy Name, and they became a popular decorative motif on fifteenth-century maiolica (see no. 2). The jar's embellishment is executed primarily in blue and ocher, although a light copper green colors the young man's pointed hat on one side, and curving and straight bands on the other. The interior is lead glazed. Marks, perhaps graduations, appear under the foot, although it is uncertain whether these were scratched at the time the jar was made or at a later date.

Two-handled jars of this form, often decorated in a very similar palette, were popular among Tuscan and Faentine potters beginning in the mid-fifteenth century, which makes it difficult to distinguish between jars from the two areas.[1] This brightly colored piece can be tentatively attributed to Faenza, since Faentine glazes are generally shinier and more brilliant than those of Florence. Moreover the ribbed handle form and painted geometric designs tended to be more prevalent in Faenza than in Florence, where twisted handles and vegetal decoration appear more common. The X pattern, formed by four small marks extending from the sides to the middle of a square, and stiff leaves were used to embellish Faentine wares,[2] although they also decorate ceramics from nearby centers such as Montelupo,[3] Siena,[4] Florence,[5] and Deruta.[6] Further supporting a Faentine attribution, the yellowish buff-colored clay body of this jar is more typical of Faenza than the more red or dark gray clays common in Tuscany.[7]

The depiction of the young man in contemporary dress on one side of this jar assists in dating the piece. Both an albarello from Pesaro of circa 1480–1490 in the

Victoria and Albert Museum, London (inv. 364-1889),[8] and another albarello of circa 1470–1500 in the British Museum, London (inv. MLA 1878, 12-30, 412), display similar young men in profile wearing pointed and plumed hats and long, curled coiffures.[9] A Faentine wet-drug jar dated to the end of the fifteenth century in the Musée des Arts Décoratifs, Lyons (from the Paul Gillet collection), also shows the profile bust of a young man in similar dress and with pointed hat.[10]

MARKS AND INSCRIPTIONS: Under foot, inscribed marks (graduations?).

PROVENANCE: Sold, Christie's, London, October 3, 1983, lot 237 (attributed to Tuscany); [Rainer Zietz, Ltd., London].

EXHIBITIONS: None.

BIBLIOGRAPHY: Christie's, London, October 3, 1983, lot 237.

CONDITION: Minor glaze chips on the handles and rim; some areas of glaze loss around the base that, because of their spacing and roughly oval shape, appear to be finger marks made when the ceramist gripped the piece to dip it upside down into glaze. The oils from his fingers would have kept the glaze from adhering properly to the jar.

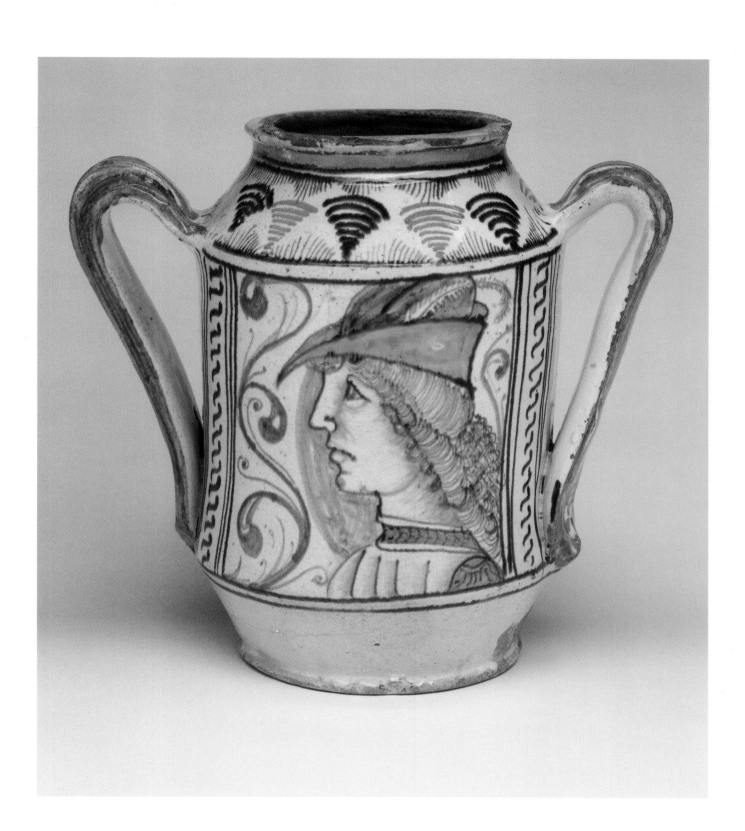

1. See, for example, entry no. 12 above; Rackham 1959, figs. 110, 111 (for other *albarelli* with Gothic-family glaze decoration, attributed, respectively, to Florence and to Faenza or Florence); Hausmann 1972, fig. 84 (attributed to "Florence?"); Cora 1973, vol. 2, fig. 210c (attributed to "zona fiorentina"); J. Giacomotti, *La majolique de la renaissance* (Paris, 1961), no. 2, pl. 7 (attributed to Faenza, although more probably Florentine); Chompret 1949, fig. 360 (attributed to Faenza).

2. See, for example, Hausmann 1972, pp. 143–145, no. 108; Giacomotti 1974, pp. 49–50, nos. 164–166; Watson 1986, pp. 42–43, no. 5 (a plate with this type of embellishment is attributed to "Faenza [?]").

3. See G. Conti, ed., *Catalogo delle maioliche: Museo Nazionale di Firenze, Palazzo del Bargello* (Florence, 1971), no. 113.

4. See Wilson 1987, p. 87, no. 132.

5. Rackham 1940, vol. 2, no. 94.

6. Giacomotti 1974, pp. 130–131, nos. 451, 452.

7. See entry no. 13 above, n. 10.

8. Rackham 1940, vols. 1, no. 110; 2, pl. 20; P. Berardi, *L'antica maiolica de Pesaro* (Florence, 1984), p. 282, fig. 70.

9. Wilson 1987, pp. 36–37, no. 31 (attributed to the central Italian regions of Emilia-Romagna, the Marches, or Umbria).

10. J. Giacomotti, "Les majoliques de la collection Paul Gillet au musée lyonnais des arts décoratifs," *Cahiers de la céramique, de verre et des arts du feu*, no. 25 (1962), ill. p. 33.

15 Peacock-Pattern Dish

Faenza(?), circa 1470–1500
H: 6.3 cm (2½ in.); Diam: 39 cm (15⅜ in.)
84.DE.103

THIS IS AN UNUSUALLY SHAPED PLATE WITH A SMALL, slightly bossed center and wide, sloping sides. The potter pierced two holes in one edge before the first firing. It has been suggested that such holes served to hang plates for firing, thereby optimizing available kiln space. Certainly any combustible strap would have disintegrated in the hot kiln, however, and if metal hooks were used, it is unclear how they would have been attached to the kiln walls.

It is more likely that ceramic plates were hung by such holes for display purposes, although we do not know whether or how maiolica display plates (including *istoriati* and *piatti da pompa*) were used. In fourteenth- and fifteenth-century paintings, common vessels such as maiolica jugs occasionally appear, but the more elaborate ware is entirely absent, and there is no proof that various depictions of display credenzas portray maiolica rather than metalwork. Moreover the possibility that maiolica ware might have been used for eating on special occasions cannot be ruled out. Since forks were still a novelty in the fifteenth century, maiolica would have been preserved from scratches caused by scraping utensils.

This rare plate is brilliantly decorated in dark and light blue, copper green, bright ocher, and manganese purple with a star or flower medallion in the center surrounded by a bold, eight-pointed whorl of stiff, tapering leaves alternating with peacock feathers. This embellishment is filled in with small blue scrolls, foliage, and dots. The reverse displays stars, scrolls, and foliate motifs in ocher, copper green, and blue on a grayish white lead-glazed ground.[1] The clay body is of a pinkish buff color.

Very few such ornamentally glazed works—without coats of arms, animals, profile busts, or pictorial scenes—have survived. Plates, vases, *albarelli*, and jugs painted in this style were most often produced for daily use and thus were frequently broken or chipped. That this dish was probably used as a display piece may explain its good state of preservation. Typical of Gothic-floral-family works, the peacock-feather motif was thought to refer to Cassandra Pavoni (*pavona* means peacock), the lover of Galeotto Manfredi, lord of Faenza in the late fifteenth century.[2]

Although one finds Faentine plates and plate sherds with similar peacock-feather and stiff-leaf motifs,[3] the closest example to this work is a plate with overall scroll and leaf decor in the Museum für Kunst und Gewerbe, Hamburg (inv. 1909.256).[4] The Hamburg plate differs, however, in its *tondino* shape and scrolling broad-leaf decoration instead of the tapering-leaf and peacock-feather designs on the present work. Although the clay body color and incised leaf scrolls of the Getty Museum's plate are more typical of Tuscan wares, the shiny surface, the particularly dark blue glaze, and the peacock-feather motif are found most often on Faentine ceramics.

MARKS AND INSCRIPTIONS: None.

PROVENANCE: Sir William Stirling-Maxwell, Bt., K.T.; Lt. Col. W. J. Stirling, Keir; sold, Sotheby's, London, June 18, 1946, lot 79; F. D. Lycett-Green, Goudhurst, Kent (sold, Sotheby's, London, October 14, 1960, lot 24, with incorrect provenance); Robert Strauss, London (sold, Christie's, London, June 21, 1976, lot 14); [Cyril Humphris, London]; [Rainer Zietz, Ltd., London].

EXHIBITIONS: None.

BIBLIOGRAPHY: J. Rasmussen, *Italienische Majolika* (Hamburg, 1984), p. 71, n. 1 (attributed to "Faenza or more probably Tuscany").

CONDITION: Glaze chips at the center and rim; some repainting around cracks; six metal staples along a hairline crack in the underside.

1. Similar unusual embellishment is also found on the reverse of a small plate formerly in the Beckerath collection, Berlin, attributed to Faenza of circa 1480 (O. von Falke, *Die Majolikasammlung Adolf von Beckerath*, sale cat., Rudolph Lepke, Berlin, November 4, 1913, lot 58).

2. See G. Strocchi, "La 'Pavona' cristiana e la 'Pavona' di Galeotto Manfredi," *Faenza* 1, no. 4 (1913), pp. 105–108; however, C. Ravanelli Guidotti (correspondence with the author, February 1988) mentions Faentine documents from which one learns that maiolica painters employed peacock-feather decoration as early as 1460, thus predating Manfredi's relationship with Pavoni. Therefore, although the duke might have popularized this pattern, it could not have originated with him; see C. Ravanelli Guidotti, "Vasellame d'uso e vasellame celebrativo," *Faenza* (forthcoming); idem, *Il pavimento della cappella Vaselli in San Petronio a Bologna* (Bologna, 1987). For a general examination of Faentine society under the Manfredi, see M. Gioia Tavoni, "Strutture e società a Faenza nell'età Manfrediana," *Faenza* 61, no. 4/5 (1975), pp. 94–105.

3. See Giacomotti 1974, figs. 84, 123, 125, 130.

4. Rasmussen 1984, no. 39 (attributed to "Faenza? or Tuscany?").

ROBERT CAMPIN (Flemish, 1375–1444). *Annunication*, early fifteenth century. Oil on panel, 64.1×63.2 cm (25¼×24⅞ in.). New York, Metropolitan Museum of Art 56.70, Cloisters Collection. Photo courtesy Metropolitan Museum of Art. The shape of the maiolica jug on the table is common to early fifteenth-century Tuscan *boccali* (see no. 3); its decoration is more typical of Florentine ceramics dating from midcentury. Judging from contemporary paintings in which maiolica *boccali* and *albarelli* are shown holding flowers, these vessels were used as vases in addition to serving as pitchers and jars.

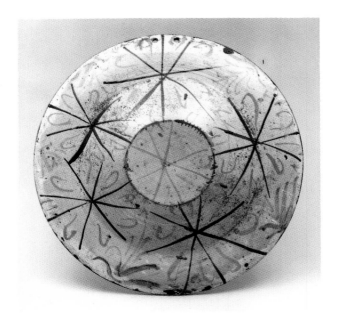

No. 15, reverse

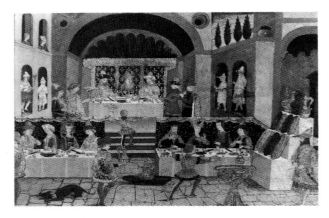

Attributed to APOLLONIO DI GIOVANNI (Italian, 1415–1465). *Dido's Feast*, mid-fifteenth century (detail). Cassone panel, 42.5×164 cm (16¾×64⁹⁄₁₆ in.). Hannover, Niedersächsiches Landesmuseum. Photo courtesy Niedersächsiches Landesmuseum. Although we cannot be sure that the plates displayed on the credenza to the right are ceramic and not metal, maiolica *piatti da pompa* might have been displayed similarly.

DUCCIO DI BUONINSEGNA (Italian, circa 1255/60–circa 1318). *Last Supper*, circa 1308–1311. Oil on panel. Siena, Opera del Duomo. Photo courtesy Art Resource, New York. A maiolica jug appears between two saints in the foreground.

16 Ecce Homo

Faenza or Florentine area(?), circa 1500
H: 60.3 cm (23¾ in.); W: 59.7 cm (23½ in.); D: 26 cm
(10¼ in.)
87.SE.148

No. 16, back view

THIS SCULPTURE DEPICTS THE BUST OF CHRIST crowned with thorns. Like devotional images of the subject in other media, the bust is half-length, terminating above the elbows and through the chest. As befits the portrayal of Christ facing his accusers after being scourged, the face is drawn and gaunt yet proud and compassionate. The sculpture presumably was made as a devotional object to be placed in a church or private chapel.

Christ's hair falls on his shoulders in corkscrew curls. He wears a tunic decorated with finely drawn geometric patterns and a cloak over his left shoulder. The eyebrows, eyes, and beard are painted with thin, blackish blue lines; the crown of thorns is painted with a mixture of the same dark blue and emerald green. The neck of the tunic and the base display incised and gilt decoration. The back of this fully modeled bust is unembellished, except for the opaque white glaze ground and the incised rendering of the hair.

This remarkable work possesses a sculptural force and sophistication rarely found in maiolica. Although the artist is unknown, the incisive depiction of a taut and sinewy face displaying a proud, almost haughty demeanor can be most closely compared to the work of late fifteenth-century Tuscan sculptors such as Lorenzo Vecchietta (1412–1480), Matteo Civitali (1436–1501), Andrea Sansovino (circa 1460–1529),[1] and in particular the so-called Master of the Marble Madonnas. Like the Museum's example in maiolica, three late fifteenth-century marble *Ecce Homo* busts by the latter master are vigorously modeled and depict Christ's proud mien with the idiosyncratic corkscrew curls, parted beard, and crown of thorns punctuated with holes (perhaps to hold thorns made of another material).[2]

This maiolica *Ecce Homo* is probably the product of a collaboration between a sculptor, who would have modeled the piece, and a ceramic artist, who would have glazed and fired it. To judge from the surface decoration, the ceramist responsible for the firing and glazing most likely worked in Faenza around 1500. The work exhibits both the particularly shiny glazes and the palette of vivid and saturated yellow, green, and blackish blue typical of that center. Moreover geometric motifs such as the cube

and cloverleaf patterns on Christ's tunic were favored on late fifteenth- and early sixteenth-century Faentine maiolica, and there are countless examples of Faentine wares of this period with similar geometric patterns.[3] However, these geometric motifs spread throughout central Italy, appearing on contemporary works from Tuscany and elsewhere.[4] In addition, whereas the bust's painted decoration points to Faenza as its place of origin, its vigorous sculptural quality brings Tuscany to mind. Thus it is possible that this work, influenced as it appears to have been by Florentine masters, was produced in a Tuscan workshop.

Fifteenth-century maiolica objects that come closest to the present bust in scale and sculptural type include the reliefs and freestanding figures produced in the Florentine della Robbia workshop, including several busts of Christ, probably influenced by Andrea del Verrocchio.[5] Della Robbia figures, however, appear "sweeter" and less vigorously modeled than the present *Ecce Homo* and are nearly always glazed in large, monochromatic areas, without the lively tracings and geometric motifs displayed by this bust.

Other comparable three-dimensional sculptures in maiolica include the *Bust of the Saviour*, attributed to Sansovino, in the Bruschi collection, Arezzo;[6] the sixteenth-century *Bust of Pope Paolo III Farnese*, attributed to "Umbria (?)," in the Museo Internazionale delle Ceramiche, Faenza (inv. 21253/c);[7] and two late fifteenth- or early

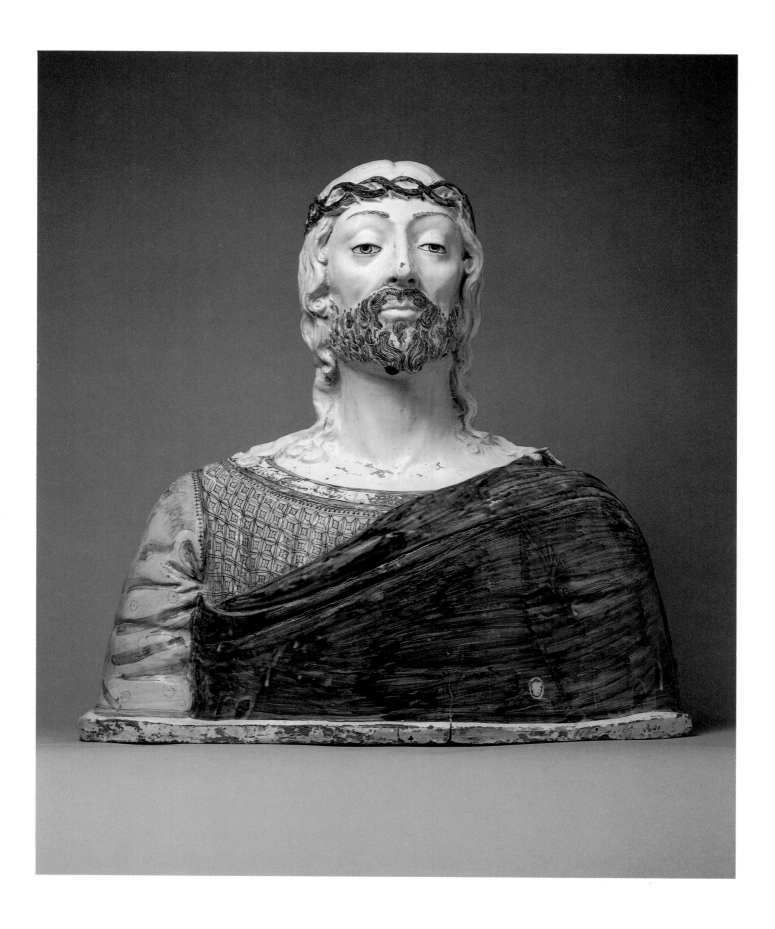

sixteenth-century small busts of the young Saint John the Baptist, one in the Ashmolean Museum, Oxford,[8] and the other in the De Ciccio Collection, Museo di Capodimonte, Naples (inv. 58).[9] As in the Getty Museum's *Ecce Homo*, the subject of both of these small busts (apparently two versions of the same work) has an unusually proud, almost haughty gaze, and the saint's animalskin tunic and hair are rendered with short, dark blue lines, much like those defining Christ's beard. The small busts, however, have a rather naive quality (possibly because of their size) that is more typical of the late fifteenth- to seventeenth-century three-dimensional inkwells, fountains, and small-scale figures commonly produced in potteries along the Metauro River in centers such as Pesaro[10] and Faenza.[11]

MARKS AND INSCRIPTIONS: None.

PROVENANCE: Private collection, Belgium; sold, Sotheby's, London, April 7, 1987, lot 44; [Rainer Zietz, Ltd., London].

EXHIBITIONS: None.

BIBLIOGRAPHY: *Burlington Magazine* 129 (March 1987), ill. p. 1; *Il giornale dell'arte*, no. 45 (1987), p. 90, fig. 50.

CONDITION: Some minor cracks and glaze faults; the proper right tip of the beard is chipped; some of the original gilding has worn off the neck of the tunic and the base; the crown displays holes into which thorns, possibly of wood, may have been inserted.[12]

1. Particularly close to the present bust is the half-figure *Saint John the Baptist* in the Museo Bardini, Florence.
2. U. Middeldorf, "An Ecce Homo by the Master of the Marble Madonnas," in *Album amicorum J. G. van Gelder* (The Hague, 1973), pp. 234–236, esp. pls. 1, 2, 4, 5.
3. For cubelike motifs, see the Museum's Faentine *albarelli* of circa 1510 (no. 24), as well as designs on the tile floor of the Capella Vaselli, Bologna, which was likely executed in Faenza in the last decades of the fifteenth century. Similar cloverleaf patterns are found on a large vase in the Victoria and Albert Museum, London (inv. 351-1872; Rackham 1940, vols. 1, p. 46; 2, no. 157, pl. 28), and on the *Bust of an Old Woman* in the Fitzwilliam Museum, Cambridge (inv. C1-1955; Liverani 1960, pl. 18), both of which are dated circa 1490 and attributed to Faenza.
4. The cube motif on Christ's tunic also decorates a Sienese *albarello* in the Museo Internazionale delle Ceramiche, Faenza (inv. 21061/c), and both the cube and cloverleaf patterns are found on an early sixteenth-century jar made in Cafaggiolo (A. Fanfani, "Ancora due righe su Cafaggiolo," *Faenza* 70, no. 5 [1984], pls. 103a–d).
5. See, for example, J. Pope-Hennessy, *Catalogue of Italian Sculpture in the Victoria and Albert Museum* (London, 1964), vol. 1, pp. 233–234, no. 232; Giacomotti 1974, nos. 358–362.
6. This work displays the same noble gaze, gentle corkscrew curls, and plain white glaze ground with only a few details (eyes and eyebrows) picked out with thin dark blue lines as the Getty Museum's example, although it has a gentler and less powerful aspect (G. Batini et al., *Omaggio a Deruta*, exh. cat. [Monte San Savino and Deruta, 1986], pp. 135–137, ill. p. 132).
7. Bojani et al. 1985, p. 300, no. 772; C. Ravanelli Guidotti, "Note di iconografia sui materiali del Museo di Faenza," *Faenza* 72, no. 3/4 (1986), p. 234, pl. 86.
8. C. D. E. Fortnum, *Maiolica: A Historical Treatise . . .* (Oxford, 1896), pl. 9 (attributed to sixteenth-century Cafaggiolo).
9. Attributed to Faenza on the label attached to its underside.
10. See, for example, P. Berardi, *L'antica maiolica di Pesaro* (Florence, 1984), pp. 212–215, fig. 93.
11. See, for example, Watson 1986, nos. 3, 4; G. Gardelli, *"A gran fuoco": Maioliche rinascimentali dello stato di Urbino da collezioni private*, exh. cat. (Palazzo Ducale, Urbino, 1987), nos. 62–69.
12. This theory was postulated by J. Pope-Hennessy to explain similar holes on Giovanni della Robbia's *Ecce Homo* in the Victoria and Albert Museum, London (Pope-Hennessy [note 5], pp. 233–234, no. 232).

17 Cylindrical Drug Jar (Albarello)

Faenza, circa 1480
H: 31.5 cm (12⅜ in.); Diam (at lip): 11.1 cm (4⅜ in.);
max. Diam: 12.4 cm (4⅞ in.)
84.DE.104

THIS WAISTED DRUG VESSEL IS DECORATED WITH A banderole label inscribed *S. ACETOSITATI CIT[RUS]* (*syrupus acetositatis citriorum*, syrup of lemon juice) bordered above and below by scrolling Gothic leaves (*a cartoccio*) in blue, green, ocher, and manganese purple. Meandering foliage in blue runs around the neck and the area above the foot. The interior is lead glazed.

The lemon was widely used for pharmaceutical purposes throughout the Mediterranean, possibly as early as the second century, in fever reducers, tonics, antiscorbutics, diuretics, and astringents.[1] Prospero Borgarucci described the preparation and use of syrup of lemon juice (which he called *sciroppo d'acetosità di cedro*) in his *Della fabrica de gli spetiali*. According to Borgarucci, this syrup served to reduce inflammations of the viscera, calm fevers (especially the "poisonous and pestilential fevers of the summer"), quench thirst, and help counteract drunkenness and dizziness.[2]

Although the exceptionally high, almost vertical neck and scrolling leaf decoration of this pharmaceutical container can be found on Neapolitan wares,[3] its slender and elegantly proportioned cylindrical form as well as the bright glazes on a pure white ground are more typical of Faentine *albarelli* of the fourteenth to the early sixteenth centuries. The Gothic design more specifically dates this work to the late fifteenth century (see no. 12). The function of these drug jars is reflected in their form: the waisted shape provided a good grasp for removing the jar from a shelf of similar vessels and for pouring its contents, and the flanged lip on a tall neck secured the string that held a cover in place.[4]

The elegance of its attenuated shape and its masterful glaze painting make this piece one of the finest fifteenth-century *albarelli* known. Other Faentine *albarelli* with scrolling Gothic leaf decoration but without labels include those in the collection of the late Arthur M. Sackler, New York (inv. 79.5.9);[5] in the State Hermitage, Leningrad (inv. F 1593);[6] formerly in the Robert Strauss collection, London;[7] formerly in the Fernandez collection;[8] and two formerly in the Bak collection, New York.[9] Faentine *albarelli* of similar shape but with peacock-feather decoration are in the Metropolitan Mu-

seum of Art, New York,[10] and the Musée du Louvre, Paris (inv. OA 5971).[11] A particularly close example to this *albarello*—of a very similar shape and likewise encircled by a banderole label but painted instead with peacock-feather decoration—was also formerly in the Pringsheim collection, Munich, and in the Damiron collection, Lyons, and is presently in the Musée National de Céramique, Sèvres (inv. MNC 25141).[12]

MARKS AND INSCRIPTIONS: On banderole, *S. ACETOSITATI CIT[RUS]*.

PROVENANCE: A. Pringsheim, Munich (sold, Sotheby's, London, June 7, 1939, lot 9); Charles Damiron, Lyons; Paul Damiron; [Rainer Zietz, Ltd., London].

EXHIBITIONS: None.

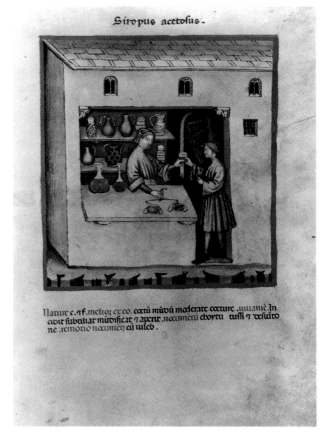

Illustration of *Siropus acetosus*. From *Theatrum sanitatis*. Northern Italy, late fourteenth century. Tempera on vellum. Rome, Biblioteca Casanatense Ms. 4182, fol. 183r. Photo courtesy Foto Murgioni Nadia, Rome. The druggist stored pharmaceuticals in what appear to be maiolica *albarelli* and wet-drug pitchers on the shelf behind him. The preparation illustrated here, "vinegar syrup," was used to calm coughs and cure diarrhea.

BIBLIOGRAPHY: Falke 1914–1923, vol. 1, no. 22, pl. 15;
E. Hannover, *Pottery and Porcelain* (London, 1925), fig.
117; C. Damiron, *Majoliques italiennes* (privately printed,
1944), no. 27 (ill.); sale cat., Sotheby's, London, November 22, 1983, lot 212.

CONDITION: Slightly abraded glaze at the rim; minor
flaws in the glaze at the base.

1. M. Grieve, *A Modern Herbal* (New York, 1971), pp. 474–
476.

2. P. Borgarucci, *Della fabrica de gli spetiali* (Venice, 1567), p.
117.

3. See, for example, the jars executed for the Aragonese pharmacy at Castelnuovo, reproduced in G. Donatone, *Maioliche napoletane della spezieria aragonese di Castelnuovo* (Naples, 1970), and two further Neapolitan *albarelli* in the Corcoran Gallery of Art, Washington, D.C. (inv. 26.405, 26.399), reproduced in Watson 1986, nos. 23, 24.

4. See, for example, covered *albarelli* on the window ledge and workbench in Cornelis Bega's *Alchemist* (see Introduction, fig. 6).

5. D. Shinn, *Sixteenth-Century Italian Maiolica* (Washington, D.C., 1982), p. 11, no. 1.

6. Kube 1976, no. 5.

7. Sale cat., Sotheby's, London, June 21, 1976, lot 10.

8. Chompret 1949, vol. 2, fig. 367.

9. *A Highly Important Collection of Early Italian Maiolica Formed by Dr. Bak of New York*, sale cat., Sotheby's, New York, December 7, 1965, lots 22, 23, 25.

10. G. Szabó, *The Robert Lehman Collection* (New York, 1975), no. 147.

11. Giacomotti 1974, no. 127.

12. Falke 1914–1923, vol. 1, no. 24, pl. 15; sale cat., Sotheby's, London, November 22, 1983, lot 211.

No. 17, alternate view

18 Dish with a Scene from the Aeneid (Coppa)

Faenza, circa 1515–1520
H: 5.4 cm (2⅛ in.); Diam: 24.6 cm (9¹¹⁄₁₆ in.)
84.DE.106

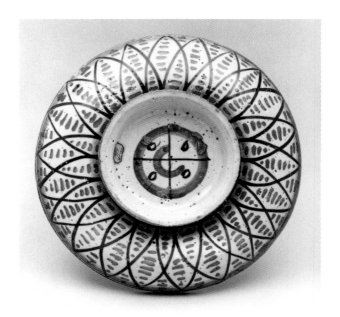

No. 18, reverse

THIS *COPPA*, OR FOOTED CONCAVE DISH, FALLS WITHIN the transition to the so-called *stile bello* (beautiful style) of the early sixteenth century, when *istoriato* decoration reached its height of popularity and pictorial sophistication.[1] On the obverse is a finely painted scene of a king seated on a high throne with groups of women and men to his proper right and left, respectively. A winged putto stands in the foreground holding a blank scroll that elegantly echoes the scrolling supports of the throne. Another putto appears on a cloud above. This *istoriato* piece is painted in blue, yellow, pale orange, pale yellowish green, pale purple, and opaque white on a pale blue ground. Blue radiating leaves filled with concentric dark ocher lines cover the reverse, encircling the foot.

On the underside of the *coppa* is a circle divided into four sections, with a smaller circle in each of the four quarters. Since 1858 this mark has been identified as the *pyros rota* (fire wheel), believed to be the mark and punning device of the Faentine Casa Pirota workshop.[2] This attribution was questioned by scholars as early as 1880,[3] and recent scholarship has cast further doubt on it. Of the two known pieces with inscriptions indicating their manufacture in the Casa Pirota,[4] neither bears the crossed-circle mark. Moreover variants of the crossed circle appear on works from centers other than Faenza (such as Gubbio and Castel Durante) as simple decorative motifs or as spheres. When depicted in the hands of small boys, for example, it resembles a *pallone*, or pneumatic ball.[5] Finally, if the Faentine examples were intended to represent spheres, there would be no reason to associate them with the Casa Pirota, since they would not also have been understood as wheels.[6]

Long misinterpreted as a betrothal scene, the *coppa*'s painted decoration appears to depict instead a debate over a betrothal described in an episode from Virgil's *Aeneid*, a work from which *istoriato*-ware subjects were commonly drawn in the sixteenth century.[7] As recounted in the *Aeneid*, King Latinus of Latium was approaching old age without a male descendant. He did have one daughter, Lavinia, who was sought in marriage by many neighboring chiefs, including Turnus, king of the Rutulians. Lavinia's parents favored this union, but Latinus had been warned by his own father in a dream that Lavin-

ia's husband would be a foreigner and that this union would produce a race destined to conquer the world. This foreigner was Aeneas, who, after vanquishing Turnus in battle, claimed Lavinia as his wife.

The *coppa*'s scene appears to be based on a passage (bk. 12, ll. 54–80) in which Amata (Lavinia's mother, the kneeling woman in the foreground) pleads with Turnus (the young warrior before her) to refrain from fighting the Trojans for fear that he, her daughter's intended husband, will die.[8] Lavinia (the hooded figure surrounded by attendants), hearing her mother's entreaty, is filled with emotion, "her burning cheeks steeped in tears, while a deep blush kindled its fire, and mantled o'er her glowing face" (ll. 65–67). Turnus then "fastens his looks upon the maid; [and], fired more for the fray, briefly he addresses Amata: 'Nay, I beseech thee, not with tears, not with such omen, as I pass to stern war's conflicts, do thou send me forth, O my mother[-in-law]; nor truly has Turnus freedom to delay his death'" (ll. 70–75). Latinus, enthroned and holding a scepter, presides over the scene.

The posture of the flying putto in the upper left suggests that the artist intended him to represent Cupid aiming his bow and arrow, attributes the artist may have simply forgotten to include after the figure had been painted. In the context of this passage from the *Aeneid*, the appearance of Cupid aiming his darts at Turnus would be appropriate both because Turnus had been promised to Lavinia in marriage and because Cupid was Aeneas' brother.

In such a carefully rendered scene, however, it is dif-

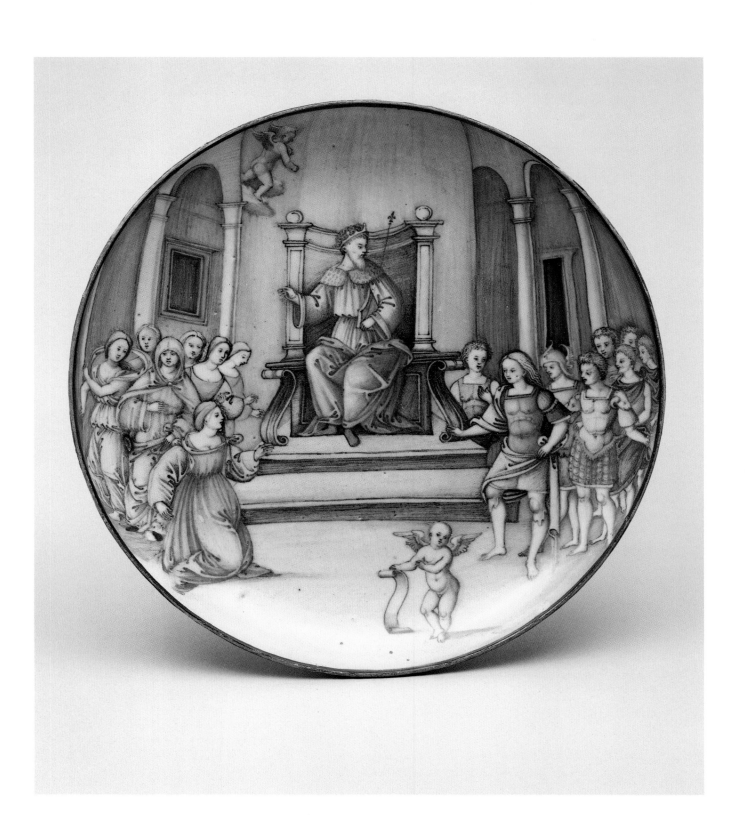

ficult to accept the proposition that the omission of Cupid's bow and arrows was merely an oversight. It is possible that this figure, deprived of bow and arrow, actually represents Cupid's rival, Anteros. In classical mythology Anteros symbolized both reciprocity in amorous relations and terrestrial love (as opposed to Cupid/Eros, who represented celestial love).[9] According to an interpretation current in the sixteenth and seventeenth centuries, Anteros symbolized physical love rejected and chastised and therefore represented *Amor virtutis*, or the castigator of love.[10] Identification of the *coppa*'s figure with Anteros instead of Eros might be more appropriate, since the intended union of Turnus and Lavinia never came to pass. Although Anteros is usually depicted fighting with or binding Eros[11] or being instructed by Mercury,[12] the painter of this *coppa* might have invented his own Anteros image to fit the composition.[13]

The closest stylistic parallels to the decoration on this dish include a plate with the subject of Perseus and Andromeda in the Victoria and Albert Museum, London (inv. c.2118-1910),[14] and a plaque dated 1518 depicting the abduction of Helen in the Museo Correr, Venice,[15] both tentatively attributed to the Master Gonela or the Master C.I. Because the styles of these two artists are so similar, Rackham suggested that the inscriptions *C.I.* and *Gonela* after which they had been named indicated one and the same master.[16] Although almost certainly by a different hand, *istoriato* works produced in the early sixteenth-century Faentine workshop of Francesco Torelli are also close in style to the Getty Museum's *coppa*;[17] the figures on the latter work display more subtle and sophisticated modeling, however, and do not have the wide, heavy foreheads often found on Torelli's figures.

MARKS AND INSCRIPTIONS: On underside, crossed circle with a smaller circle in each of the four quarters.

PROVENANCE: Sold, Sotheby's, London, November 21, 1978, lot 42; [Rainer Zietz, Ltd., London].

EXHIBITIONS: None.

BIBLIOGRAPHY: Sotheby's, London, November 21, 1978, lot 42.

CONDITION: A small hairline crack across the kneeling woman at the lower left toward the center of the plate; minor rim repairs; the male figure on the far right-hand edge has been restored.

1. According to Ballardini 1933–1938, vols. 1, pp. 13–14; 2, p. 10; Ballardini 1975, pp. 59–71, 92.

2. J. C. Robinson, "Ceramic Art," in J. B. Waring, ed., *Art Treasures of the United Kingdom from the Art Treasures Exhibition, Manchester*, vol. 1 (London, 1858), pp. 13–14.

3. See C. Malagola, *Memorie storiche sulle maioliche di Faenza* (Bologna, 1880), pp. 140–141; A. Genolini, *Maioliche italiane: Marche e monogrammi* (Milan, 1881), p. 57.

4. Located in the Museo Civico, Bologna (inv. 984; see G. Ballardini, "Alcune marche di Ca' Pirota," *Faenza* 28, no. 4 [1940], pp. 67–68; C. Ravanelli Guidotti, *Ceramiche occidentali nel Museo Civico Medievale di Bologna* [Bologna, 1985], pp. 76–79, no. 42), and formerly in the Baron Gustav de Rothschild collection, Buckinghamshire; now in the Musée National de Céramique, Sèvres (ibid., p. 67; H. P. Fourest, *La céramique européenne* [Paris, 1983], pl. 43).

5. For examples, see A. V. B. Norman, *Catalogue of Ceramics I: The Wallace Collection* (London, 1976), no. c67; G. Conti, *L'arte della maiolica in Italia*, 2nd edn. (Milan, 1980), no. 220; Giacomotti 1974, no. 684.

6. For more information regarding the crossed-circle mark, see Ballardini (note 4), pp. 66–72, pls. 14–17; A. V. B. Norman, "A Note on the So-called Casa Pirota Mark," *Burlington Magazine* 111 (July 1969), pp. 447–448.

7. See, for example, G. Ballardini, "Alcuni aspetti della maiolica Faentina nella seconda metà del cinquecento," *Faenza* 17, no. 3/4 (1929), pl. 17; *The Pringsheim Collection . . . of Superb Italian Majolica*, sale cat., Sotheby's, London, June 7, 1939, lot 77; sale cat., Sotheby's, London, March 18, 1975, lot 36; sale cat., Sotheby's, London, March 11, 1980, lots 16, 17.

8. I would like to thank Dr. W. Trimpi, Stanford University, for his assistance in identifying the scene.

9. V. Cartari, *Imagini delli dei de gl'antichi* (Venice, 1647; reprint, Graz, 1963), p. 258.

10. A. Alciati, *Emblemata* (Padua, 1621), no. 111.

11. See, for example, ibid.; E. Panofsky, *Studies in Iconology* (New York, 1962), figs. 96, 100.

12. As discussed in E. Verheyen, "Eros et Anteros: 'L'éducation de Cupidon' et la prétendue 'Antiope' du Corrège," *Gazette des beaux-arts* 65 (May–June 1965), pp. 321–340.

13. For further discussion of the interpretations and depictions of Anteros in the Renaissance and their relationship to classical texts, see Panofsky (note 11), pp. 95–128; C. Dempsey, "'Et Nos Cedamus Amori': Observations on the Farnese Gallery," *Art Bulletin* 50, no. 4 (1968), pp. 363–374.

14. Rackham 1940, vols. 1, no. 258; 2, pl. 41.

15. Ballardini 1933–1938, vol. 1, no. 66.

16. Rackham 1940, vol. 1, p. 81.

17. See G. Liverani, "Una sconosciuta bottega maiolicara del primo cinquecento a Faenza," *Faenza* 43, no. 1 (1957), pls. 1, 2.

19 Dish with Three Saints (Coppa)

By Baldassare Manara (active circa 1526–1547)
Faenza, circa 1535
H: 3.8 cm (1½ in.); Diam: 21.5 cm (8⁷⁄₁₆ in.)
84.DE.107

PAINTED IN OLIVE GREEN, COPPER GREEN, BLUE, YEL-low, ocher, grayish yellow, opaque white, and black, this *coppa* depicts three saints in a mountainous landscape with a city or large castle in the background. In the center Saint Catherine of Siena carries a scroll inscribed *PETRE DILIGIS ME* (Peter, love me[1]) and a vase or oil jar in one hand and her attributes of a lily and a book in the other. She is flanked by Saint Peter on her right and by a female saint holding aloft a palm frond, identifying her as a martyr, on her left. Two putti appear above the saints supporting a shield bearing a cross flanked by the letters *M* and *C* below annulets (possibly a merchant's trademark or more likely the mark of a religious order). The reverse of the dish is painted with a yellow and ocher scale ornament and is signed *Baldasara Manara fa[e]n[tino]* or *Baldasara Manara fa[e]n[za]* in the center of the raised foot.

Baldassare Manara was a member of a family of potters living in Faenza in the first half of the sixteenth century. In Faentine records he is described as *figulus* (potter) of the chapelry of Saint Thomas. Manara's name appears as early as 1526, and he is known to have died before June 15, 1547.[2]

Roughly thirty pieces are signed by or attributed to the artist. Among those that have been published are a plate with Joseph finding the gold cup (signed; Prague, Museum of Industrial Art inv. 273);[3] a plate with the Vestal Tuccia and a plaque with Battistone Castellini (both signed; London, British Museum inv. MLA 1855, 12-1, 94, MLA 1855, 3-13, 10);[4] plates with Narcissus at the fountain (unsigned), with the Resurrection (signed), and with a Roman battle scene (unsigned; London, Victoria and Albert Museum inv. 4726-1901, 62-1876, C.2112-1910);[5] a *coppa* with Pyramus and Thisbe (signed; Paris, Petit Palais, Dutuit 1063);[6] plates with Petrarch's "Triumph of Time" and with Caesar receiving the head of Pompey (both signed; Oxford, Ashmolean Museum);[7] a plate with Atalanta and Hippomenes (signed; Italy, private collection);[8] a plate with the death of Hesperia (signed; Cambridge, Fitzwilliam Museum);[9] and *coppe* with an allegorical scene and with the martyrdom of Saint Cecilia (both unsigned; formerly in the Adda collection, Paris).[10]

MARKS AND INSCRIPTIONS: On obverse, at top, shield with a holy cross flanked by *M* and *C* below annulets; on scroll, *PETRE DILIGIS ME*; on underside, *Baldasara Manara fa[e]n[tino]* or *Baldasara Manara fa[e]n[za]*.

PROVENANCE: [Stora, Paris]; Charles Damiron, Lyons (sold, Sotheby's, London, June 16, 1938, lot 20); Paul Damiron; [Rainer Zietz, Ltd., London].

EXHIBITIONS: None.

BIBLIOGRAPHY: C. Damiron, *Majoliques italiennes* (privately printed, 1944), no. 79; Chompret 1949, vols. 1, p. 77; 2, fig. 500; sale cat., Sotheby's, London, November 22, 1983, lot 209; *Art at Auction: The Year at Sotheby's* (London, 1983–1984), p. 290.

CONDITION: Minor chips around the rim, repainted, and one chip in the base.

1. The artist, possibly not fluent in Latin, may have misspelled or miscopied this curious inscription, which may have been intended to read "Peter loves me" or "Peter leads me."
2. C. Grigioni, "Documenti relativi alla famiglia Manara," *Faenza* 20, no. 3/4 (1932), p. 181.
3. J. Vydrova, *Italian Majolica* (London, 1960), p. 30, no. 35.
4. Wilson 1987, pp. 70–71, no. 102; 144, no. 221.
5. Rackham 1940, vols. 1, nos. 800–802; 2, pls. 126–127.
6. C. Join-Dieterle, *Catalogue des céramiques I* (Paris, 1984), no. 36.
7. C. D. E. Fortnum, *Maiolica* (London, 1873), pp. 482–483; idem, *Maiolica* (Oxford, 1896), pl. 19.
8. Falke 1914–1923, vol. 2, no. 204; Ballardini 1933–1938, vol. 2, no. 127.
9. Falke 1914–1923, vol. 2, figs. 203, 204; Ballardini 1933–1938, vol. 2, no. 126.
10. Rackham 1959, pls. 131a–b, 133c.

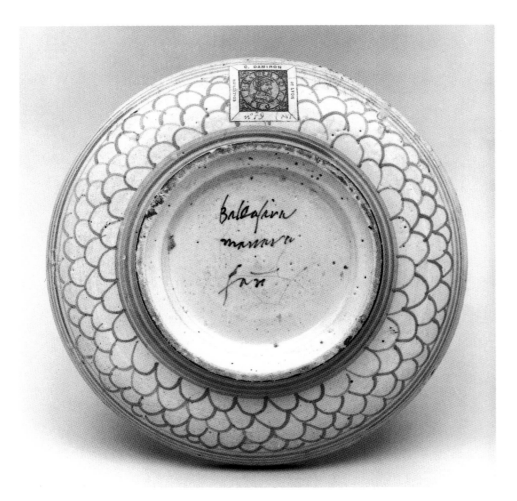

No. 19, reverse

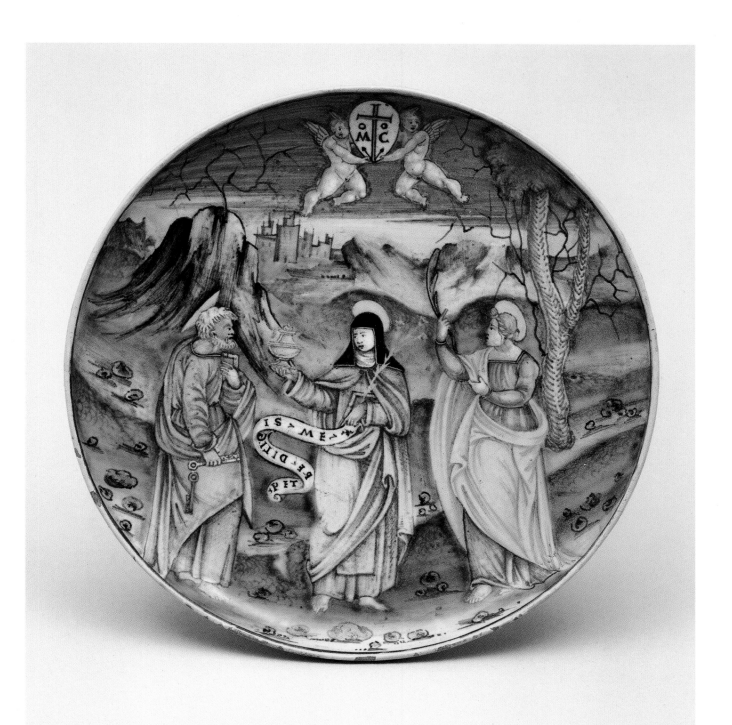

20 Plate with Saint Peter

Faenza or Cafaggiolo(?), circa 1500
H: 4.8 cm (1⅞ in.); Diam: 27.3 cm (10¾ in.)
84.DE.108

THIS UNUSUALLY SHAPED PLATE WITH SMALL BASE AND wide, sloping sides displays a finely painted, striking close-up portrait of Saint Peter in blue, orange, ocher, green, and yellow against a dark blue background. The saint is pointing with his right hand to a pair of keys held in his left hand, which is out of view; to the right and left of his head are the initials *SP* (for San Pietro). The rim inventively forms part of the saint's yellow halo, so that the circular shapes of nimbus and rim complement each other. Saint Peter's cloak is decorated with a geometric interlace border. The reverse of the plate displays two manganese purple bands among concentric lines in blue on a pinkish white ground. The clay body is of a reddish buff color.

This plate is one of very few works painted with dramatic close-up busts covering the entire obverse surface; it is virtually unique in its forceful and vigorous painting. It has been suggested that this piece was produced in the Tuscan center of Cafaggiolo because a few plates attributed to that city exist showing similarly dramatic close-up portraits rendered with lively brushstrokes in a saturated palette.[1] Furthermore the unusual rimless shape of the present plate appears in Cafaggiolo in the early sixteenth century.[2] Faenza is more likely to be the source of this plate, however. Faentine workshops excelled, even more than those of Cafaggiolo, in vigorously rendered, lively subjects painted in an especially brilliant and saturated palette. Moreover, although used in other centers, the reverse concentric-circle design (*a calza*, like the threads of a stocking) was most common in the Faentine decorative repertory.[3] A similar sixteenth-century Faentine plate, likewise decorated with the portrait of an apostle (Saint Paul), is in the Musée de la Renaissance, Ecouen (Cluny 2975).[4]

MARKS AND INSCRIPTIONS: None.

PROVENANCE: Private collection, Switzerland; [Rainer Zietz, Ltd., London].

EXHIBITIONS: None.

BIBLIOGRAPHY: None.

CONDITION: Repainted cracks through the body in the area of the keys, rim, face, and blue background; minor chips in the rim.

No. 20, reverse

1. See, for example, a plate with the subject of Marcus Curtius attributed to Cafaggiolo and dated circa 1510–1515 in the Herzog Anton Ulrich-Museum, Braunschweig (inv. 837; J. Lessmann, *Italienische Majolika* [Braunschweig, 1979], no. 83, pl. 1), and an early sixteenth-century plate with the subject of the fall of Phaeton, also attributed to Cafaggiolo, in the Victoria and Albert Museum, London (inv. C.2082-1910; Cora and Fanfani 1982, no. 106; Rackham 1940, vols. 1, p. 109, no. 314; 2, pl. 52).
2. Cora and Fanfani 1982, no. 23.
3. See, for example, a Faentine plate of Hercules and Cerberus dated circa 1520 in the Herzog Anton Ulrich-Museum, Braunschweig (inv. 4; Lessmann [note 1], p. 98, no. 17). Interestingly, this plate's shape—rimless with small base and sloping sides—is very similar to that of the Getty Museum's piece.
4. Giacomotti 1974, pp. 60–61, no. 240.

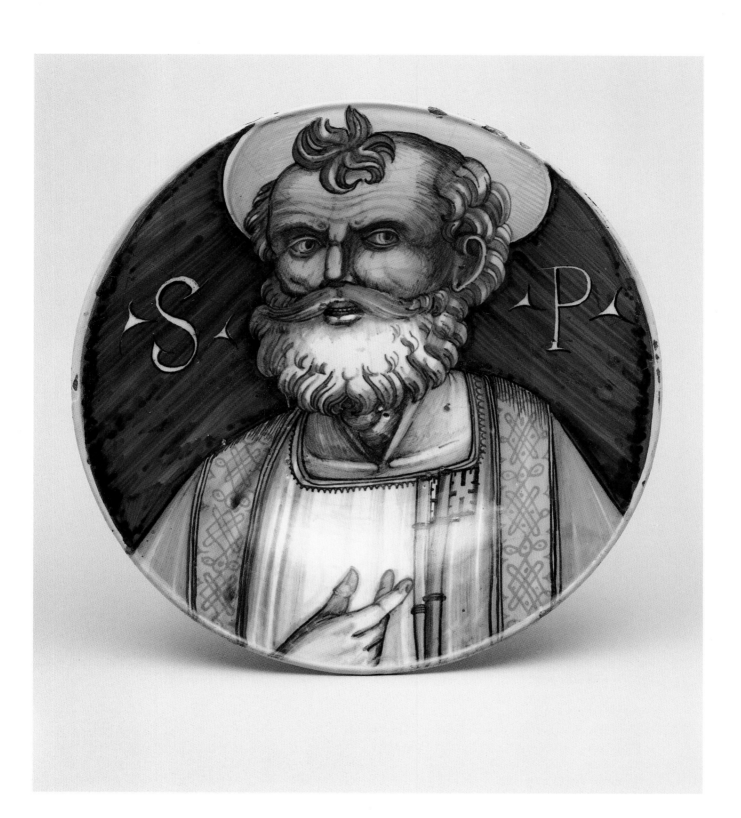

21 Alla Porcellana *Dish* (Tondino)

Attributed to Jacopo di Stefano di Filippo (1490[?]–after 1576)
Cafaggiolo, circa 1500–1525
H: 4.8 cm (1⅞ in.); Diam: 24.3 cm (9%₆ in.)
84.DE.109

No. 21, reverse

THE *CAVETTO*, OR WELL, OF THIS DEEP *TONDINO* DISplays a carrack (a broad-beamed merchant ship) within interlocking ogival quatrefoils with fleurs-de-lis and foliage sprays. The rim is decorated with four musical trophies—a harp with sheets of music, a lute with a scroll inscribed *MVSICA*, a reed pipe and wind blower, and an urn and dulcimer—divided by stylized foliage sprays and arabesques. The reverse is embellished with three sprays of scrolling foliage and marked in the center either *J[acop]o chafagguolo* or *In chafagguolo*. All of the painted decoration is executed in blue pigment on a thin, creamy, yellowish white ground. The clay body itself is of a very light yellowish buff color.

This type of delicate foliage and floral embellishment in blue on a white ground, termed *alla porcellana* decoration because it imitates Chinese porcelain ware, was much sought after in fifteenth- and sixteenth-century Italy. This work is a particularly elaborate example from a group of similarly decorated *alla porcellana tondini* executed in Cafaggiolo in the first quarter of the sixteenth century. Nine other known pieces from this group include a *tondino* decorated with a long-beaked bird (Cambridge, Fitzwilliam Museum);[1] a *tondino* with a bird holding a serpent in its beak (Faenza, Museo Internazionale delle Ceramiche inv. n. 21224/c);[2] a *tondino* with flowers (formerly in the Della Gherardesca collection, Bolgheri);[3] a *tondino* with a serpentlike dolphin (Florence, Museo Nazionale, Palazzo del Bargello inv. F.G.S. n. 13798);[4] a *tondino* with a small branch bearing two pears (Museo Nazionale, Palazzo del Bargello inv. F.G.S. n. 13799);[5] a *tondino* with a carrack (location unknown);[6] and a *tondino* with a small branch bearing three acorns (Berlin, private collection).[7] Like the Getty Museum's dish, all of these works are marked *J[acop]o chafagguolo* or *In chafagguolo* on the reverse.

G. Cora and A. Fanfani have interpreted this inscription as the signature of Jacopo Cafaggiolo, also known as Jacopo di Stefano di Filippo or, in the seventeenth century, as Jacopo Fattorini.[8] In 1498 Jacopo's father and uncle, Stefano and Piero di Filippo, moved to Florence from their native Montelupo to work in the

Cafaggiolo workshop, just north of the Tuscan capital. This workshop, which was supported by members of the Medici family, was located in a section of the Medici villa there. The brothers began signing their works with the initials *SP*, referring either to their first names or to the Medici motto, *Semper* (always). After the deaths of Piero and Stefano in 1507 and 1532, respectively, the direction of their workshop was taken up by their sons. In 1568 Jacopo di Stefano is mentioned in documents as sole director.[9] The Medici patronage in Cafaggiolo enabled the royal potteries there to produce some of the most elegant wares of the early sixteenth century.

It is indeed likely that Jacopo painted the Getty Museum's *tondino*, because the elegantly painted *alla porcellana* decoration, exactly measured to fit the dimensions and circular form of the piece, conforms with the decoration on other works both signed by and attributed to the artist.[10] The interpretation of this *tondino*'s inscription, however, is debatable. It is possible that the first word, a large *J* or *I* surmounted by what appears to be a small circle, could signify *in*, since various plates from Cafaggiolo exist, many with *alla porcellana* decoration, whose reverses clearly bear the inscription *In chafagguolo*.[11] Yet according to the norms of contemporary paleography, the word *in* should have been abbreviated by means of an *i* surmounted by a straight or wavy line, not a circle. On all of the examples cited above, moreover, the orthography of the inscription—as well as the decoration—varies considerably from that on the Museum's *tondino*.

That the first word signifies *Jacopo* is likewise un-

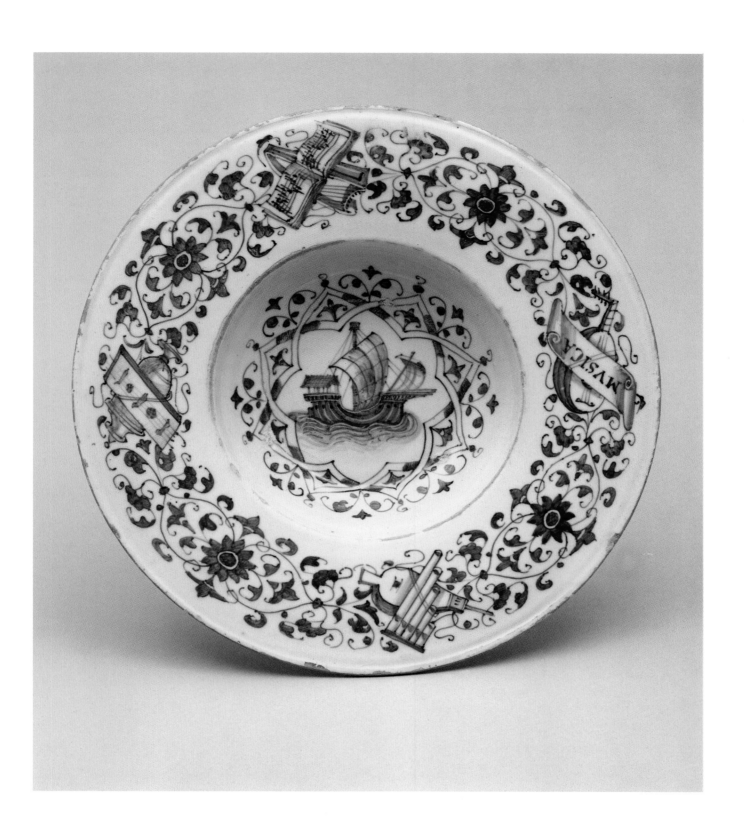

certain, since the name would normally have been abbreviated *Jac⁰* or *Jap⁰*, as it is on Jacopo's signature piece, a plate with the subject of Judith and Holofernes in the Victoria and Albert Museum, London.[12] The orthography on the Getty Museum's *tondino*, as on all dishes from this group, is very similar to that on Jacopo's Judith and Holofernes plate, however. Moreover the Judith plate and all of the *tondini* from the *alla porcellana* group are datable to the first quarter of the sixteenth century. If the Museum's *tondino* was not executed by Jacopo di Stefano di Filippo, it is curious that its artist apparently disappeared from Cafaggiolo around 1525 (more than fifty years before Jacopo's death), although it is possible that he simply died or moved to another center around that year.

To complicate matters further, a plate with the subject of the sacrifice of Abel in the British Museum, London,[13] is clearly inscribed on the reverse *Jn chafaggiuolo*, with the *J* surmounted by a small circle between two triangles. The meaning of the marks above *Jn* are not known. In a letter written in Cafaggiolo in 1521 from one Giovanni Francesco Zeffi to Francesco da Empoli, one finds the abbreviation *jᵃ lettera* for *una lettera*.[14] Could *j⁰* also have signified *one*?

Although the Museum's *tondino* can be cautiously attributed to Jacopo di Stefano di Filippo, the interpretation of its reverse inscription must remain open to further, and one would hope more conclusive, research.

MARKS AND INSCRIPTIONS: On reverse, *J[acop]o chafagguolo* or *In chafagguolo* in blue.

PROVENANCE: Charles Loeser, Torri Gattaia (sold, Sotheby's, London, December 8, 1959, lot 55); Robert Strauss, London (sold, Christie's, London, June 21, 1976, lot 19); [Rainer Zietz, Ltd., London].

EXHIBITIONS: None.

BIBLIOGRAPHY: Cora and Fanfani 1982, p. 66, fig. 48; H. Morley-Fletcher and R. McIlroy, *Christie's Pictorial History of European Pottery* (Englewood Cliffs, N.J., 1984), p. 44, fig. 1.

CONDITION: Very small chips and slight rubbing on the inner and outer borders of the rim; three stilt marks in the well.

1. *A Very Choice Collection of Old Italian Maiolica . . . the Property of M. Damiron, Lyons*, sale cat., Sotheby's, London, June 16, 1938, lot 74; Chompret 1949, vol. 2, fig. 54; Bellini and Conti 1964, ill. p. 75; Cora and Fanfani 1982, no. 43.

2. Cora and Fanfani 1982, no. 44; Bojani et al. 1985, no. 389.
3. Bellini and Conti 1964, ill. p. 75; Liverani 1960, fig. 13; Cora and Fanfani 1982, no. 51.
4. G. Conti, *Catalogo delle maioliche: Museo Nazionale di Firenze, Palazzo del Bargello* (Florence, 1971), no. 483; Cora and Fanfani 1982, no. 53; G. Liverani, *Italian Maiolica*, Masterpieces of Western and Near Eastern Ceramics, vol. 5 (Tokyo, 1980), no. 42.
5. Conti (note 4), no. 484; Cora and Fanfani 1982, no. 58.
6. In Cora and Fanfani 1982 (no. 60), it is mistakenly stated that this work is in storage at the Museo Nazionale, Palazzo del Bargello, Florence.
7. Sale cat., Christie's, London, April 12, 1976, lot 175.
8. Cora and Fanfani 1982, p. 66, no. 48.
9. Ibid., pp. 19, 171.
10. See, for example, the reverse of the artist's signature plate, cited below (note 12).
11. Cora and Fanfani 1982, nos. 47, 57, 61, 63, 65, 72, 99, 102, 114, 129.
12. Rackham 1940, vols. 1, no. 306; 2, pl. 51; Cora and Fanfani 1982, p. 67, no. 50.
13. Wilson 1987, no. 130.
14. G. Guasti, *Di Cafaggiolo e d'altre fabbriche di ceramiche in Toscana* (Florence, 1902; reprint, Bologna, 1973), reprinted in Cora and Fanfani 1982, p. 2 of documents.

22 Lustered Display Plate with Female Bust (Piatto da Pompa)

Deruta, circa 1500–1530
H: 8.8 cm (3½ in.); Diam: 42.8 cm (16⅞ in.)
84.DE.110

THE CENTER OF THIS BLUE AND GOLD LUSTERED PLATE displays an idealized bust of a young woman in profile wearing a winged headdress and tied bodice; the background is decorated with a vertical scroll and a floral spray. The whole is surrounded by a garland and an *a quartieri* (quartered or sectioned) rim of alternating scale patterns, formal foliage, and radiating bands. The reverse is painted with a transparent lead glaze, a less precious medium than the tin glaze used for the obverse. Before the first firing, two holes were pierced through the foot ring, from which this plate was probably suspended for display. In their haste, glaze painters apparently often failed to consider the position of the pierced holes when painting scenes. The present plate, for example, would hang askew if suspended from its foot-ring holes.

The scroll inscription—*VIVIS ERO VIV[U]S E MORTV[U]S ERO VIV[U]S* (when alive, I shall be among the living, and when dead, I shall be among the living)[1]—may be a statement of undying love;[2] a memento mori signifying the patron's eternal love for a woman who has died, depicted as the figure in profile;[3] or a *vanitas* subject (the transitory nature of life had been a dominant theme in Italian art since the Middle Ages).[4]

Idealized female images like the one on this plate were clearly influenced stylistically and iconographically by the work of painters such as Perugino (circa 1450–1523) and Pinturicchio (circa 1454–1513), who came from Umbria, the region in which Deruta is located. These classicizing busts, often nearly identical in pose and appearance, were presumably copied from a workshop's stock repertory. The ceramists no doubt copied a given image from a drawing or print tacked to the studio wall, as is illustrated in Cipriano Piccolpasso's maiolica treatise (see Introduction, fig. 5). It is also possible that several glaze painters shared a popular image. The model drawing or engraving could have been copied freehand or used as a template for the decoration. The cartoon used as a template was likely either pricked with holes through which the ceramists forced a dark powder onto the ceramic surface (a technique known as pouncing) or else traced with wet glaze and then pressed against the plate.

Given the often formulaic nature of the busts and rim embellishments, Derutan potteries probably turned out these works at a fast pace. The Museum's plate is a particularly fine and beautifully rendered example, however. The young woman is shown in a self-assured pose, with her chin up. The modeling of her face is especially subtle, and an outline of blue glaze delicately sets off her head and the banderole from the background.

Plates very similar to this one—with *a quartieri* rim decoration, a vertical scroll, and a female figure in profile adorned with unusual headdress and tied bodice—include one in the Musée de la Renaissance, Ecouen (Cluny 2449);[5] another in the Musée du Louvre, Paris (inv. OA 1238);[6] a third sold at auction in Milan;[7] and a fourth, unlustered, formerly in the Pringsheim collection, Munich.[8] There are a number of plates of the same type, several of which are closely related to the Getty Museum's example.[9]

MARKS AND INSCRIPTIONS: On scroll, *VIVIS ERO VIV[U]S E MORTV[U]S ERO VIV[U]S.*

PROVENANCE: R. W. M. Walker, London (sold, Christie's, London, July 25, 1943, lot 73); Adda collection, Paris; sold, Christie's, London, November 20, 1967, lot 87; [Rainer Zietz, Ltd., London].

EXHIBITIONS: None.

BIBLIOGRAPHY: Rackham 1959, p. 143, no. 354b, pl. 231; H. Morley-Fletcher and R. McIlroy, *Christie's Pictorial History of European Pottery* (Englewood Cliffs, N.J., 1984), p. 52, fig. 7.

CONDITION: Chips along the rim and base.

1. B. Rackham, however, has posited that the inscription should be read *Vivis ero vivus et mortuis ero vivus* (alive I shall be among the living, and alive I shall be among the dead); see Rackham 1959, p. 143, no. 354b, pl. 231. Since glaze painters often did not compose and possibly did not even understand the words they copied for inscriptions, both the abbreviated forms and the meaning of this phrase must be considered open to interpretation.
2. Like that expressed in the amorous inscription *Sogie tovesero perfihivivo epo[i]lamorte* (I will be subject to you as long as I live and even after death) on a basin in the Corcoran Gallery of Art, Washington, D.C. (Watson 1986, p. 78, no. 28).
3. The memento mori theme also appears explicitly on maiolica plates; see, for example, a lustered *tondino* of circa 1525 attributed to the workshop of Maestro Giorgio Andreoli in the Ringling Museum of Art, Sarasota (C. Duval and W. J. Karcheski, *Medieval and Renaissance Splendor*, exh. cat. [Ringling Museum of Art, Sarasota, 1983], pp. 91–92, no. 82).

4. Other Derutan plates with similar female busts and similar inscriptions concerned with the transience of life include two formerly in the Adda collection, Paris: one inscribed *Um bel morire tuta la vita onora* (a beautiful death makes honorable a whole life) and the other inscribed *Non e si vago e fiore che no[n] i[n]bia[n]ca o cassca* (no flower is so fair that it does not fade or fall); see Rackham 1959, nos. 354, 344. This concern may well have been influenced by the plague, a constant menace in early Renaissance Italy that had at one point reduced the population of certain centers by half.

5. Giacomotti 1974, no. 516; E. Sarasino, *Le maioliche di Deruta* (Milan, 1924), p. 61, pl. 52.

6. Giacomotti 1974, no. 586.

7. Sale cat., Finarte, November 21–22, 1963, pl. 80, lot 158.

8. Falke 1914–1923, vol. 1, no. 124, pl. 68.

9. See Chompret 1949, vol. 2, figs. 200, 203–207, 820, 823, 824; Giacomotti 1974, nos. 517, 582–585, 587.

No. 22, reverse

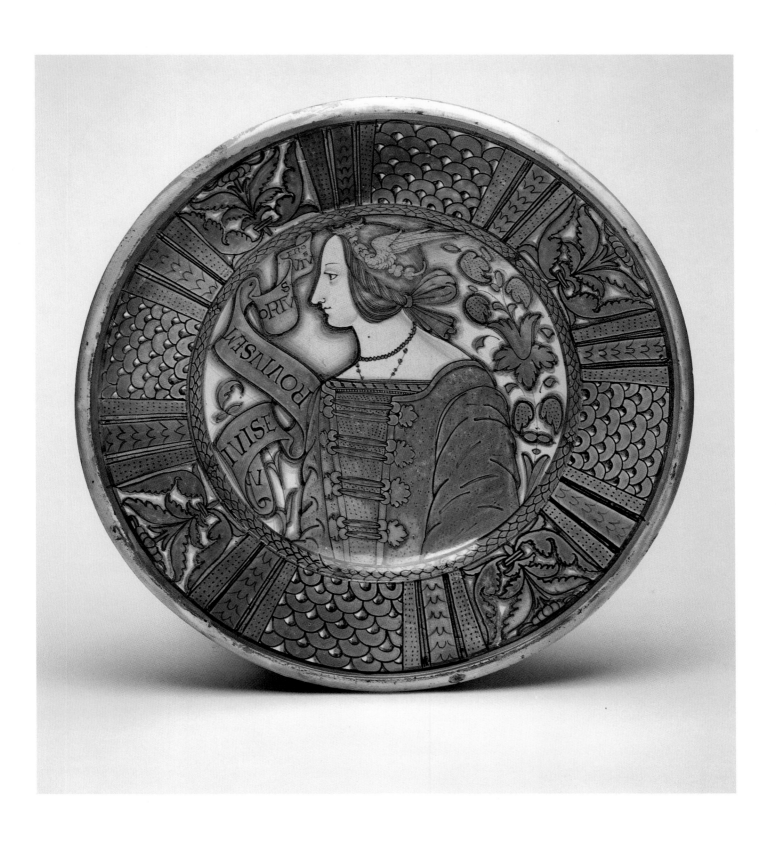

23 Lustered Armorial Plate

Workshop of Maestro Giorgio Andreoli
Gubbio, 1524
H: 7.3 cm (2⅞ in.); Diam: 39.9 cm (15¹¹⁄₁₆ in.)
84.DE.111

THE WELL OF THIS BRILLIANTLY LUSTERED PLATE displays a shield bearing the coat of arms of the Vigeri family of Savona.[1] The wide rim is decorated with four heart-shaped motifs interspersed with four dolphins, all surrounded by leaf scrolls. The gold and ruby luster embellishment fills in the blue background decoration, which is accented with green and black. Four large and four small foliate scrolls in gold luster decorate the reverse, which is inscribed in the center M^o G^o 1524, also in gold luster, all on a pinkish white ground.

The inscription M^o G^o refers to the workshop of Maestro Giorgio Andreoli of Gubbio. Born near Lake Maggiore in the late 1470s, Andreoli moved around 1490 to Gubbio, in central Italy, where he became director of an active maiolica workshop and was granted citizenship and exempted from paying taxes and duties by the duke of Urbino. In 1519 Pope Leo X renewed Andreoli's exemptions "in consideration of the honor which redounds to the city . . . and in consideration of [his wares'] great usefulness and profitableness in revenue."[2]

The Hispano-Moresque products that served as models for Italian lusterware display predominantly blue and gold or monochrome decoration, color schemes imitated in Deruta. Lusterware from Gubbio, however, is distinguished not only by its characteristic red, gold, or silver iridescence but also by the vibrant polychrome decoration upon which the lusters were fired. In addition to applying the metallic lusters that appeared after a final reduction firing (that is, in a kiln atmosphere rich in carbon monoxide), it is not known whether Andreoli also applied the polychrome decoration of the second firing to the luster products bearing his mark. Because of his great skill in the elusive luster technique, he was frequently engaged to luster the wares of other workshops, including objects painted by famed artists from other centers such as Francesco Xanto Avelli of Rovigo, who worked in Urbino. Indeed, after adorning the works of other masters with his luster, Andreoli often inscribed these works with his own mark.[3]

This lustered plate is one of six known pieces from a Vigeri family service, including two in the National Gallery of Art, Washington, D.C.;[4] one formerly in the Robert de Rothschild collection, Paris;[5] one in the Cleve-

No. 23, reverse

land Museum of Art (inv. 43.56);[6] and one in the Hetjens-Museum, Düsseldorf.[7]

MARKS AND INSCRIPTIONS: On reverse, at center, M^o G^o 1524.

PROVENANCE: Sold, Sotheby's, London, November 21, 1978, lot 41; [Cyril Humphris, London]; [Rainer Zietz, Ltd., London].

EXHIBITIONS: None.

BIBLIOGRAPHY: Sotheby's, London, November 21, 1978, lot 41.

CONDITION: Small glaze fault on the inside of the rim.

1. Information on this family is meager. We know that a certain Marco Vigerio was born in Savona in 1446. A cardinal bishop and learned humanist, Vigerio was the grandnephew of Francesco della Rovere (who became Pope Sixtus IV in 1471) and patron of Saint Francis of Paola. Although Vigerio died in 1516, eight years before this plate was made, it is likely, though not certain, that he belonged to the family that either ordered or was the recipient of the fine table service to which it belongs (G. Moroni, *Dizionario di erudizione storico-ecclesiastico* [Venice, 1860], pp. 97–98; D. R. Campbell, in *New Catholic Encyclopedia* [Washington, D.C., 1967], under "Vigerio").
2. Liverani 1960, p. 46.
3. A plate in the Petit Palais, Paris, provides at least one example of a work that was not only lustered but also painted by Andreoli or someone in his workshop; this piece is signed in unlustered blue (C. Join-Dieterle, *Musée du Petit Palais: Catalogue de céramiques I* [Paris, 1984], pp. 172–173, no. 54).

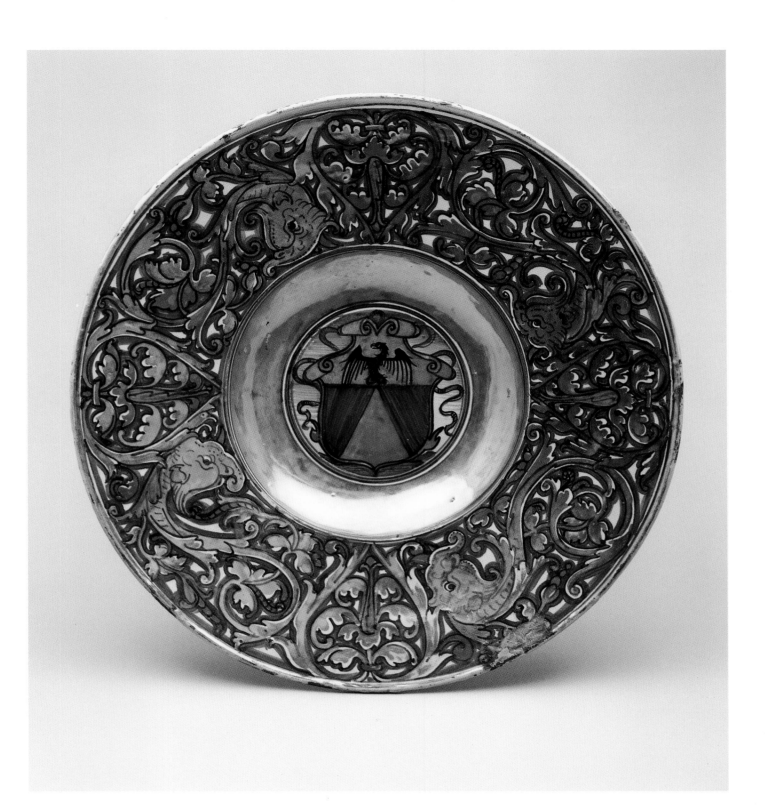

4. Widener Collection inv. c-56, c-57; see D. Shinn, *Maiolica* (Washington, D.C., 1982), nos. 31, 32.

5. Ballardini 1933–1938, vol. 1, no. 146.

6. Inscribed *W* or *M* on the rim; E. Molinier, *La collection Spitzer* (Paris, 1892), vol. 4, no. 160 bis; B. Rackham, *Italian Maiolica*, Catalogue of Pottery and Porcelain in the Collection of Otto Beit, vol. 2 (London, 1916), no. 807; Ballardini 1933–1938, vol. 1, no. 147; J. Rothenstein, "Shorter Notices: Two Pieces of Italian Pottery," *Burlington Magazine* 85 (August 1944), p. 205, pl. B; *Bulletin of the Cleveland Museum of Art* 31 (January 1944), p. 11 (right).

7. Formerly in the museum at Trèves; Rothenstein (note 6), p. 205, pl. A; A. Klein, *Fayencen Europas* (Braunschweig, 1980), p. 133, fig. 140.

24 Cylindrical Jar with Lame Peasant (Albarello)

Cylindrical Jar with Woman and Distaff (Albarello)

Faenza, circa 1510
H: 24.8 cm (9¾ in.); Diam (at lip): 12.9 cm (5¹⁄₁₆ in.);
max. Diam: 15.9 cm (6¼ in.); 16.8 cm (6⅝ in.)
84.DE.112.1–2

THE CYLINDRICAL BODIES OF THESE TWO CONTAINERS are painted in tones of orange, blue, green, and yellow with single figures—on the first a lame peasant, possibly a beggar, with a crutch holding a ceramic jug, and on the second a woman with a distaff beside three fighting geese—within panels bordered by blue lines. The upper right corner of each figurative panel is painted with orange rays, and the back of each jar is inscribed with a *B* surmounted by an *o*. Decorative geometric patterns run around the shoulder and base of each *albarello*.

These jars belong to a set of twenty known *albarelli* inscribed *B* or *Bᵒ* on the reverse. On the basis of the inscription, these works were formerly attributed to the Sienese workshop of Maestro Benedetto.[1] Their style, however, differs considerably from that of other known works by this artist. Moreover they are more convincingly attributed to a Faentine rather than a Sienese workshop, since their distinctive geometric motifs, the vigorous modeling of the figures, the saturated blue, orange, yellow, and green palette, and the shiny glazes are characteristic of Faenza. Also, as one scholar has pointed out, the carefully rendered decoration on the jug held by the lame peasant is typical of late fifteenth-century Faentine *boccali*.[2]

Marks like this *Bᵒ* would normally indicate the workshop in which the pieces were executed or possibly the person who commissioned the wares. It has been suggested that the *B* or *Bᵒ* mark might refer to the names *Betini* and *Bolognesi*, which are inscribed on the hexagonal tiles in the Cappella San Sebastiano of San Petronio, Bologna.[3] Aside from their common Faentine origin[4] and their similar inscriptions, however, there is no indication that the San Petronio floor and the *B/Bᵒ albarelli* were produced by the same hand or even in the same workshop. Interestingly, another Faentine work—a small bowl filled with sculpted fruit in the Musée National de Céramique, Sèvres (inv. 4655)[5]—bears the same *Bᵒ* mark on its reverse but is clearly the work of a different

artist than that of the Getty Museum's *albarelli*. If these Faentine marks could be linked (although there is no evidence that would allow one to do so with any certainty at present), might they have been commissioned by the same early sixteenth-century collector of Faentine maiolica? Recently, an attempt was made to link the *B/Bᵒ* set with ceramics made at Castelli d'Abruzzo.[6] This proposition is based on the similarity between the drug jars' form, palette, and decorative motifs and those of works of the "Orsini-Colonna" typology, which have been newly and convincingly given to Castelli.[7] At present this new attribution of the *albarelli*, although enticing, appears tenuous and unpersuasive, and more evidence would be necessary to supplant a Faentine attribution with a Castellan one.[8]

The twenty vessels from this *B/Bᵒ* set are clearly the work of different hands, since they vary both in style and sophistication. The Museum's *albarelli* can be considered among the most adroitly rendered of the group. Another feature distinguishing these jars is their size, according to which the works can be roughly divided into two sets. Each piece in the first group, including fifteen of the twenty pieces, is smaller (approximately twenty to twenty-two centimeters high) and can be characterized by predominantly amorous or erotic subjects. The consistency of subject matter, with the frequent occurrence of cupids and other love imagery, suggests an intentional thematic program for this set of jars. The subjects depicted include a cupid holding a pierced heart and a blindfolded cupid (Washington, D.C., Corcoran Gallery of Art inv. 26.400, 26.404);[9] a cupid holding a rope (Cologne, Kunstgewerbemuseum E 1921);[10] a cupid leading a dog on a leash (Paris, Musée du Louvre inv. OA 2629);[11] a cupid with a violin and a cupid bearing a tree trunk and rope (formerly in the Peter Harris collection, London);[12] a cupid with a drum and one with a horn and skull (formerly in the Pringsheim collection, Munich);[13] a female figure;[14] a woman, possibly Temperance, holding a wine cup and pitcher;[15] a youth holding a shield and banner and another holding a pierced heart and standing beside a burning tent (Berlin, private collection);[16] a woman lifting her skirt to expose her sex (Baltimore, Walters Art Gallery inv. 48.2234);[17] a woman lifting her skirt to a winged phallus (Hamburg, Museum für Kunst und Gewerbe inv. 1959.151);[18] and a man holding a small sphere facing a woman whose right foot rests on a larger sphere and who holds an urn with flames (Naples, Museo Nazionale della Ceramica "Duca di Martina" inv. 955).[19]

The drug jars in the second group are larger (approximately twenty-four to twenty-five centimeters

high) and fewer in number. This group includes the Museum's two jars and three *albarelli* in the Louvre (inv. OA 7390, OA 6306, OA 7391) decorated with the angel of the Annunciation, a youth bearing an animal on his shoulders, and Prudence holding a compass and mirror.[20]

Lacking further evidence, any attempt to establish a thematic program linking the various jars from the *B/B°* group must be considered hypothetical. R. Drey has suggested that the set or sets might portray the "vicissitudes, tribulations and temptations to which the human race is subject."[21] If so, the woman with distaff could be Clotho, one of the three Fates, spinning the thread of human destiny, and the lame man could symbolize old age or infirmity.

For the larger jars a possible religious theme has been suggested.[22] In the upper right-hand corner of the scenes on all five jars from this second group, rays emanate from the sky. These rays appear on only one of the smaller *albarelli*, however.[23] Similar rays decorate various contemporaneous luster dishes from Deruta and may signify God's benediction on the subject.[24] The subjects of the larger jars include, in addition to the scene of the Annunciation, the figure of Prudence, who represented one of the four cardinal virtues adopted by the Church to teach moral lessons. The figure of a youth bearing an animal on his shoulders might represent Abel, younger son of Adam, who offered God a lamb from his flock. The figures on the final two *albarelli* from this group, those in the Museum's collection, are somewhat more problematic, since at first glance their subjects, dressed in contemporary peasant clothes, appear to be genre or allegorical figures.[25] They may depict Adam and Eve after the expulsion from Eden, however. Not only does the painted landscape seem barren, but the fighting geese might refer to the world's grief and discord after the Fall. Adam and Eve are occasionally depicted at their toil after the expulsion, Adam with a spade or hoe to work the barren land and Eve, now ashamed of her nudity, with a distaff to weave her clothes.[26] Could the peasant's crutch be a liberal interpretation of Adam's hoe?

Not the rarest of subjects on maiolica ware, the theme of Adam and Eve after the expulsion appears, for example, on four plates from Urbino of around the middle of the sixteenth century.[27] These painted scenes copy a curious print attributed to the Bolognese artist Amico Aspertini (1474/75–1552), in which the biblical images of the tree of knowledge, the expulsion from paradise, life after the expulsion, and the sacrifice of Cain are conflated.[28] Like other contemporary representations, the print depicts the despondent Eve with a distaff and Adam with a hoe. Although the man with a crutch on the Mu-

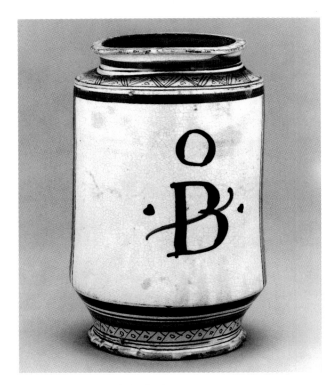

No. 24 (84.DE.112.1), back view

ANTONIO POLLAIUOLO (Italian, 1433–1498). *Adam*, circa 1470. Pen and wash on paper, 28 × 18 cm (11 × 7 1/16 in.). Florence, Gabinetto Disegni e Stampe degli Uffizi 95F. Photo courtesy Uffizi.

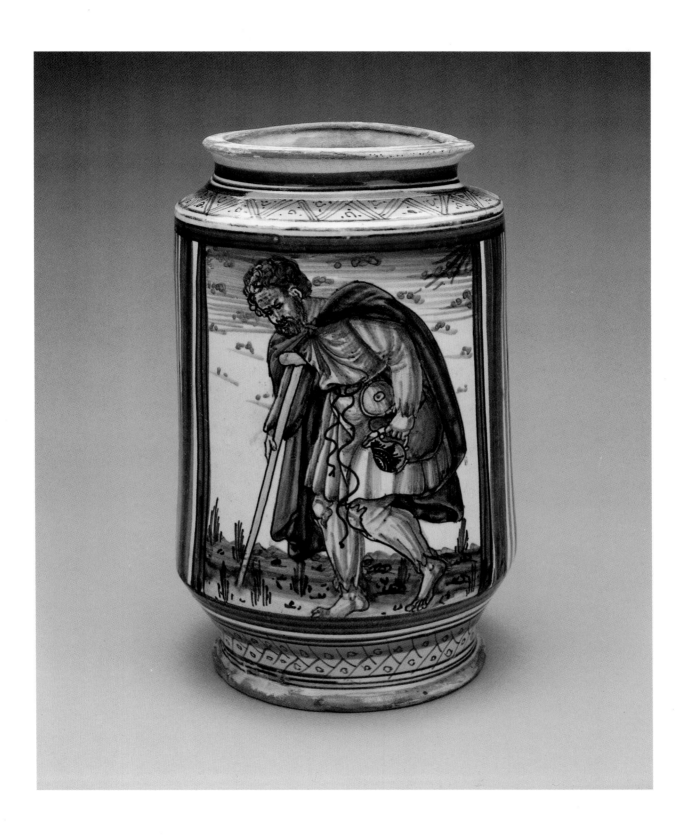

seum's jar suggests an allegorical representation of old age or infirmity rather than Adam, who is usually depicted as youthful, Aspertini and his maiolica copyists portrayed Adam in a similar manner: old and bearded. Whether one can establish a biblical theme for the Getty examples must be the subject for further research.

In a broader context the distaff, an instrument for spinning wool and therefore of domestic labor, was a conventional attribute of the industrious, rectitudinous wife in the sixteenth century and commonly appears in female portraiture and allegorical representations.[29] It was also used in a negative context as a symbol of domestic discord.[30] In sixteenth-century European art and literature, moreover, spinning represented erotic activities,[31] and an erotic interpretation of this jar's image might connect this work with the smaller set of *albarelli*. The set or sets to which these larger jars belong could, however, be incomplete, and discovery of missing pieces and possible print sources for the painted images might well clarify the iconography of the individual subjects as well as a possible thematic connection among the jars.

Although probably not from the same set, an uninscribed *albarello* in the Cleveland Museum of Art (inv. 40.12) may well have been influenced by, or produced in the same workshop as, the *B*- or *B°*-inscribed jars. This *albarello*, although larger (about thirty centimeters high), is of comparable shape and displays ornamentation similar to that on the *B/B° albarelli*; it is decorated with geometric patterns around the shoulder and base and with the figure of Venus (after an engraving by Marcantonio Raimondi of the birth of Venus, which may have been inspired by a print by Jacopo de' Barbari) in a panel on the body.[32]

MARKS AND INSCRIPTIONS: On back of each jar, *B°*.

PROVENANCE: J. Pierpont Morgan, New York; Joseph E. Widener, Elkins Park (sold, Samuel T. Freeman and Co., Philadelphia, June 20, 1944, lots 326, 327); Dr. Bak, New York (sold, Sotheby's, New York, December 7, 1965, lot 54); Benjamin Sonnenberg, New York (sold, Sotheby's, New York, June 5, 1979, lot 356); [Rainer Zietz, Ltd., London].

EXHIBITIONS: None.

BIBLIOGRAPHY: B. Rackham, "A New Chapter in the History of Italian Maiolica," *Burlington Magazine* 27 (May 1915), p. 50; *Inventory of the Objets d'Art at Lynnewood Hall, Elkins Park, Estate of the Late P. A. B. Widener* (Philadelphia: privately printed, 1935), pp. 67, 68; Bellini and Conti 1964, p. 100, pls. A, C; J. Rasmussen, *Italienische Majolika* (Hamburg, 1984), pp. 84, 86.

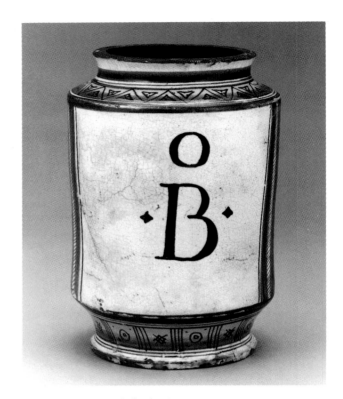

No. 24 (84.DE.112.2), back view

ANTONIO POLLAIUOLO. *Eve*, circa 1470. Pen and wash on paper, 27.5 × 18.5 cm (10 13/16 × 7 1/4 in.). Florence, Gabinetto Disegni e Stampe degli Uffizi 97F. Photo courtesy Uffizi.

CONDITION: (84.DE.112.1) Small chips on the rim and base; (84.DE.112.2) restorations on the base, bottom, and rim, and some painted areas (upper right corner of sky and woman's apron and right sleeve).

1. O. von Falke, in B. Rackham, "A New Chapter in the History of Italian Maiolica," *Burlington Magazine* 27 (May 1915), p. 50.

2. Watson 1986, p. 46. One must bear in mind, however, that although they belong to a Faentine typology, these stout jugs with a central medallion encircled by a "ladder" motif were produced throughout central Italy in the late fifteenth century (see, for example, P. Berardi, *L'antica maiolica di Pesaro dal XIV al XVII secolo* [Florence, 1984], figs. 24, 79, 81 [attributed to Pesaro]; Hausmann 1972, no. 80 [attributed to Florence]; G. Gardelli, *5 secoli di maiolica a Rimini* [Ferrara, 1982], figs. 54, 71–75, 79, 82, 83 [attributed to Rimini]; Bojani et al. 1985, nos. 170–174 [attributed to the general region of Romagna]).

3. G. Bolognesi, "Di alcune maioliche nella collezione Giovanni Bolognesi," *Faenza* 41, no. 1/2 (1955), p. 8; however, the existence of a Betini factory in Faenza was questioned by C. D. E. Fortnum as early as 1896, when he noted that the inscription *BE FAVE [N]T [I]CIE* following the names of three women (Chornelia, Zetila, and Xabeta) might more convincingly be read *bella Faentina* (beauty of Faenza) (*Maiolica* [Oxford], p. 254). This pavement is illustrated in Liverani 1960, pl. 12.

4. The tile floor and B/B° *albarelli* all display the typical Faentine decorative repertory, although the floor embellishment is of an earlier type. Dated either 1487, according to an inscription on one of the floor tiles, or 1492, according to the building history of the chapel (Berardi [note 2], pp. 18–19, n. 21), roughly twenty years before the jars were made, the San Petronio floor tiles are painted with a remarkably wide variety of fifteenth-century severe-style ornament, such as the peacock-feather, Persian palmette, and Gothic leaf motifs. The jars' painted scenes, however, are examples of the early *istoriato* transition to the *stile bello* of the first quarter of the sixteenth century.

5. Giacomotti 1974, no. 289.

6. C. Fiocco and G. Gherardi, "Sulla datazione del corredo 'Orsini-Colonna' e sul servizio 'Bo,'" *Faenza* 72, no. 5/6 (1986), pp. 290–294, pls. 94–98.

7. See C. de Pompeis et al., "Nuovi contributi per l'attribuzione a Castelli della tipologia Orsini-Colonna," *Museo delle Genti d'Abruzzo: Quaderno 13* (November 1985), pp. 3–36.

8. One is afforded the unusual opportunity to compare closely the B/B° and Orsini-Colonna typologies at the Neapolitan Museo Nazionale della Ceramica in the Villa Floridiana. Here on a single shelf (room 18, case 131) one finds a B-inscribed *albarello* from the Faentine set between two works of the Castellan Orsini-Colonna type. Immediately, their differences are more striking than their similarities.

9. Watson 1986, pp. 46–47, nos. 8–9.

10. B. Klesse, *Majolika* (Cologne, 1966), p. 147, no. 270.

11. Giacomotti 1974, p. 62, no. 245.

12. B. Rackham, "La raccolta Beit di maioliche italiane," *Bollettino d'arte* 25, no. 8 (1932), p. 343, fig. 4; the *albarello* with a cupid bearing a tree trunk is now in a private collection, Florence (see G. Conti, *L'arte della maiolica in Italia*, 2nd edn. [Milan, 1980], no. 142).

13. Falke 1914–1923, vol. 1, nos. 86–87, pl. 51.

14. This work is cited as being in the Grassimuseum, Leipzig, in J. Rasmussen, *Italienische Majolika* (Hamburg, 1984), p. 84, although in correspondence with the Getty Museum dated June 17, 1986, the Leipzig museum shows no record of the object.

15. Rasmussen (1984) located this jar in the Museo Civico, Bologna (pp. 84; 86, n. 13), although it appeared in a 1987 Florentine sale (Semenzato, November 11, lot 305). See also G. Ballardini, *Le maioliche della collezione Ducrot* (Milan, [193-]), pl. 12; Bolognesi (note 3), pl. 3a. This figure is based on an engraving by Marcantonio Raimondi entitled *Young Woman Watering a Plant* (K. Oberhuber, ed., *The Illustrated Bartsch*, vol. 27 [formerly vol. 14, pt. 2] [New York, 1978], no. 383 [292]), which in turn, because of stylistic similarities, may have been based on a print by Jacopo de' Barbari.

16. Rackham (note 1), p. 51, pls. 30–p.

17. Conti (note 12), no. 130 (incorrectly described as located in the Museum für Kunst und Gewerbe, Hamburg).

18. Rasmussen (note 14), p. 85, no. 129.

19. The subject appears to be based on a print by Marcantonio Raimondi after Francesco Francia (reprod. in Oberhuber [note 15], no. 377-1 [286]).

20. Giacomotti 1974, pp. 62–63, nos. 243, 244, 246.

21. Correspondence with the author, November 1987.

22. By L. Fusco in conversation with the author, April 1987.

23. Decorated with a cupid bearing a tree trunk and rope (see above [note 12]).

24. A. Caiger-Smith, *Lustre Pottery* (London, 1985), p. 80, pl. 23.

25. A similar image of a lame peasant embellishes a jar formerly in the Imbert collection (sale cat., Sotheby's, London, March 11, 1980, lot 38). Other examples of women with distaffs adorning maiolica objects include a *brocca* of the early sixteenth century from Rimini that sold at auction in Milan (Semenzato Nuova Geri Srl, November 5, 1986, lot 123; the figure is unconvincingly identified as "possibly Atropos") and a *crespina* of circa 1540 from Faenza, attributed to the workshop of Virgiliotto Calamelli (G. Conti, ed., *Una collezione di maioliche del rinascimento* [Milan, 1984], no. 37).

26. See, for example, three engravings by Cristoforo di Michele Robetta portraying Adam and Eve with Cain and Abel (A. M. Hind, *Catalogue of Early Italian Engravings . . . in the British Museum* [London, 1909–1910], pp. 197–198, nos. 1–3), and Antonio Pollaiuolo's pen-and-wash drawings of Adam and Eve, in the Uffizi, Florence.

27. C. Ravanelli Guidotti, "'Adamo eua' su di un istoriato al museo di Faenza e su altri simili," *Faenza* 65, no. 6 (1979), pls. 99a–b, 100a–b, 101a–b.

28. Ravanelli Guidotti has reproduced and discussed this print as a source for *istoriato* decoration (see ibid., pp. 302–311).

29. For example, Maerten van Heemskerck's *Portrait of Anna Pietersd Codde* and Cornelis Bos' engraving *The Righteous Wife*,

both illustrated in R. Grosshans, *Maerten van Heemskerck* (Berlin, 1980), pls. 4, 147.

30. See, for example, Israhel van Meckenem's *Battle for the Pants*, reproduced in R. van Marle, *Iconographie de l'art profane . . .* (New York, 1971), vol. 2, fig. 486.

31. See, for example, an anonymous northeastern Italian engraving of an allegory of sensual pleasures (J. Levenson et al., *Early Italian Engravings from the National Gallery of Art* [Washington, D.C., 1973], pp. 526–527); Barthel Beham's print *Spinning Room* (1524; M. Geisberg, *The German Single-Leaf Woodcut: 1500–1550*, ed. W. L. Strauss [New York, 1974], no. 154); and two sixteenth-century paintings of lovers by Pieter Pietersz. (K. Renger, *Lockere Gesellschaft* [Berlin, 1970], figs. 78–79). A. Stewart has pointed out that late medieval French, English, and German words for spindle could mean phallus, presumably because of their similar shapes ("The First 'Peasant Festivals': Eleven Woodcuts Produced in Reformation Nuremberg by Barthel and Sebald Beham and Erhard Schön circa 1524–1535" [unpub. Ph.D. diss., Columbia University, 1986], p. 286). Even today the Italian *filare*, "to spin wool," colloquially refers to making love or flirting (M. Cortelazzo and P. Zolli, *Dizionario etimologico della lingua italiana* [Bologna, 1979], under "fila"). Examples on maiolica objects of the distaff portrayed as a sexual instrument include a plate by Maestro Giorgio Andreoli dated 1528 in the Museo Civico, Arezzo, showing Hercules suggestively pointing a distaff at his wife, Deiamira.

32. Falke 1914–1923, vol. 1, nos. 85a–b, pl. 50 (unconvincingly attributed to the Sienese workshop of Maestro Benedetto); Fiocco and Gherardi (note 6), pl. 96a; W. M. Milliken, "Italian Majolica," *Bulletin of the Cleveland Museum of Art* 27 (March 1940), pp. 33–34. The subject and style of the panel figure together with the passages of *alla porcellana* decoration on the body relate this jar most directly to the Temperance *albarello* formerly in the Ducrot collection, Paris (see above [note 15]).

25 Cylindrical Drug Jar (Albarello)

Faenza, circa 1520–1530
H: 37 cm (14⁹⁄₁₆ in.); Diam (at lip): 12.5 cm (4¹⁵⁄₁₆ in.);
max. Diam: 16.5 cm (6½ in.)
84.DE.105

THIS TALL AND WAISTED CYLINDRICAL DRUG VESSEL IS painted with a label describing its contents, *FILONIJ P[ER]SICHI*, in dark blue, surrounded by fruit, foliate arabesques, and interlacing in yellow, ocher, dark blue, green, and white. The areas around the neck and above the base display a triangular pattern in dark blue and white, and around the shoulder is a garland in yellow, ocher, and green; all of this embellishment is painted on a light blue *berettino* ground. The white tin glaze that covers the inside of this jar is unusual; before the early sixteenth century, areas that were rarely seen, such as the undersides of plates and interiors of jars, more commonly displayed less precious lead-based glazes.

The jar's inscription is a variant of *philonium persicum* (Persian philonium), named after the first-century B.C. physician Philon of Tarsus. This pharmaceutical electuary was prepared from opium and other ingredients, including saffron, white pepper, camphor, honey of roses, and ground bloodstone, pearls, and amber. The resultant confection served to relieve pain, induce sleep, improve blood circulation, prevent miscarriages, and reduce the pain of hemorrhoids and of heavy menstruation.[1]

In place of the white tin-glaze ground characteristic of most maiolica, *berettino* works are distinguished by a lavender-gray ground embellished with delicate designs of floral and foliate sprays, arabesques, cherubs' heads, grotesques, garlands, interlacing, and trophies. These designs, referred to in contemporary documents as *gentilezze e vaghezze* (refinements and embellishments),[2] were painted mainly in cobalt blue highlighted with touches of white, although green and yellow were sometimes used for decorative emphasis, as on this *albarello*. According to G. Liverani, "in this type of ornament we find the most highly developed use of color by the artists of the Faventine school."[3]

Sherds found in Faenza and in areas to which Faentine products were exported indicate that a large number of maiolica wares decorated with wreaths, flowers, and fruit on a *berettino* ground were produced in various Faentine workshops in the third and fourth decades of the sixteenth century. Most *berettino* products were apparently employed for household purposes, because

No. 25, alternate view

these works do not often bear dates or makers' marks and very few have survived intact, being easily broken and chipped with use. This *albarello* is remarkable both for its good state of preservation and for its type, since *berettino* decoration is more common on plates[4] and is rarely found on jars and flasks.

Other *albarelli* similarly decorated with festoons and arabesques on a light blue *berettino* ground include those in the State Hermitage, Leningrad (inv. F 3087);[5] formerly in the Adda collection, Paris;[6] reproduced in F. Liverani and R. Bosi, *Maioliche di Faenza*;[7] and sold at auction in Milan.[8] The Museum's jar is distinguished by being both the tallest of these examples and the only one labeled with an inscribed banderole. An ovoid vase with similar decoration is in the Museo Internazionale delle Ceramiche, Faenza (inv. n. 21297/c).[9]

MARKS AND INSCRIPTIONS: On banderole, *FILONIJ P[ER]SICHI*.

PROVENANCE: [Stora, Paris]; Whitney Warren, New York (sold, Parke Bernet Galleries, New York, October 7, 1943, lot 448); sold, Sotheby's, London, November 22, 1983, lot 197; [Rainer Zietz, Ltd., London].

EXHIBITIONS: None.

BIBLIOGRAPHY: Sotheby's, London, November 22, 1983, lot 197.

CONDITION: Minor chips around the rim.

1. R. Drey, *Apothecary Jars* (London, 1978), pp. 202, 222; P. Borgarucci, *Della fabrica de gli spetiali* (Venice, 1567), pp. 453–454.
2. Liverani 1960, p. 40.
3. Ibid.
4. See, for example, Falke 1914–1923, vol. 2, no. 184, pl. 96.
5. Kube 1976, no. 13.
6. Rackham 1959, no. 127A; Chompret 1949, vol. 2, fig. 563.
7. F. Liverani and R. Bosi, *Maioliche di Faenza* (Faenza, 1974), pl. 10.
8. Semenzato Nuova Geri Srl, Milan, November 5, 1986, lot 89.
9. Bojani et al. 1985, p. 57, no. 110.

26 Plate with Hero and Leander (Tagliere)

Faenza, circa 1525
H: 3.8 cm (1½ in.); Diam: 44 cm (17 5⁄16 in.)
84.DE.113

THE WELL OF THIS LARGE DISPLAY PLATE (*PIATTO da pompa*) is decorated with a scene from the story of Hero and Leander in green, yellow, black, ocher, orange, grayish green, opaque white, and gray (produced by painting white on black) pigments. The wide rim is decorated with scrolling foliage, cherubs' heads, and "man-in-the-moon" motifs reserved in light blue with touches of white and cobalt blue on a *berettino* glaze ground. A central swan, possibly a maker's mark consisting of the artist's or workshop's rebus, surrounded by two concentric bands of *alla porcellana* decoration in light and dark blue and white embellishes the reverse.

The *istoriato* scene on the obverse tells the sad story of Hero, priestess of Aphrodite, who fell in love with Leander, a youth from Abydos. According to this myth, Leander would swim across the Dardanelles from Abydos to Sestos every night to visit his beloved in her tower. When Leander was drowned one night in a tempest, the despairing Hero threw herself from the tower into the sea and perished. Once thought an impossible feat, the swimming of the strait between Asia and Europe was proved possible when Lord Byron actually performed it himself and recounted it in his poem "The Bride of Abydos."

Leander is painted three times on this plate, so that his story unfolds in a continuous narrative. The tower from which Hero gazes seems to project awkwardly from the sea, evidence that the artist miscalculated the composition and attempted to rectify the error by painting over the bottom portion of the tower with blue pigment to widen the strait of water. This interesting mistake illustrates that once the artist applied pigments and glazes, imperceptible changes could be made only by completely washing off the painted scene and applying the colors anew.

In both style and color the painted decoration on this plate is similar to that on works attributed to the "Green Man." First identified in 1873, this artist was given his sobriquet because he painted his figures with yellow pigment over a light blue ground, resulting in green-toned flesh.[1] B. Rackham attributed to this artist a series of works dating from 1524 to 1550,[2] including a bowl now believed to be the work of the so-called Master of the

Bergantino Bowl.[3] It is probable that more than one artist is represented in Rackham's Green Man group.

Rackham also identified an artist he called Master C. I. after a plate inscribed with these initials in the State Hermitage, Leningrad. To this artist Rackham attributed a panel with a scene of Coriolanus and his family in the Victoria and Albert Museum, London (inv. 4277-1857), which shares stylistic and compositional elements with the Getty Museum's plate showing Hero and Leander.[4]

Also close in style is a panel with the Abduction of Helen dated 1518 in the Museo Correr, Venice, which Rackham attributed to Master Gonela.[5] The plate for which this artist is named,[6] inscribed *Gonela* on the reverse, shares with the Getty Museum's example stiff-legged figures with bulbous, "geometricized" musculature, although the figures on the Gonela plate are modeled with more sophistication and subtlety.[7]

Much confusion continues to surround the lives and activities of these maiolica artists. Whether they are one and the same master or different craftsmen working in the same Faentine workshop, or even in different centers of production, remains to be determined.

The Museum's plate forms part of a group of *piatti da pompa* that combine *istoriato* subjects with *berettino* decoration. This group includes two plates with the subject of Alexander and Diogenes (Washington, D.C., Corcoran Gallery of Art inv. 26.309,[8] and formerly in the Schlossmuseum, Berlin [inv. K1834]);[9] a plate with the Judgment of Paris (London, Victoria and Albert Museum inv. C.2110-1910);[10] and two others with the same subject (Ecouen, Musée de la Renaissance, Cluny 2436, 2438);[11] two plates with the subject of Diana and Actaeon, both of which, like the Getty Museum's plate, display a central swan with two bands of *alla porcellana* decoration on the reverse (Braunschweig, Herzog Anton Ulrich-Museum inv. 1155,[12] and Museum für Kunst und Kulturgeschichte der Stadt Dortmund, Schloss Cappenberg c6909);[13] and a plate with a scene of the Rape of Europa (Toronto, George R. Gardiner Museum of Ceramic Art).[14]

MARKS AND INSCRIPTIONS: On reverse, at center, a swan.

PROVENANCE: Henri Gautier, Paris (sold, Hôtel Drouot, Paris, May 4, 1929, lot 28); George Durlacher, Esq., London (sold, Christie's, London, April 7, 1938, lot 26); H. S. Reitlinger, London (sold by his executors, Sotheby's, London, April 27, 1959, lot 142); Robert Strauss, London (sold, Christie's, London, June 21, 1976, lot 24).

EXHIBITIONS: None.

BIBLIOGRAPHY: Chompret 1949, vol. 2, fig. 458; *Christie's Review of the Season* (London, 1976), p. 397; H. Morley-Fletcher and R. McIlroy, *Christie's Pictorial History of European Pottery* (Englewood Cliffs, N.J., 1984), p. 36, fig. 5.

CONDITION: Minor repair to the upper border; several chips in the rim.

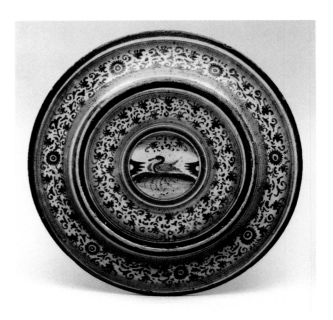

No. 26, reverse

1. C. D. E. Fortnum, *Catalogue of the Maiolica . . . in the South Kensington Museum* (London, 1873), p. 479.
2. Rackham 1940, vol. 1, pp. 99–100.
3. G. Liverani, "Fata in Faenza in la botega de Maestro Piere Bergantino," *Faenza* 27, no. 1/2 (1939), pp. 3–9.
4. For example, the figures' stiff and open-legged stance, the distant architecture of crenellated towers, and the placement of figures and objects in the foreground, middle ground, and background to move the eye back in space (see Rackham 1940, vols. 1, pp. 81–82; 2, no. 259, pl. 42).
5. Ibid., vol. 1, p. 81; Ballardini 1933–1938, vol. 1, pl. 10. Like the Getty Museum's plate, the Correr panel displays rocky crags in the foreground, crenellated architecture in the background, and drapery with regular curving folds, especially around the heads. The panel, however, is painted with shorter, more "nervous" and animated brushstrokes, and the figures appear more relaxed and less stiff than those on the Museum's plate. The Correr panel is also close in style to the Museum's Faentine dish with a scene from the *Aeneid* (see entry no. 18 above).
6. Formerly in the Damiron collection, Lyons (*A Very Choice Collection of Old Italian Maiolica . . . the Property of M. Damiron, Lyons*, sale cat., Sotheby's, London, June 16, 1938, lot 75).
7. The Gonela plate depicts the story of Caesar after a drawing of about 1516 attributed to Jacopo Ripanda in the Musée des Beaux-Arts, Lille, which in turn is a copy of a fresco of about 1509 by Girolamo Genga in the Palazzo Petrucci, Siena (Wilson 1987, p. 115, fig. 15). Several Faentine plates exist that copy this drawing, which may indeed have served as a maiolica cartoon, since the right side appears to follow a platelike curve (J. Byam Shaw, "Iacopo Ripanda and Early Italian Maiolica," *Burlington Magazine* 61 [July 1932], pp. 19–25; idem, "Una composizione di Jacopo Ripanda e tre piatti Faentini," *Faenza* 21, no. 1 [1933], pp. 3–9). This drawing and another plate from the same design are reproduced in Wilson 1987, pp. 115–117.
8. Watson 1986, pp. 48–49, no. 10.
9. Ballardini 1933–1938, vol. 2, fig. 165.
10. Rackham 1940, vol. 1, no. 297.
11. Chompret 1949, vol. 2, figs. 462, 464; Giacomotti 1974, nos. 335, 336.
12. J. Lessmann, *Italienische Majolika* (Braunschweig, 1979), p. 99, no. 19, ill. p. 29.
13. *Vieweg Collection, Brunswick*, sale cat., Rudolph Lepke, Berlin, March 18, 1930, pl. 67, lot 155.
14. Falke 1914–1923, vol. 2, pl. 94, fig. 180; J. P. Palmer and M. Chilton, *Treasures of the George R. Gardiner Museum of Ceramic Art* (Toronto, [circa 1984]), p. 26.

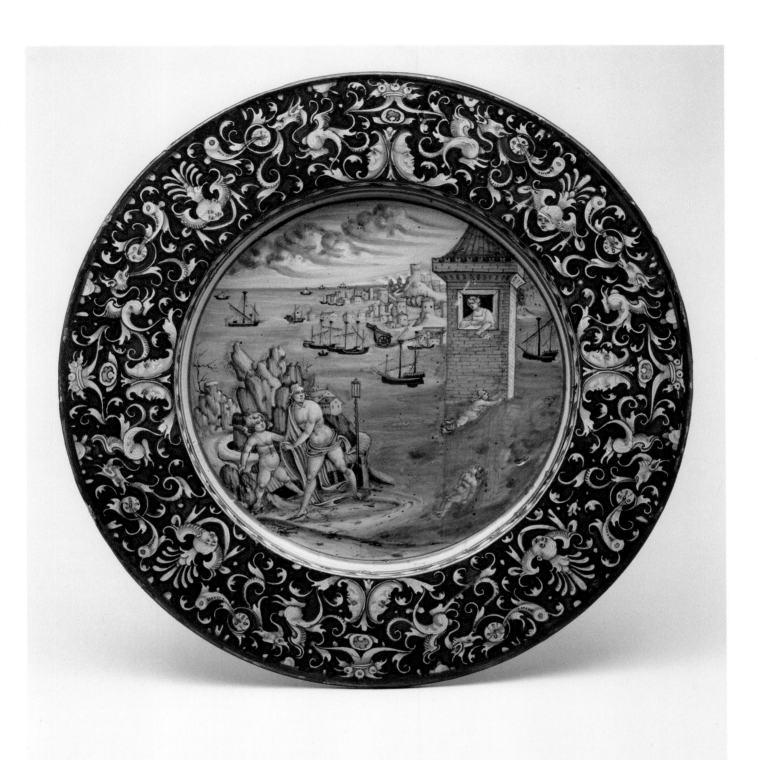

27 Molded Dish with an Allegory of Love (Crespina)

Faenza, circa 1535
H: 7.3 cm (2⅞ in.); Diam: 28 cm (11 in.)
84.DE.114

CERAMIC *CRESPINE*—FROM THE ITALIAN *CRESPA*, meaning wrinkle or ripple—were forms molded in imitation of metalwork designs which were popular from roughly the second quarter of the sixteenth century on. The shallow body of this footed *crespina* is molded with flutes that issue from a low central boss. This convex boss, surrounded by a rope motif, displays a youth in contemporary dress seated against and bound to a tree painted in ocher, yellow, and blue, heightened with white. Light blue leaves, foliate scrolls, and stylized dolphins, accented with white and reserved on alternately dark blue and ocher grounds, decorate the petal-shaped *a quartieri* panels around the boss. The reverse is glazed with the same light blue *berettino* and is painted with alternately dark blue and ocher dashes following the molded panels' shapes around the foot. This dish belongs to a group of works previously attributed to the so-called Green Man because of the artist's palette.[1] A molded dish in the same style and perhaps painted by the same artist bears the mark attributed to the workshop of Virgiliotto Calamelli of Faenza.[2]

The central figure on the raised boss probably represents an allegory of love: the young man is bound to love much as he is bound to the tree. Love portrayed in this manner was apparently a popular subject of the time. The same allegory appears, for example, in a Florentine engraving of circa 1465–1480 entitled *The Cruelty of Love*, made for the decorative cover of a woman's toilet or work box, in which a standing youth bound to a tree faces a young woman who holds his heart in her hand.[3] Moreover a lustered plate from the workshop of Maestro Giorgio of Gubbio (New York, Metropolitan Museum of Art 65.6.10) portrays a man bound to a tree confronted by a woman with a knife. Whether she intends to liberate or wound the man is unclear, but the inscription on this piece, *Medol limfamio tua: piu ch[e] [i]l morire* (your disgrace [of me?] hurts more than death), expresses a particularly painful view of love.

In contrast to the glorified images of love popular on ceramic *coppe amatorie*, the series of molded dishes to which the Getty Museum's *crespina* belongs portrays love as a bittersweet force that holds its victims captive. Other *crespine* from this group include one with the image of a

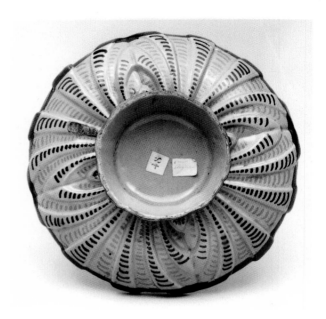

No. 27, reverse

standing youth bound to a tree (London, Wallace Collection);[4] one displaying a standing woman bound to a tree (Hamburg, Museum für Kunst und Gewerbe 1880.511);[5] a dish also showing a woman bound to a tree and another with a running cupid holding a bow (Paris, Musée du Louvre inv. N16, OA 1591);[6] three showing cupids bound to trees and another with a cupid holding a heart in his proper left hand (Ecouen, Musée de la Renaissance, Cluny 7549, 1878, 7541, 16861);[7] a molded dish likewise displaying a cupid holding a heart in his proper left hand (Faenza, Museo Internazionale delle Ceramiche inv. 21338/c);[8] one with a cupid holding a heart pierced by an arrow (Sèvres, Musée National de Céramique inv. 2490);[9] and a dish with a three-quarter image of a youth bound to a tree and pierced through the heart by an arrow (London, Victoria and Albert Museum inv. 4626-1858).[10]

One finds similarly decorated *crespine* painted with various religious, mythological, and popular subjects in British, French, American, German, and Russian collections.[11] An example that is particularly close in style is attributed to the Calamelli workshop; it displays a woman seated against a tree holding a distaff.[12] As on the Museum's dish, the central bosses of all the above-mentioned *crespine* are surrounded by rope motifs.

MARKS AND INSCRIPTIONS: None.

PROVENANCE: Prince Thibault d'Orléans, Paris (sold, Sotheby's, London, February 5, 1974, lot 30); [Rainer Zietz, Ltd., London].

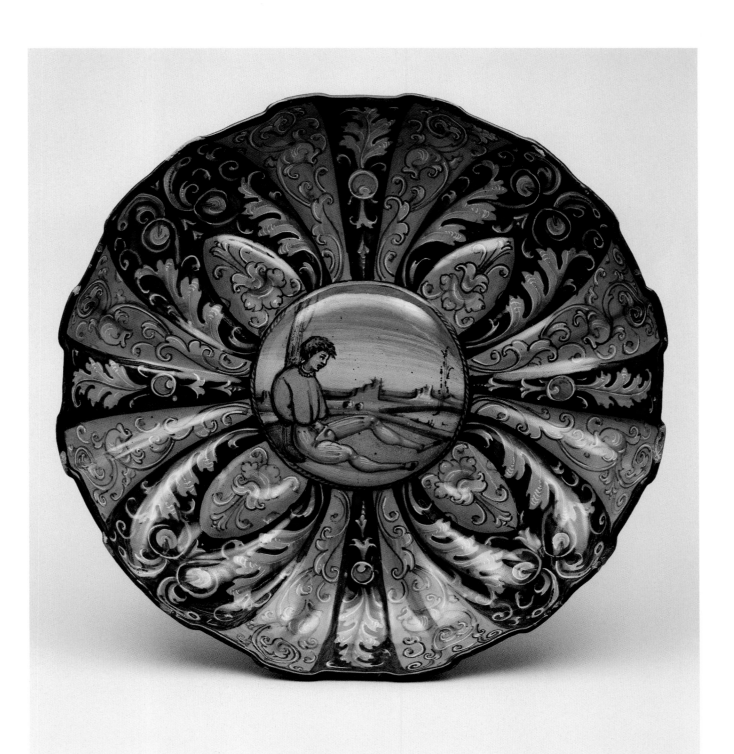

EXHIBITIONS: None.

BIBLIOGRAPHY: Sotheby's, London, February 5, 1974, lot 30.

CONDITION: Glaze chip on the underside and minor chips at the rim.

1. See entry no. 26 above for a discussion of this artist.
2. Falke 1914–1923, vol. 2, pl. 98, fig. 188.
3. A. M. Hind, *Early Italian Engraving* (London, 1938–1948), vol. 2, pl. 144, A.IV.15.
4. A. V. B. Norman, *Catalogue of Ceramics I: The Wallace Collection* (London, 1976), pp. 126–127, no. c56.
5. J. Rasmussen, *Italienische Majolika* (Hamburg, 1984), pp. 110–112, no. 72.
6. Giacomotti 1974, nos. 940, 952.
7. Ibid., nos. 942, 950, 951, 954.
8. Bojani et al. 1985, no. 542.
9. Giacomotti 1974, no. 949.
10. Rackham 1940, vols. 1, no. 301; 2, pl. 50.
11. See, for example, ibid., nos. 300, 302, 934, 935; Giacomotti 1974, pp. 306–312; Watson 1986, nos. 11, 12, 73; Hausmann 1972, no. 131; B. Klesse, *Majolika* (Cologne, 1966), nos. 279, 280; J. Lessmann, *Italienische Majolika* (Braunschweig, 1979), nos. 20–25; Kube 1976, no. 17.
12. G. Conti, ed., *Una collezione di maioliche del rinascimento* (Milan, 1984), no. 37.

28 Jug with Berettino Ground (Boccale)

Faenza, 1536
H: 32.5 cm (12 13/16 in.); Diam (at lip): 13.3 cm (5 1/4 in.);
max. W: 26 cm (10 1/4 in.)
84.DE.115

THIS JUG HAS AN OVOID BODY WITH PINCHED SPOUT and broad, ribbed handle. Three large medallions ornament the body. They depict a man, perhaps Orpheus, playing a *lira da braccio* (lyre); a musician in contemporary dress playing a lute;[1] and a bearded and turbaned old man reading a book, accompanied by the inscription *Elixeo.* Laurel garlands encircle the medallions and run down the handle. The ocher, yellow, green, black, and opaque white decoration is surrounded by a dark blue reserve set against a light blue *berettino* ground, which covers the rest of the body and consists of cherubs, dolphins, books, and foliate scrolls. Small labels inscribed with the date 1536 appear under each medallion and under the handle, and a wavy ribbon pattern embellishes the areas around the rim and base. The interior is tin glazed.

The old man labeled *Elixeo* may well be the Old Testament prophet Elisha (or Eliseus in the New Testament [Luke 4:27]). If this figure is Elisha, an incident from the prophet's life may establish a thematic connection among the three medallion figures on the jug. Before foretelling the success of their expedition against Moab to the allied kings of Israel, Jehoshaphat and Edom, Elisha asked for a minstrel to play a stringed instrument. The music induced an ecstatic state in which the prophet gave his oracle (2 Kings 3:15ff.). This musical association among what appear to be a popular, a mythological, and a biblical figure in the medallions might suggest that the patron for whom the jug was executed was a lover of music or perhaps a musician himself.

This jug is rare because of its large size, unusual form, and exceptionally beautiful glaze painting. There are very few known vessels from the large group of Faentine *berettino* wares with comparably elaborate grotesque decoration. The closest parallel is a pair of cylindrical jars in the Victoria and Albert Museum, London (inv. C.2108-1910, C.2107-1910).[2] Both of these jars are decorated on either side with a polychrome subject in a circular medallion reserved against a *berettino* ground of cherubs, dolphins, books, and foliate scrolls. They are likewise encircled with wavy ribbons and include small tablets inscribed with the date, in this case 1540. Strikingly similar to the Getty Museum's jug is the medallion

figure on one of the jars in London showing a seated man, also perhaps Orpheus, playing a *lira da braccio.*[3]

Other related *berettino* pieces of unusual form include an armorial ewer formerly in the Pringsheim collection, Munich;[4] and a spouted ewer and pair of candlesticks in the Victoria and Albert Museum (inv. C.2123-1910, C.2103-1910, C.2104-1910).[5] In a private Florentine collection is a Faentine jug of similar size (thirty-eight centimeters high) and form but decorated with delicate fruit, flowers, and leaves; this work was executed in the workshop of Virgiliotto Calamelli and is dated to the second half of the sixteenth century.[6]

MARKS AND INSCRIPTIONS: On each of four tablets under the medallions, *1536*; in one medallion, *Elixeo* beside a bearded and turbaned old man.

PROVENANCE: A. Castellani, Rome (sold, Hôtel Drouot, Paris, May 27–29, 1878, lot 230); J. Pierpont Morgan, New York; George R. Hann, Sewickley Heights, Pennsylvania (sold, Christie's, on the Hann premises, Treetops, Sewickley Heights, May 19, 1980, lot 91); [Rainer Zietz, Ltd., London].

EXHIBITIONS: Metropolitan Museum of Art, New York, 1913–1916.

BIBLIOGRAPHY: Sale cat., Hôtel Drouot, Paris, May 27–29, 1878, lot 230; sale cat., Christie's, May 19, 1980, lot 91.

CONDITION: Restorations around the rim and the neck on either side; glaze faults (crawling), particularly in areas of yellow glaze; chips on the handle and around the rim.

1. A similar figure of a musician, also wearing a contemporary cap and displaying rugged, chiseled features, appears in the sixteenth-century portrait engraving of Philotheo Achillini by Marcantonio Raimondi after Francesco Francia (A. M. Hind, *A History of Engraving and Etching* [New York, 1923], fig. 37; K. Oberhuber, ed., *The Illustrated Bartsch*, vol. 27 [formerly vol. 14, pt. 2] [New York, 1978], no. 469 [349]).
2. Rackham 1940, vols. 1, nos. 303, 304; 2, pl. 50.
3. Ibid., vol. 1, p. 103, no. 303.
4. Falke 1914–1923, vol. 2, nos. 182a–b, pl. 95; Chompret 1949, vol. 2, fig. 488.
5. Rackham 1940, vols. 1, nos. 290–292; 2, pl. 46; Chompret 1949, vol. 2, fig. 487.
6. G. Liverani, "Di un boccale cinquecentesco faentino e di altre cose," *Faenza* 61, no. 6 (1975), p. 140, pls. 88a–b, 89a, 90a–b.

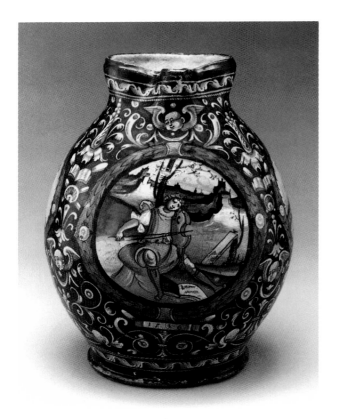

No. 28, alternate view

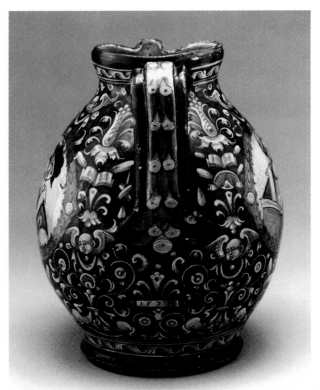

No. 28, alternate view

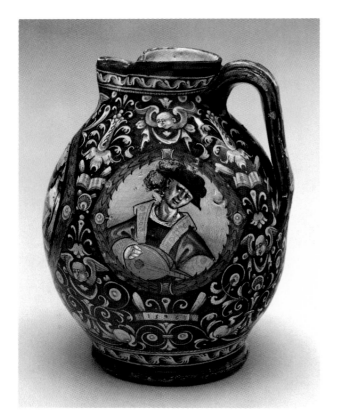

No. 28, alternate view

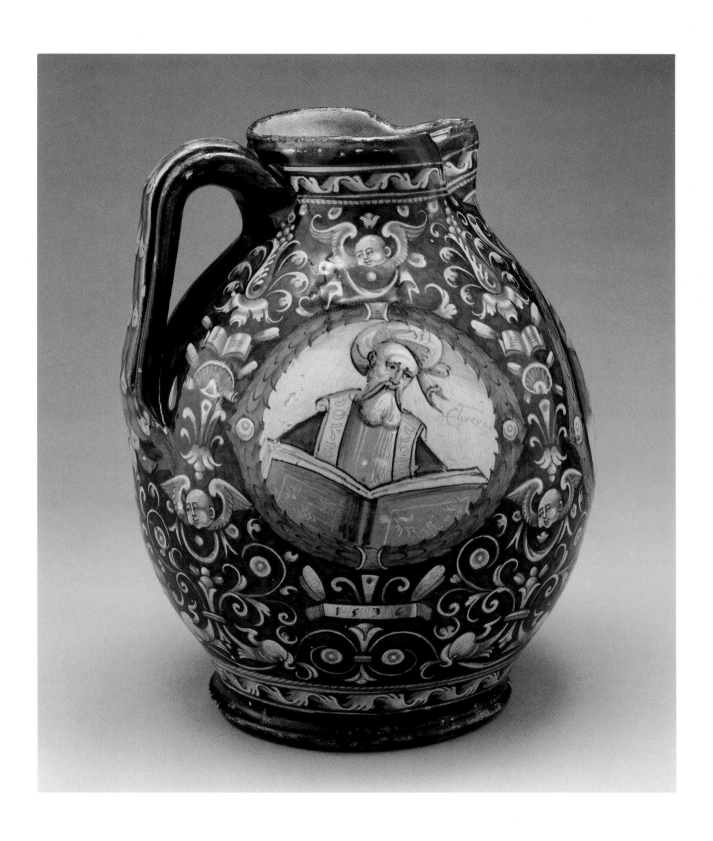

29 Dish with a Cupid on a Hobbyhorse (Tondino)

Castel Durante(?), circa 1510–1520
H: 2.4 cm (15/16 in.); Diam: 23.5 cm (9¼ in.)
84.DE.116

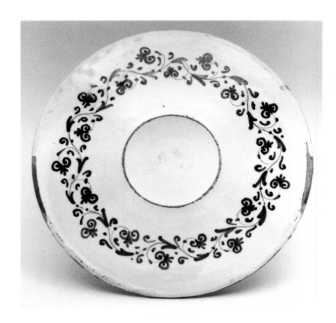

No. 29, reverse

THE WELL OF THIS *TONDINO* IS DECORATED WITH A cupid on a hobbyhorse before a lagoon landscape, with two bust portraits in medallions reserved on a ground of harpylike figures, monsters, cornucopias, and strings of beads around the wide rim. The blue, dark reddish amber, brown, yellow, green, purple, and opaque white embellishment is exceptionally brilliant and jewellike, an effect the ceramic artist achieved by applying a final transparent *coperta* glaze to the piece. Popular around Urbino, *coperta* glazes produce a shiny, porcelainlike surface that enhances the pigments beneath. The dark reddish amber pigment appears to be bole, a variety of clay colored red by iron oxide, which is found in Armenia and Tuscany and was used to decorate Iznik pottery. The reverse displays a band of blue and white foliate scrolls in the *alla porcellana* style.

The bust portraits in medallions depict a bald man in classical dress and a bearded man wearing a turbanlike hat. Although the significance of the two figures remains unclear, their idiosyncratic appearance and physiognomy might suggest that they were intended as portraits of specific individuals. Portraits of both Mohammad II (1430–1481), who became sultan of the Ottoman Turks in 1451,[1] and John VIII Palaeologus (1390–1448), the Byzantine emperor who traveled to Italy in the early fifteenth century to discuss a possible union between the Greek and Latin churches, display the distinctive headgear, pointed beard, and chiseled features of the turbaned figure.[2] It has been suggested that the bald man might represent Cicero.[3] Any identification of these medallion figures must be considered tentative, however, since similarities with known portraits do not appear convincing; these busts may simply represent generalized Eastern types.

This dish has been attributed to Giovanni Maria of Castel Durante because of its similarity to a bowl in the Metropolitan Museum of Art, New York,[4] inscribed *1508 adi 12 de sete[m]br[e] facta fu i[n] Castel dura[n]t[e] Zova[n] maria v[asa]ro* (made in Castel Durante by the potter Giovanni Maria on September 12, 1508); it is not known, however, whether Giovanni Maria was the director of the workshop as well as the painter of the bowl. This signed and dated piece has been used as a benchmark

for attributing a number of maiolica works to the artist.[5] These wares do not, however, appear to form a homogeneous group, and attribution of the Getty Museum's *tondino* to Giovanni Maria must be considered tentative.

The pieces most closely related to this *tondino*, which probably form a group, include a *tondino* also showing a cupid on a hobbyhorse (Oxford, Ashmolean Museum);[6] one with a cupid riding a dolphin (London, Victoria and Albert Museum inv. C.2087-1910);[7] one with a cupid riding a goose (London, British Museum MLA 1855, 12-1, 107);[8] and one displaying a cupid with a shield (Washington, D.C., National Gallery of Art, Widener Collection inv. C-38).[9]

Other *tondini* with central figures surrounded by bust portraits or other heads or trophies and grotesque decoration include a dish with Saint Jerome (Victoria and Albert Museum inv. C.2148-1910);[10] a *tondino* with a cupid holding a shield in the boss (formerly in the Pringsheim collection, Munich);[11] and another showing a young man playing a lute (Lyons, Musée des Arts Décoratifs).[12] A vase attributed to Giovanni Maria in the Herzog Anton Ulrich-Museum, Braunschweig (inv. 379), displays *a candelieri*[13] decoration with grotesques, cornucopias, harpylike figures, putti, and bead swags very similar to that of the Getty Museum's *tondino*.[14]

Most of the above-mentioned works have been attributed to Castel Durante of circa 1510–1520; Faenza and Cafaggiolo, however, have also been suggested, as has Venice.[15]

MARKS AND INSCRIPTIONS: None.

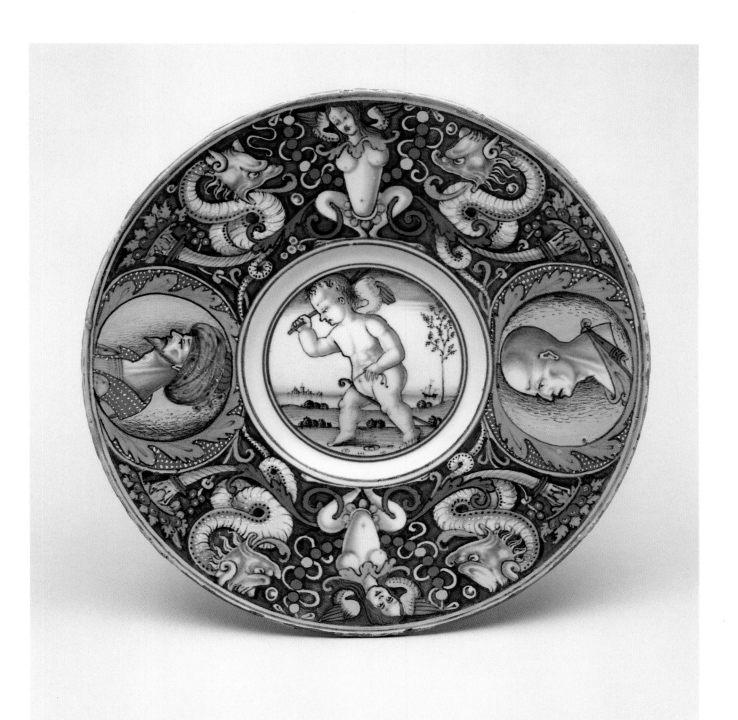

PROVENANCE: Alessandro Castellani, Rome (sold, Hô-
tel Drouot, Paris, May 27, 1878, lot 34); Charles Dami-
ron, Lyons (sold, Sotheby's, London, June 16, 1938, lot
60); Robert Strauss, London (sold, Christie's, London,
June 21, 1976, lot 22); [Cyril Humphris, London]; [Rai-
ner Zietz, Ltd., London].

EXHIBITIONS: None.

BIBLIOGRAPHY: B. Rackham, "The Damiron Collec-
tion," *Apollo*, no. 25 (1937), p. 256, fig. 7; Chompret
1949, vol. 2, pl. 13, fig. 93; *Christie's Review of the Season*
(London, 1976), p. 396; H. Morley-Fletcher and R.
McIlroy, *Christie's Pictorial History of European Pottery*
(Englewood Cliffs, N.J., 1984), p. 66, fig. 3.

CONDITION: Minor glaze chips on the rim.

1. See the portrait medal of the sultan by Costanzo da Ferrara,
illustrated in C. Wilson, *Renaissance Small Bronze Sculpture and
Associated Decorative Arts at the National Gallery of Art* (Wash-
ington, D.C., 1983), p. 42, no. 2 (obverse).

2. See R. Weiss, *Pisanello's Medallion of the Emperor John VIII
Palaeologus* (London, 1966), frontis., pls. 6, 9–12, 14–16.

3. See catalogues of Hôtel Drouot, Sotheby's, and Christie's
sales cited above under "Provenance" and "Bibliography."

4. G. Szabó, *The Robert Lehman Collection* (New York, 1975),
pp. 39–40, no. 150.

5. See B. Rackham, "Der Majolikamaler Giovanni Maria von
Castel Durante," pt. 1, *Pantheon* 2 (September 1928), pp. 435–
445; pt. 2, *Pantheon* 3 (February 1929), pp. 88–92.

6. C. D. E. Fortnum, *Maiolica: A Historical Treatise . . .* (Ox-
ford, 1896), pl. 19 (attributed to Faenza of circa 1520).

7. Rackham (note 5), pt. 2, p. 90, fig. 22; Rackham 1940, vols.
1, no. 532; 2, pl. 83 (attributed to Castel Durante of circa 1515).

8. M. L. Solon, *A History and Description of Italian Majolica*
(London, 1907), fig. 10; Rackham (note 5), pt. 2, p. 90, fig. 21;
Wilson 1987, no. 119 (attributed to "perhaps the Marches or
Venice" of circa 1505–1525).

9. D. Shinn, *Maiolica* (Washington, D.C., 1982), p. 19, no. 24
(attributed to Castel Durante of circa 1520).

10. Rackham (note 5), pt. 2, p. 89, fig. 20; Rackham 1940, vols.
1, no. 529; 2, pl. 83.

11. Falke 1914–1923, vol. 2, no. 157, pl. 84 (attributed to
"Faenza, possibly Cafaggiolo").

12. J. Giacomotti, "Les majoliques de la collection Paul Gillet
au Musée des Arts Décoratifs," *Cahiers de la céramique, du verre
et des arts du feu*, no. 25 (1962), p. 29 (attributed to Castel Durante
or Cafaggiolo of circa 1510).

13. Like a candelabra, that is, arranged symmetrically around
a central axis.

14. J. Lessmann, *Italienische Majolika* (Braunschweig, 1979),
no. 16, pl. 17 (attributed to Faenza or Castel Durante of circa
1520).

15. T. Wilson, "Maiolica in Renaissance Venice," *Apollo*, no.
125 (1987), p. 186, n. 8; Wilson 1987, no. 176.

30 Armorial Plate with the Flaying of Marsyas

By Nicola (di Gabriele Sbraghe) da Urbino (circa 1480–
1537/38)
Urbino, mid-1520s
H: 5.7 cm (2¼ in.); Diam: 41.4 cm (16⁵⁄₁₆ in.)
84.DE.117

THE WELL OF THIS LARGE ARMORIAL PLATE DISPLAYS A
coat of arms on a shield held by two putti surrounded by
bianco sopra bianco decoration. The wide rim is elegantly
painted with a continuous narrative sequence of the
competition between Apollo and Marsyas and the flay-
ing of Marsyas. The palette consists of blue, ocher, cop-
per green, grayish green, yellowish green, yellow,
brown, brownish orange, black, and opaque white. A
white glaze ground covers the reverse, which is other-
wise undecorated.

This plate was painted by arguably the most tal-
ented and celebrated maiolica master of the Cinque-
cento, who signed his works *Nicola da Urbino*. The artist
has been identified thanks to a handful of pieces that bear
his signature: a *coppa* painted with a seated king, dated
1521 (Leningrad, State Hermitage F.363);[1] a plate frag-
ment with a scene inspired by Raphael's *Parnassus* (Paris,
Musée du Louvre OA 1244);[2] a plate dated 1528 with a
scene inspired by Raphael's *Martyrdom of Saint Cecilia*
(Florence, Museo Nazionale, Palazzo del Bargello);[3] a re-
cently published plate with an Old Testament scene
(Novellara, Santo Stefano);[4] and, perhaps, a plate with
the scene of an animal sacrifice in the British Museum,
London (inv. MLA 1855, 3-13, 23).[5] According to archival
documents, Nicola was apparently a man known as Ni-
cola di Gabriele Sbraghe (or Sbraga). Sbraghe is the only
potter recorded in Urbino whose name and dates of ac-
tivity correspond to those of the artist we have come to
know as Nicola da Urbino.[6]

Frustratingly little is known about this important
exponent of early *istoriato* painting.[7] From the inscription
on the Saint Cecilia plate we know that Nicola worked,
possibly as a visiting master, in the large and successful
Urbino *bottega* of Guido da Castel Durante, otherwise
known as Guido Durantino.[8] That Nicola was also Gui-
do's father, a man mentioned in documents as Nicolò
Pellipario, is no longer accepted.[9]

Nicola's work is characterized by a delicate and so-
phisticated rendering of figures and space in an excep-
tionally rich and varied palette. Because of Nicola's great
skill, he was much admired and sought after by impor-

tant patrons of maiolica in the sixteenth century. Around
1525, for example, he produced a splendid *credenza*, or
table service, for Isabella d'Este.[10] Other *credenze* attrib-
uted to Nicola include the Correr or "Ridolfi" service of
circa 1517–1520 in the Museo Correr, Venice,[11] and two
services dating to the 1530s: one executed for Duke Fed-
erico, Isabella's son, and another for Federico and his
wife, Margherita Paleologo.[12]

The Getty Museum's plate belongs to yet another
service, sometimes referred to as the ladder service, that
was either commissioned by or given to a member of the
Brescian Calini family, whose coat of arms appears in the
central shield.[13] Using Nicola's two signed and dated
works together with the dates ascribed to his table ser-
vices, one may place the Calini set roughly in midcareer,
that is, in the mid-1520s, between the earlier, more del-
icate, blue-toned style of the Correr service and the
warmer, compositionally more complex painting of the
1528 Saint Cecilia plate. In both style and palette the Cali-
ni service is closest to the Este-Gonzaga group of circa
1525.

Nicola's plate tells the story of the contest between
Apollo and Marsyas. According to the ancient legend,
Athena made a flute that she played beside a stream.
Watching her reflected image in the water, she saw her
face become blue and her cheeks swollen, so she threw
down the flute and laid a curse on anyone who picked it
up. Marsyas stumbled on the flute, which made beautiful
sounds, inspired by the memory of Athena's music. He
then invited Apollo, master of the lyre, to a contest, the
winner of which could inflict whatever punishment he
pleased on the loser. The sly Apollo challenged Marsyas
to play his instrument upside down, knowing that this
could be done with the lyre but not with the flute. The
Muses declared the winner to be Apollo, who took cruel
revenge by flaying Marsyas alive.

The figures on this plate are adapted from folio 49
verso of the 1497 Venetian edition of Ovid's *Metamor-
phoses*. The plate's istoriato scenes, however, differ curi-
ously from the Venetian woodcut, evidence that Nicola
interpreted the ancient legend liberally and inventively.
In the woodcut only the figure of Marsyas is portrayed
nude, whereas on Nicola's plate both Apollo and Mar-
syas are nude when they meet in competition and in the
flaying episode. In addition Nicola shows Marsyas as an
old man on the far right but otherwise portrays him as a
young man.

Clearly inspired by the woodcut, the figure of
Athena on the plate plays a bagpipe. This is not an un-
usual substitution. Renaissance artists often replaced the
ancient *aulos* (reed flute) mentioned in the legend with its

contemporary counterpart, the *zampogna* (bagpipe).[14] Although Marsyas retrieves Athena's bagpipe on the plate, he is then shown playing a syrinx in competition with Apollo, who leans contemplatively against a rock with his quiver and ancient lyre. Although the syrinx is usually played by Pan in ancient sculpture and Renaissance painting, it is also occasionally played by Marsyas.[15] For his syrinx-playing Marsyas, Nicola might have been inspired by another woodcut in the 1497 *Metamorphoses* that shows the competition between Apollo and Pan.[16] The conflation of both woodcut scenes on this plate is understandable, since they depict the two ancient legends about musical contests.

On the upper right of the Marsyas woodcut, his flayed skin is displayed in a shrine, but on the plate this skin has been transformed into a sculpture on a pedestal in a classicized, circular temple. Nicola's temple was likely inspired by actual buildings of this type, such as Donato Bramante's Tempietto. Though separated by a generation, both Bramante and Nicola were born in Castel Durante, and on more than one occasion Nicola seems to have drawn on Bramante's architectural achievements—such as his celebrated domed and niched circular structures—for his own architectural inventions.[17]

In addition to the present work, Nicola illustrated the Apollo and Marsyas contest on two other plates: one from the Correr service[18] and another from the Este-Gonzaga set in the Wernher collection, Luton, Bedfordshire.[19] Although the mythological subject is interpreted differently on the earlier plate in Venice, it is very similarly illustrated on the Getty Museum and the Este-Gonzaga pieces.

Including the Museum's plate, there are eleven known works from the Calini service. Their subjects are Apollo and Pan (London, British Museum inv. MLA 1855, 12-1, 73),[20] the sacrifice of Iphigenia (Ecouen, Musée de la Renaissance, Cluny 1863),[21] the death of Achilles (New York, Metropolitan Museum of Art 84.3.2),[22] and an allegorical scene with Calliope and a youth (Washington, D.C., Corcoran Gallery of Art inv. 26.348).[23] Five further pieces with scenes of Saint George and the dragon, Perseus and Andromeda, the Brazen Bull of Phalaris, Cycnus changed into a swan, and an unidentified subject are in the Royal Scottish Museum, Edinburgh.[24] A final plate with the Rape of Europa, whose present whereabouts are unknown, was formerly in the Damiron collection, Lyons.[25]

MARKS AND INSCRIPTIONS: None.

PROVENANCE: Ralph Bernal, London (sold, Christie's, London, March 5, 1855, lot 1767, to Wareham for Roth-

No. 30, reverse

schild); sold, Christie's, London, April 12, 1976, lot 179, pl. 13; [Rainer Zietz, Ltd., London].

EXHIBITIONS: None.

BIBLIOGRAPHY: H. Morley-Fletcher and R. McIlroy, *Christie's Pictorial History of European Pottery* (Englewood Cliffs, N.J., 1984), p. 65, fig. 8.

CONDITION: Broken and repaired, with the breaks generally confined to the top half of the piece; overpainting in small areas of landscape to the left, in the *bianco sopra bianco*, and above the head of the putto on the right side.

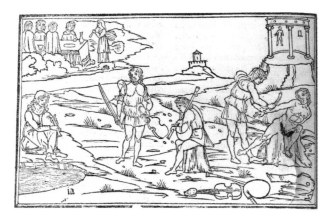

The Contest between Apollo and Marsyas. From Ovid, *Metamorphoses* (Venice, 1497), fol. 49v. Woodcut. Washington, D.C., Library of Congress, Rare Book and Special Collections Division, Rosenwald cat. no. 322. Photo courtesy Library of Congress.

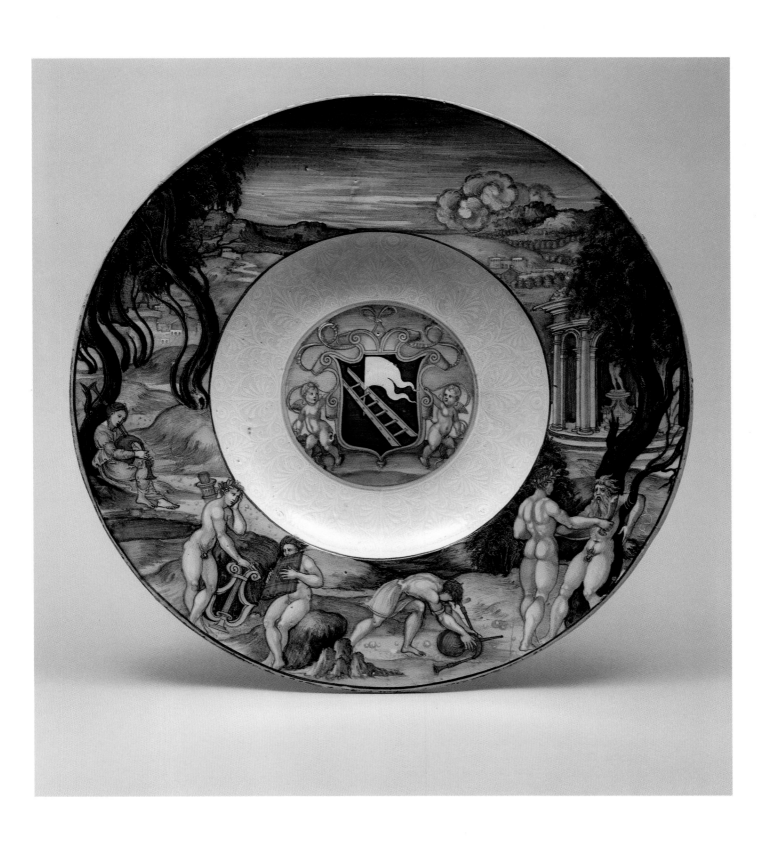

1. Kube 1976, no. 58.

2. Giacomotti 1974, no. 829.

3. G. Conti, *Catalogo delle maioliche: Museo Nazionale di Firenze, Palazzo del Bargello* (Florence, 1971), no. 16.

4. F. Liverani, "Un piatto di Nicola e altro," *Faenza* 71, no. 4/6 (1985), nos. 4–6, pl. 125; Wilson 1987, pp. 44–45, 49, no. 62.

5. Wilson 1987, p. 50, no. 63. J. V. G. Mallet has questioned the attribution of this plate to Nicola ("Mantua and Urbino: Gonzaga Patronage of Maiolica," *Apollo*, no. 114 [1981], p. 164, n. 6), and B. Wallen has rejected it ("A Majolica Panel in the Widener Collection," in *Report and Studies in the History of Art* [Washington, D.C., 1968], p. 100, n. 2, figs. 8, 9).

6. A. Darcel, *Notice des fayences peintes italiennes* (Paris, 1864), p. 181; P. Berardi, *L'antica maiolica di Pesaro dal XIV al XVII secolo* (Florence, 1984), p. 17, n. 9; F. Negroni, "Nicolò Pellipario: Ceramista fantasma," *Notizie da Palazzo Albani* 14, no. 1 (1985), pp. 15–20; J. V. G. Mallet, "In bottega di Maestro Guido Durantino in Urbino," *Burlington Magazine* 129 (May 1987), pp. 284–286.

7. For an examination of the artist's life and work, see, in addition to the works cited above, J. Rasmussen, "Zum Werk des Majolikamalers Nicolò da Urbino," *Keramos* 58 (December 1972), pp. 51–64; Wilson 1987, pp. 44–51.

8. Mallet (note 6), p. 286.

9. Wallen (note 5), pp. 95–105; Negroni (note 6), pp. 13–20.

10. Examples from this service are reproduced in G. Chambers and J. Martineau, eds., *Splendours of the Gonzaga* (London, 1981–1982), nos. 131–133, 135, 136, 138; for dating of this set, see J. V. G. Mallet, "The Gonzaga and Ceramics," ibid., p. 40.

11. H. Wallis, *Seventeen Plates by Nicola Fontana da Urbino at the Correr Museum, Venice* (London, 1905).

12. Mallet, in Chambers and Martineau, eds. (note 10), p. 40; see also examples reproduced as nos. 194, 195, 197.

13. For identification of these arms, see C. Ravanelli Guidotti, "L'araldica della nobile famiglia Calini su alcuni piatti compendiari," *Faenza* 71, no. 4/6 (1985), pp. 394–399; for a discussion of the Calini family, see H. von Schrattenhofen, "La nobile famiglia bresciana Calini di Calino," *Rivista del collegio araldico* 25 (June 1927), pp. 243–257; and for the postulation that this service may have been executed for Luigi Calini on the occasion of his first son's birth, see Watson 1986, pp. 112–114.

14. E. Winternitz, "The Curse of Pallas Athena," in *Studies in the History of Art Dedicated to W. E. Suida on His Eightieth Birthday* (London, 1959), pp. 187–189.

15. Ibid., p. 189, n. 13.

16. The woodcut is reproduced in Wallis (note 11), p. 15, fig. 5.

17. For a discussion of architecture in Nicola's work, see B. Rackham, "Nicola Pellipario and Bramante," *Burlington Magazine* 86 (June 1945), pp. 144–148; for a general examination of architecture painted on maiolica, see C. Bernardi, *Immagini architettoniche nella maiolica italiana del cinquecento* (Milan, 1980).

18. Wallis (note 11), p. 39, fig. 16; G. Conti, *L'arte della maiolica in Italia*, 2nd edn. (Milan, 1980), no. 188.

19. M. Urwick Smith, *The History and Treasures of Luton Hoo: The Wernher Collection* (London, 1978), p. 22.

20. Wilson 1987, no. 53.

21. Giacomotti 1974, no. 820.

22. B. Rackham, "Some Unpublished Maiolica by Pellipario," *Burlington Magazine* 52 (May 1928), pl. 3D.

23. Watson 1986, no. 45.

24. Except for the Getty Museum's plate, all of these pieces are illustrated in Rackham (note 22), pls. 1–4.

25. *A Very Choice Collection of Old Italian Maiolica . . . the Property of M. Damiron, Lyons*, sale cat., Sotheby's, London, June 16, 1938, lot 57; B. Rackham, "The Damiron Collection of Italian Maiolica—II," *Apollo*, no. 26 (1937), p. 256, fig. 9.

31 Plate with the Abduction of Helen

By Francesco Xanto Avelli (circa 1486/87–circa 1544)
Urbino, 1534
H: 6.3 cm (2½ in.); Diam: 46.1 cm (18⅛ in.)
84.DE.118

THE ENTIRE OBVERSE SURFACE OF THIS LARGE *ISTO-riato* plate is painted with a scene of the Abduction of Helen by the Trojans in brilliant blue, yellow, brown, ocher, buff, orange, manganese purple, turquoise, several tones of green, black, and opaque white. The warm, orange-toned palette of this work is typical of Xanto's production and of *istoriato* painting in Urbino around 1530. The center of the reverse is inscribed in blue with the date and artist's signature as well as a verse, adapted from Petrarch's "Triumph of Love,"[1] describing the painted mythological scene: *1534—This is the shepherd who ill-fatedly admired the beautiful face of Helen of Greece—and that famous abduction for which the world was thrown into confusion. Francesco Xanto Avelli da Rovigo in Urbino.*

Xanto was the most talented and prolific follower of the celebrated early sixteenth-century ceramic artist Nicola da Urbino.[2] Although an abundance of Xanto's works have come down to us—many of which are signed, dated, and otherwise inscribed—little is known about the artist. He appears to have been a learned and multitalented man. For his *istoriato* works and their inscriptions, he drew upon a variety of important artistic and literary sources, which he often inventively modified to suit his compositions and verse. Xanto was also a poet, and over a period of several decades he wrote a series of sonnets honoring Francesco Maria I della Rovere, duke of Urbino (r. 1508–1538).[3] These sonnets contain numerous allusions to historical events and therefore assist in establishing a biography of the artist as well as a chronology of his work.[4]

Born in Rovigo in the late 1480s, Xanto moved to Urbino by 1530, the year in which he began inscribing *in Urbino* on his wares,[5] and for the following decade and a half he executed a vast number of signed works exhibiting an exceptional consistency of style. T. Wilson has suggested that a trade dispute of 1530 in which Xanto was embroiled may have induced the artist to begin signing his plates with his full name.[6] According to documents, Xanto was clearly a workshop employee at the time of this dispute. He attempted to improve his position by banding together with other employees (*dipendenti dell'arte figulina*) to demand higher wages; in response a group of workshop heads (*capi-bottega*) agreed to resist the employees' demands and simply not hire them without the consent of the other *capi*.[7] It is certainly possible that by signing his wares, Xanto was attempting to wrest control of his products from the workshop directors.

Xanto's works are distinguished by dynamic and vigorously modeled figures in crowded compositions frequently based on engravings by Marcantonio Raimondi and others, which he often inventively and eclectically excerpted and recombined. For the present plate's *istoriato* decoration, Xanto drew upon an engraving of the same subject either by Marcantonio or by Marco Dente, called Marco da Ravenna (active 1510–1527), after Raphael. This image was apparently a favorite of the artist and his peers, including Nicola da Urbino, since it appears with slight variations on numerous plates of the early sixteenth century. The consistency of these Abduction of Helen scenes indicates that instead of copying the engraving freehand, the artists may have used a template of some sort—probably either traced or punched with holes, through which powder was forced—to transfer the image to the ceramic plates.

Other versions of this subject either signed by or attributed to Xanto include two plates in the Musée du Louvre, Paris (Cluny 915, OA 1839)[8] and one each in the Victoria and Albert Museum, London (inv. C.2232-1910);[9] in the Museo Internazionale delle Ceramiche, Faenza;[10] formerly in the Schlossmuseum, Berlin (probably destroyed);[11] in the Colocci Honorati collection, Jesi;[12] and formerly in the Pringsheim collection, Munich.[13] A *piatto da pompa* in the collection of the late Arthur M. Sackler, New York (inv. 78.2.20), is painted with the same subject and is attributed to Nicola da Urbino.[14] Many of these plates bear inscriptions that are identical or nearly so to that on the Getty's plate, which is among the largest and most faithful to the original engraving.

MARKS AND INSCRIPTIONS: On reverse, .*M.D.XXXIIII / Quest'è'l pastor che mal mirò'l bel / volto / D'Helena Greca, e, quel famoso rapto / pel qual fu'l mondo sotto sopra volto. / .Fra[ncesco]:Xa[n]to. A[velli]. / da Rovigo, i[n] / Urbino.* in blue.

PROVENANCE: Ralph Bernal, London; sold, Sotheby's, London, November 21, 1978, lot 44; [Rainer Zietz, Ltd., London].

EXHIBITIONS: P. D. Colnaghi and Co. Ltd., London, June 10–July 31, 1981.

BIBLIOGRAPHY: A. González-Palacios, ed., *Objects for a "Wunderkammer,"* exh. cat. (Colnaghi and Co., London, 1981), pp. 124–125, no. 65.

CONDITION: Minor cracks and repairs, partly over-painted, on the rim; a break in the upper left section of the dish, with moderate to heavy overpainting; some glaze faults; seven stilt marks on the obverse along the rim (originally, there were eight, but one is missing because of the repair).

1. "Triomfo d'amore," bk. I, ll. 136–138: "Seco è 'l paster che mal il suo bel volto / mirò sí fiso, ond'uscir gran tempeste, / e funne il mondo sottosopra vòlto."

2. See entry no. 30 above.

3. These sonnets are presently in the Vatican Library; for further references, see Watson 1986, p. 25, n. 51.

4. See J. V. G. Mallet, "La biografia di Francesco Xanto Avelli alla luce dei suoi sonetti," *Faenza* 70, no. 4/6 (1984), pp. 384–402.

5. According to a plate dated 1530 in the Castello Sforzesco, Milan (inv. M232).

6. Wilson 1987, p. 52; see also J. V. G. Mallet, "In bottega di Maestro Guido Durantino in Urbino," *Burlington Magazine* 129 (May 1987), p. 33.

7. Interestingly, these documents indicate that the workshop heads involved in the dispute included Guido Durantino and Nicola di Gabriele Sbraghe (F. Negroni, "Nicolò Pellipario: Ceramista fantasma," *Notizie di Palazzo Albani* 14, no. 1 [1985], p. 18, n. 33).

8. Chompret 1949, vol. 2, figs. 988, 995; Giacomotti 1974, nos. 856, 866.

9. Rackham 1940, vols. 1, no. 634; 2, pl. 100.

10. "Accessioni al Museo," *Faenza* 32, no. 3/4 (1946), pl. 19a.

11. Ballardini 1933–1938, vol. 2, no. 191.

12. Ibid., no. 41.

13. Ibid., no. 192, fig. 182; Falke 1914–1923, vol. 2, no. 267, pl. 138.

14. Falke 1914–1923, vol. 2, no. 254, pl. 131.

No. 31, reverse

MARCANTONIO RAIMONDI (Italian, circa 1480–1534) after Raphael (Italian, 1483–1520). *The Abduction of Helen*, circa 1510–1520. Engraving, 29.6 × 42.4 cm (11 5/8 × 16 3/4 in.). Vienna, Graphische Sammlung Albertina 1970/425. Photo courtesy Albertina.

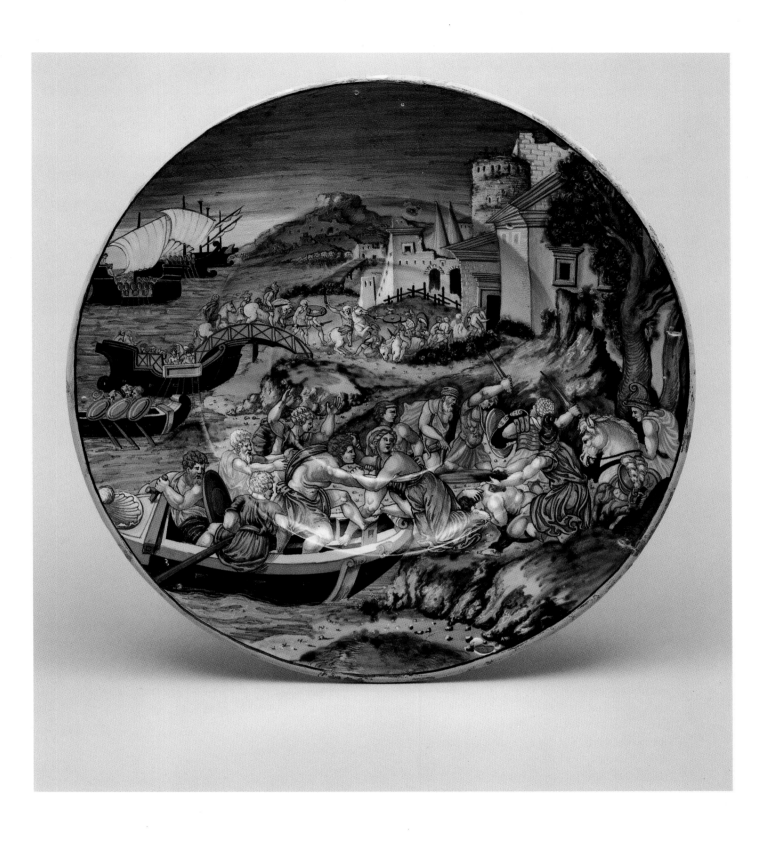

32 Pilgrim Flask and Cover with Marine Scenes (Fiasca da Pellegrino)

By the Fontana Workshop
Urbino, circa 1560–1570
H: 44.1 cm (17⅜ in.); max. W: 28.6 cm (11¼ in.)
84.DE.119A–B

THIS VESSEL IS MOLDED IN THE FORM OF A PILGRIM flask with a tall, tapering neck and screw cover surmounted by a vase-shaped knop; both neck and cover are decorated with black birds among clouds, commonly found on Fontana wares. The handles, in the form of horned grotesque masks, have curling "beards" that become relief volutes complementing the shape of the flask body. The ceramic pilgrim-flask form reflects the influence of metal pilgrim flasks patterned after the dried gourds used by travelers to carry drinking water, which were suspended from side loops. The horned masks on the sides of the Museum's flask and the holes cut from either side of the base would never have been used to suspend the object; they were retained as decorative reminiscences of the earlier functional forms.

The flask is painted on both sides with marine scenes: a triton abducting a nereid on one and two fighting tritons on the other. The palette consists of blue, buff, dark manganese purple, copper green, yellowish green, brownish ocher, yellow, turquoise, black, and opaque white; this exceptionally rich and varied coloring is typical of Fontana workshop ceramics. The workshop was established by Orazio Fontana (1510–1571), eldest son of the master potter Guido Durantino, who took the Fontana family name after he moved to Urbino from his native Castel Durante. In the early sixteenth century Guido helped shift the dominant area for maiolica production and innovation from Faenza to Urbino and its neighboring Castel Durante by introducing *istoriato* decoration there. Together with Francesco Xanto Avelli, Guido's descendants brought this type of decoration to maturity in their Urbino workshop.

Orazio's brothers Camillo and Nicola and his nephew Flaminio were also maiolica potters, although Orazio appears to have been the most celebrated of the Fontana ceramists. He worked with his father for most of his career, until 1565, when he set up his own *bottega* not far from that of his father in Urbino's Borgo San Paolo. From that time on, it appears that Orazio occupied himself mainly with the luxurious *istoriato* and gro-

tesque-decorated ceramics, leaving to his father the plainer, and probably more profitable, white and common wares.[1] Whether Orazio continued to paint the pieces produced in his workshop after 1565 or whether he then functioned solely as *capo-bottega* (workshop head) is not known.

The present flask can be dated between 1560 and 1570, when the Fontana workshop began to apply classical *istoriato* embellishment to decorative forms such as vases, flasks, and basins. Another Fontana innovation of this period was the use of marine motifs—tritons, nereids, sea horses, and various sea monsters—set against decorative expanses of blue waves, as on the Museum's flask.

Fontana flasks of identical shape and very similar marine-inspired decoration, possibly from the same set as the present work, include one in the Herzog Anton Ulrich-Museum, Braunschweig (inv. 919),[2] and another in the Helen Foresman Spencer Museum of Art, Lawrence (inv. 60.76).[3] Further Fontana workshop examples of the same flask form are in the Victoria and Albert Museum, London (inv. 8408-1863, 8409-1863),[4] and formerly in the Basilewski collection, Paris.[5] Five similarly shaped flasks produced in the workshop of Orazio Fontana are in the Museo Nazionale, Palazzo del Bargello, Florence.[6] Like the Getty Museum's example, a pilgrim flask of the late 1560s or early 1570s in the Nationalmuseum, Stockholm (inv. NM 60), displays marine subjects (Amphitrite or Galatea crowned by a putto, a triton abducting a nereid, and other sea creatures, against an overall background of blue waves).[7]

MARKS AND INSCRIPTIONS: None.

PROVENANCE: Thomas F. Flannery, Jr., Chicago; sold, Sotheby's, London, November 22, 1983, lot 160; [Edward Lubin, New York]; [Rainer Zietz, Ltd., London].

EXHIBITIONS: None.

BIBLIOGRAPHY: Sotheby's, London, November 22, 1983, lot 160.

CONDITION: Cracks and restorations on the side loops and on the cover.

1. J. V. G. Mallet, "In Bottega di Maestro Guido Durantino in Urbino," *Burlington Magazine* 129 (May 1987), pp. 287–288.
2. J. Lessmann, *Italienische Majolika* (Braunschweig, 1979), no. 230.
3. *Helen Foresman Spencer Museum of Art: Handbook of the Collection* (Lawrence, [circa 1978]), pp. 28–29; B. Cole, *Italian*

Maiolica from Midwestern Collections (Bloomington, 1977), no. 37; Chompret 1949, vols. 1, p. 194; 2, p. 130, fig. 1033; *Catalogue of the Celebrated Fountaine Collection*, sale cat., Christie's, London, June 16, 1884, lot 376.

4. Rackham 1940, vols. 1, nos. 840, 841; 2, pl. 133.

5. Illustrated in A. Darcel and H. Delange, *Recueil des faïences italiennes des XV, XVI, XVII siècles* (Paris, 1867), pl. 97; it is likely that this is the "unpublished" flask that passed from the Basilewski collection into the State Hermitage, Leningrad, in the late nineteenth century (Kube 1976, no. 84).

6. G. Conti, *L'arte della maiolica in Italia*, 2nd edn. (Milan, 1980), figs. 291, 292; these flasks figure among the wares traditionally thought to have been executed for the table service of Duke Guidobaldo II della Rovere of Urbino, although proof of this commission has not yet come to light. See also idem, *Catalogo delle maioliche: Museo Nazionale di Firenze, Palazzo del Bargello* (Florence, 1971), nos. 25, 27, 46, 50, 52.

7. H. Dahlbäck Lutteman, *Majolika från Urbino* (Stockholm, 1981), no. 20.

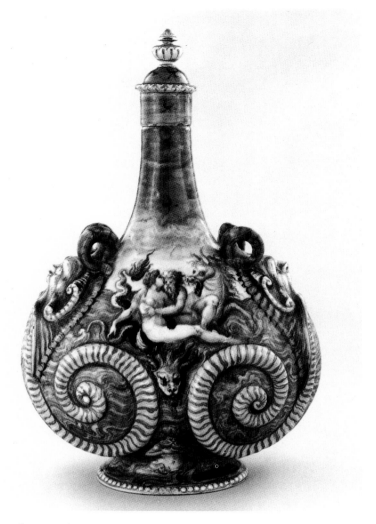

No. 32, alternate view

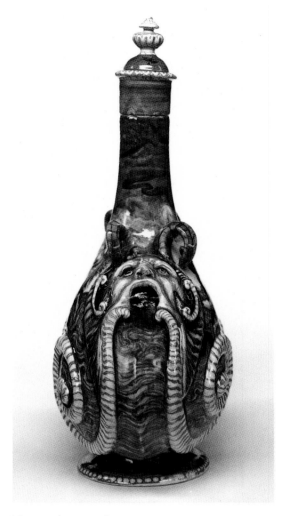

No. 32, alternate view

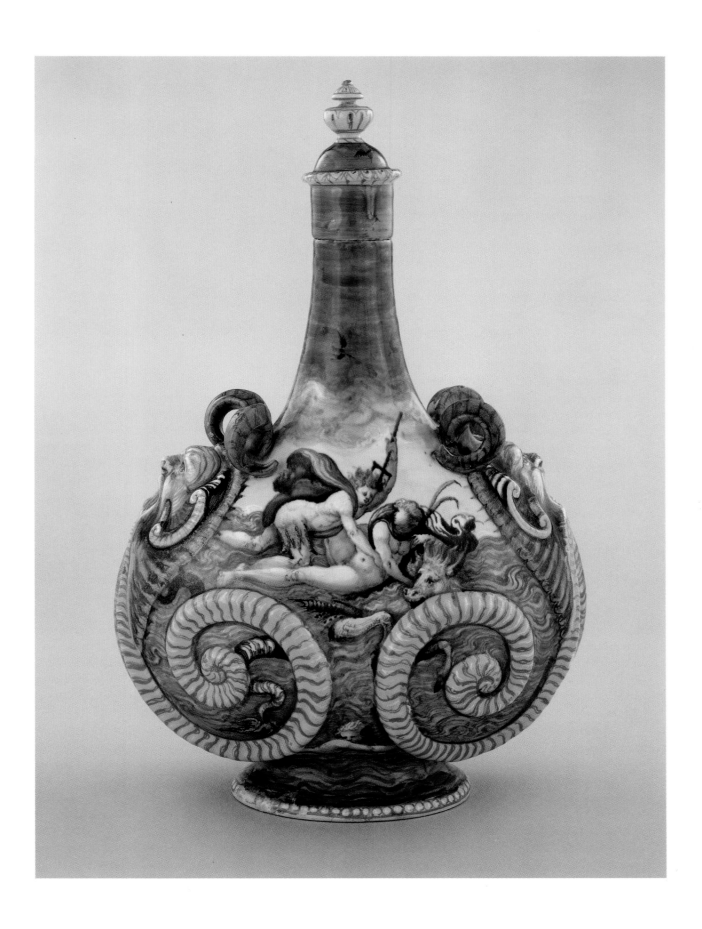

33 A Candelieri *Plate*

Venice, circa 1540–1560
H: 5.7 cm (2¼ in.); Diam: 47.7 cm (18¾ in.)
84.DE.120

No. 33, reverse

THIS PLATE IS EMBELLISHED WITH CHERUBS' HEADS, griffins, cornucopias, bead swags, drapery, dolphins, and foliate scrolls arranged *a candelieri*. A central male figure supports a basket on his head flanked by birds and surmounted by a panel inscribed *.S.P.Q.R.*[1] The grotesque decoration is painted in greenish grisaille (that is, in various tones of gray as a trompe l'oeil of marble relief) enriched with white and reserved on a dark blue ground. The reverse displays a row of radiating dashes and a border of scrolling *alla porcellana* foliage in dark blue on a light blue *berettino* ground.

This plate appears to be a unique masterpiece. No other known work of the period approaches its Mannerist elegance and sophisticated rendering of figures and decoration. One finds the most closely related trophy and *a candelieri* designs—often in grisaille, on a light or dark blue ground, and with "filled-in" backgrounds of white scrolling ribbons—on wares from the first half of the sixteenth century from Castel Durante and Venice. This kind of decoration has traditionally been associated with Castel Durante, and objects decorated in this style are often described as painted in the *maniera durantina*.[2] Similar stylistic elements—such as the elaborate *a candelieri* designs and delicately rendered faces with straight and pointed noses, pointed chins, small mouths, and dark "dots" for eyes—can be found on pieces attributed to Giovanni Maria, a ceramist active at Castel Durante in the first decades of the sixteenth century.[3] It is altogether possible that the artist who painted this piece was born or trained in Castel Durante but became active in Venice around the middle of the century, since, judging from its shape and glaze colors rather than its painting style, this plate was almost certainly executed in Venice.

Unusually large plates with wide, shallow wells were produced in Venice, and both the blue-and-white enamel on a light grayish blue ground and the reverse *alla porcellana* border on the same *berettino* ground are typical of Venetian wares.[4] The closest analogies to the present work include a large Venetian plate dated 1534 that sold at auction in Rome;[5] another Venetian plate, also dated 1534, decorated with figures of Samson and Delilah surrounded by trophies (Milan, Castello Sforzesco 70); and a plate dated circa 1550–1560 and attributed to the workshop of Domenico da Venezia with a putto and a woman

holding a cornucopia surrounded by trophies (London, Victoria and Albert Museum inv. 1744-1855).[6] These three plates share with the Getty Museum's work similar shapes and comparable dimensions. Furthermore they display grisaille decoration "filled in" with delicate scrolling ribbons on the obverse and *alla porcellana* foliage on the reverse, all on a *berettino* ground.

The Getty Museum's plate is distinguished by its exceedingly mannered and refined painting style. The central figure is almost astonishingly bizarre, a favorite effect of Mannerist artists. This figure's expression of surprise, elongated proportions, and twisted torso that ends in foliage and leafy scrolls at the thighs and shoulders all contribute to its fantastic nature. Also favored by the Mannerists was an extreme elegance in surface decoration, exemplified on the present work by such details as the beautifully draped fabric along the plate's upper edge and the way in which the grotesque figure on the right gracefully crosses his left hand over his right arm, throwing a shadow on his extended forearm.

The decoration on the present work is of such high quality, and the style of painting is so remarkably current with the prevailing Mannerist tendencies of the first half of the sixteenth century, that one would wish to attribute its design to a contemporary master.[7] Around the mid-sixteenth century artists Battista Franco (1498–1561) and Taddeo Zuccaro (1529–1566) both produced designs for maiolica plates from which several pieces were commissioned by Duke Guidobaldo II della Rovere of Urbino (r. 1538–1574) and executed by such workshops as that of the Fontana in Urbino.[8] Although these plate designs

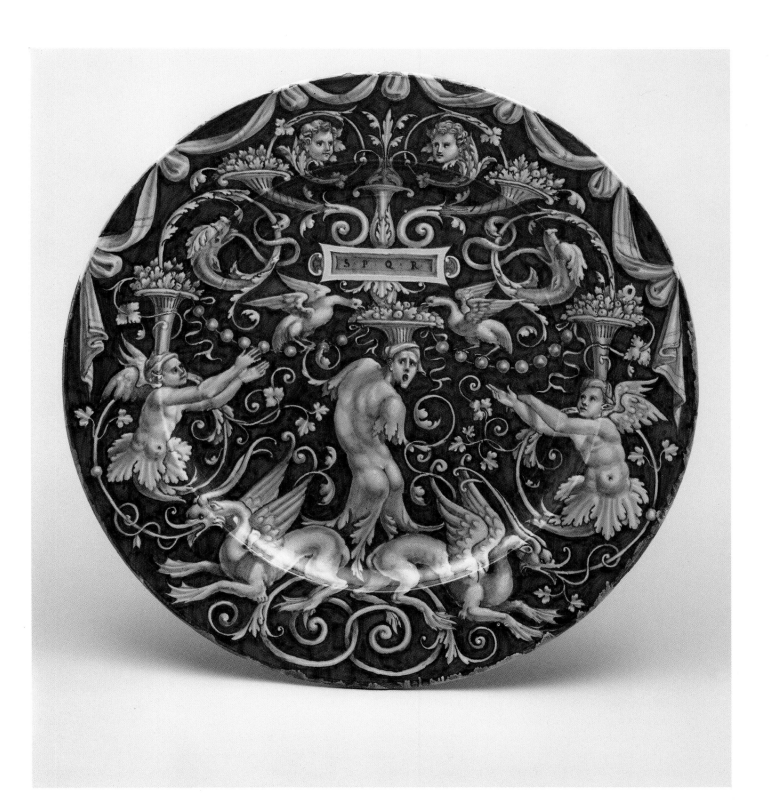

Attributed to GIOVANNI ANTONIO DA BRESCIA (Italian, active circa 1490–after 1525). *Ornament Panels with Grotesque Figures*, late fifteenth–early sixteenth century. Engravings, 9.1 × 26.1 cm (3⁹⁄₁₆ × 10¼ in.); 11 × 26.7 cm (4⁵⁄₁₆ × 10½ in.). Rome, Istituto Nazionale per la Grafica F.C. 35116, F.C. 35117. Photos courtesy Istituto Nazionale per la Grafica.

often feature grotesques, trophies, or *a candelieri* putti embellishing the rims, the wells are always decorated with narrative scenes emphasizing the often complicated placement of figures in three-dimensional space, an interest almost completely lacking in the Museum's plate.

J. Marryat has suggested that the Museum's plate is based on a design by Franco.[9] The painting style, however, differs significantly from any of the artist's known maiolica designs. The Mannerist treatment of the plate's surface decoration is more closely related to the style of Zuccaro,[10] although no comparable works that would convincingly link this artist with the present plate have come to light.

In the mid-sixteenth century Cipriano Piccolpasso wrote that "[Designs of] grotesques [on maiolica] have been almost discarded, and I do not know why; it is a delicate style of painting, the use of which is derived from I know not what source; they cost two florins a hundred in the state [of Urbino], and at Venice 8 lire."[11] Piccolpasso must have been referring to the type of decoration on the Museum's plate and not to the more delicate grotesque designs on white ground influenced by Raphael's frescoes of 1518–1519 for the Vatican Loggie (see no. 34), which became extremely popular, especially on Fontana workshop ceramics, in the third quarter of the sixteenth century. The type of grotesques on the present plate might instead have been inspired by prints of contemporary ornament, such as those executed by

the engravers Agostino Musi (called Agostino Veneziano; circa 1490–circa 1540)[12] or Giovanni Antonio da Brescia (active circa 1490–after 1525).

MARKS AND INSCRIPTIONS: On obverse, .S.P.Q.R.

PROVENANCE: "Royal collection" (according to J. Marryat, *A History of Pottery and Porcelain* [London, 1857], p. 34, fig. 18);[13] Robert Strauss, London (sold, Christie's, London, June 21, 1976, lot 52); [Rainer Zietz, Ltd., London].

EXHIBITIONS: None.

BIBLIOGRAPHY: Marryat 1857, p. 34, fig. 18 (described as "probably after a design of B. Franco"); H. Morley-Fletcher and R. McIlroy, *Christie's Pictorial History of European Pottery* (Englewood Cliffs, N.J., 1984), p. 86, fig. 1 (unconvincingly attributed to the master of the Venetian dish of circa 1520 with arms of the Imhof and Schlaudersbach families, formerly in the Adda collection, Paris).[14]

CONDITION: Hairline cracks on the right edge and on the left side, with retouching.

1. Rather than indicating specific Roman patronage, this *Senatus populusque romanus* inscription likely serves both a decorative and a generalized symbolic function, since it commonly appears on maiolica wares, most often with trophy motifs, from pottery centers throughout Italy.

2. For examples of comparable decoration on works produced in Castel Durante, see Giacomotti 1974, nos. 747–772; Chompret 1949, figs. 65–101; Ballardini 1933–1938, vol. 1, pl. 28, figs. 213, 217–220, 223; Rackham 1940, vols. 1, no. 615; 2, pl. 97; L. Corradi, ed., *La ceramica rinascimentale metaurense*, exh. cat. (Palazzo Ducale Urbania, Rome, 1982), no. 50; M. Mancini della Chiara, *Maioliche del Museo Civico di Pesaro* (Bologna, 1979), nos. 83, 85. One finds similarly mannered grotesque decoration on the rim of a plate of uncertain origin in the Victoria and Albert Museum, London, which, according to Rackham, "points to Castel Durante" (Rackham 1940, vol. 1, no. 994), as well as around the rim of a large plate from Castel Durante of around the mid-sixteenth century in the Museo Civico, Pesaro (Chiara 1979, no. 79). Grisaille drapery used in a manner similar to that on the Getty Museum's example—elegantly framing the decoration—is found on a Castel Durante plate dated 1553 with the subject of Apollo and Daphne in the Museo Civico, Pesaro (Chiara 1979, no. 58).

3. See, for example, Rackham 1940, vol. 2, nos. 535–537, pl. 84.

4. For Venetian plates that are similar in both shape and decoration, see A. Alverà Bortolotto, *Storia della ceramica a Venezia* (Florence, 1981), pls. 36c–d, 43a, 46a, 47a–d, 48a–e, 51, 55a; idem, "Due pittori maiolicari nella Venezia del cinquecento," *Arte veneta* 34 (1980), p. 154, figs. 1, 2; T. Wilson, "Maiolica in Renaissance Venice," *Apollo*, no. 125 (1987), pls. 3–8. For a discussion of Venetian wares with *berettino* glaze and *alla porcellana* motifs, see ibid., pp. 63–66; A. Alverà Bortolotto, "A proposito dei piatti veneziani con decoro 'alla porcellana,'" *Faenza* 69, no. 3/4 (1983), pp. 310–312, pls. 82–85; Wilson 1987, pp. 184–189.

5. Christie's, May 8–9, 1984, lot 154.

6. Rackham 1940, vols. 1, pp. 326–327, no. 968; 2, pl. 156.

7. In general maiolica designs were somewhat retardataire in relation to contemporary oil and fresco painting; for example, the depiction of three-dimensional space in maiolica painting was only attempted around 1500, two centuries after Giotto and nearly a century after Alberti's perspective studies. Ceramic artists were apparently fully occupied with mastering the new and difficult techniques of maiolica production—including the particularly demanding tasks of glaze manufacture, painting, and firing—and were less concerned with rivaling the stylistic innovations of other art forms.

8. For a discussion of Battista Franco and maiolica, see M. Fagiolo, ed., *Virgilio nell'arte e nella cultura europea*, exh. cat. (Biblioteca Nazionale Centrale, Rome, 1981), pp. 245–248; T. Clifford and J. V. G. Mallet, "Battista Franco as a Designer of Maiolica," *Burlington Magazine* 118 (June 1976), pp. 387–410. For an examination of Taddeo Zuccaro's maiolica designs, see J. A. Gere, "Taddeo Zuccaro as a Designer for Maiolica," *Burlington Magazine* 105 (July 1963), pp. 306–315; M. Laskin, Jr., "Taddeo Zuccaro's Maiolica Designs for the Duke of Urbino," in *Essays Presented to Myron P. Gilmore*, ed. S. Bertelli and G. Ramakus (Florence, 1978), pp. 281–284, pls. 1, 2; W. Watson, "Taddeo Zuccaro's Earliest Drawing for Maiolica," Paper delivered at "Italian Renaissance Ceramics: A Specialist Colloquium," British Museum, London, September 2–5, 1987 (in preparation).

9. Marryat 1857, p. 34, fig. 18.

10. See, for example, the nude man seen from the rear on the left-hand side of Zuccaro's design for *Banquet in a Piazza* (Laskin [note 8], pl. 1).

11. C. Piccolpasso, *The Three Books of the Potters Art* (translation of *Li tre libri dell'arte del vasaio*), trans. and ed. R. Lightbown and A. Caiger-Smith, vol. 1 (1557; reprint, London, 1980), fol. 67r.

12. K. Oberhuber, ed., *The Illustrated Bartsch*, vol. 27 (formerly vol. 14, pt. 2) (New York, 1978), nos. 564-II (396), 579-II (399).

13. Sir Geoffrey de Bellaigue, Surveyor of the Queen's Works of Art, has, however, found no indication that this dish once belonged to the English royal collection (correspondence with the author, February 1988).

14. Rackham 1959, no. 450, pls. 208, 209B.

34 Basin with Deucalion and Pyrrha (Bacile Trilobato)

By Orazio Fontana (1510–1571) or His Workshop
Urbino, circa 1565–1571
H: 6.3 cm (2½ in.); Diam: 46.3 cm (18¼ in.)
86.DE.539

No. 34, reverse

BASINS OF THIS TYPE WERE MOST LIKELY USED TO hold scented water, which was offered to guests at the dining table so that they could wash their hands between the courses of a meal. This trilobed basin's elaborate molded and painted decoration, however, suggests that it served solely for display. The three molded lobes are painted to resemble shells. Delicate grotesques on a painterly white ground fill these lobes and run around the rim, where they are dispersed *a candelieri* around cameo-like medallions showing single figures in silhouette. A fisherman catching a large fish, a sea nymph riding a sea monster, and a nereid either riding on or being abducted by a triton are painted on a background of blue waves between the three shell-like cartouches. The blue wave decoration continues on the reverse, on which six swans are molded in relief following the contours of the basin's three lobes. Molded strapwork encircles each of the three pairs of swans and is decorated with geometric patterns primarily in ocher, orange, and black, which are typical of Fontana workshop ceramics in design and palette. The remainder of the decoration is executed in tones of ocher, yellow, blue, grayish green, yellowish green, turquoise, buff, black, and opaque white.

The central boss displays the scene of Deucalion and Pyrrha (Ovid, *Metamorphoses*, bk. 1, ll. 315–415).[1] Deucalion, son of Prometheus and Clymene, was the Noah of the Greeks. After surviving the deluge sent by Zeus, Deucalion and his wife, Pyrrha, withdrew to a temple on Mount Parnassus to ask the gods how the two might renew their race. The oracle told the couple to cast behind them the bones of their mother. Pyrrha was horrified, but Deucalion understood that the oracle was referring to their mother the earth. The two began to cast stones, which, upon hitting the ground, assumed human shape. The stones thrown by Deucalion became men and those thrown by Pyrrha became women.

Orazio Fontana was one of the most sought-after and innovative ceramists active in mid-sixteenth-century Italy (see no. 32). He helped develop a new genre of maiolica decoration inspired by Raphael's frescoes in the Vatican Loggie, which in turn were inspired by antique paintings that had recently been rediscovered in the Do-

mus Aurea. Orazio used these so-called Raphaelesque or grotesque motifs to embellish increasingly large areas of his works, and in his later and more "baroque" objects, such as the Museum's basin, grotesques dominate the glaze decoration while the traditional Renaissance narrative scenes are relegated to medallions or cartouches.[2]

Not only the painted embellishment but also the forms of Fontana workshop ceramics reflect the new, ornate style of the mid-sixteenth century. Orazio produced ceramic works—including oval trays, *piatti da impagliata* (parturition sets), basins, and jars—in shapes that were

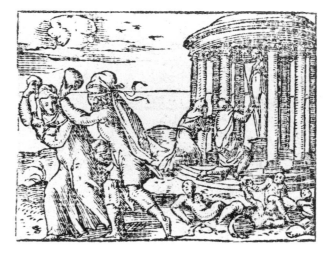

Deucalion and Pyrrha. From Ovid, *Metamorphoses* (Lyons, 1559), p. 23, fol. 11r. Santa Monica, Getty Center for the History of Art and the Humanities 85-B8407. Photo courtesy Getty Center Library Special Collections.

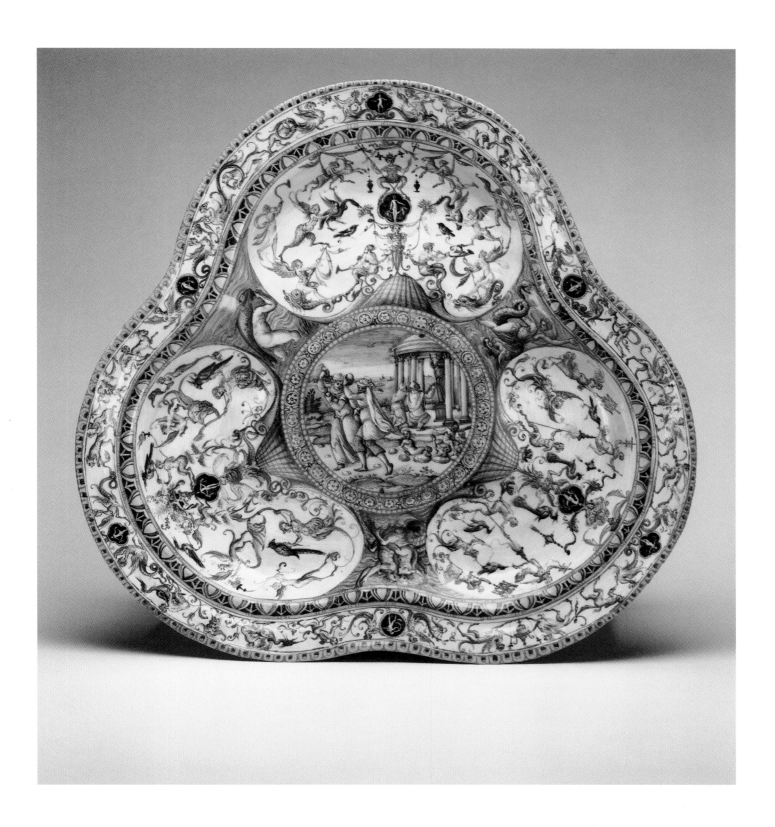

ENEA VICO (Italian, 1523–1567). *The Sun in a Chariot*, mid-sixteenth century. Engraving, 24.7 × 19.6 cm (9¾ × 7¾ in.). Budapest, Szépmüvészeti Múzeum. Photo courtesy Szépmüvészeti Múzeum. The type of delicate grotesque decoration seen in this print was also a specialty of the Fontana workshop.

highly decorative, sculptural, and often fantastic, much like the elegant grotesques he favored. He molded this trilobed basin into a particularly plastic shape, emphasizing the object's curved, bulging quality.

The Museum's basin has traditionally been thought to belong to a service of maiolica ware executed by Orazio for Duke Guidobaldo II della Rovere of Urbino, although no proof of this commission has come to light.[3] Because of its elaborate decoration and form, however, it is altogether possible, even likely, that the present *bacile* did come from a ducal collection of Urbino. Stylistically, this work falls easily within the years of Orazio Fontana's activity and can therefore be dated circa 1565–1571, the years between the opening of this artist's own workshop, separate from that of his father, and his death.

One finds the largest group of similar works, comprising thirty-two objects also traditionally described as part of the Guidobaldo II service, in the Museo Nazionale, Palazzo del Bargello, Florence.[4] Many of these objects entered the Bargello from the collections of Francesco I, Cardinal Ferdinando, and Don Antonio de'

Medici;[5] others may have arrived in Florence from Urbino with Vittoria della Rovere, Guidobaldo's great-granddaughter and last of the della Rovere ducal line, on the occasion of her marriage to Ferdinando II de' Medici in 1637.[6] This Bargello group includes four trilobed basins of identical form, which apparently originate from the same mold; all four are decorated primarily with *istoriato* scenes. Although the Museum's basin differs from the four in the Bargello both in decoration and in shape (it was clearly made from a different mold), it is stylistically consistent with the oval plates from the Bargello group, whose surfaces are similarly broken up into cavities and bosses as well as decorated with Orazio's trademark grotesques.

Related pieces, possibly also originally part of a ducal collection of Urbino, include one in the Victoria and Albert Museum, London (inv. 78-1885);[7] another formerly in the Adda collection, Paris;[8] and a third formerly in the Schlossmuseum, Berlin.[9] The works most closely related to the Getty Museum's example include basins in the Veneziani collection, Rome,[10] and formerly in the Spitzer collection, Paris.[11] Other trilobed basins of an apparently identical shape to the Getty Museum's work and presumably formed in similar, if not identical, molds include one in the Musée du Louvre, Paris (inv. OA 1467),[12] and one in the British Museum, London (inv. MLA 1889, 9-2, 28).[13]

MARKS AND INSCRIPTIONS: None.

PROVENANCE: Baron Adolphe de Rothschild, Paris, between 1870 and 1890; Baron Maurice de Rothschild, Paris, until 1916; [Duveen, New York]; private collection, Stuttgart; sold, Reimann and Monatsberger, Stuttgart, January 1986; [Alain Moatti, Paris].

EXHIBITIONS: None.

BIBLIOGRAPHY: *Antiquitäten-Zeitung*, no. 25 (1985), p. 611.

CONDITION: Broken and repaired at the top and in the proper right lobe.

1. According to A. Henkel and A. Schöne (*Emblemata: Handbuch zur Sinnbildkunst des XVI. und XVII. Jahrhunderts* [Stuttgart, 1976], p. 1590, from N. Reusner, *Emblemata* [Frankfurt, 1581], vol. 3, no. 5), Fontana copied this scene from a woodcut by either Virgil Solis or Jost Amman. This woodcut is reproduced in *La vita et Metamorfoseo d'Ovidio, figurato & abbreviato in forma d'epigrammi da M. Gabriello Symeoni* (Lyons, 1559), p. 23.
2. The type of grotesque embellishment favored by the Fontanas was also popular in and spread by graphic images in the

second half of the sixteenth century, such as those by Enea Vico; see W. L. Strauss, ed., *The Illustrated Bartsch*, vol. 30 (formerly vol. 15, pt. 3) (New York, 1985), nos. 467–489 (361–367).

3. M. Spallanzani, "Maioliche di Urbino nelle collezioni di Cosimo I, del Cardinale Ferdinando e di Francesco I de' Medici," *Faenza* 65, no. 4 (1979), p. 111.

4. G. Conti, *Catalogo delle maioliche: Museo Nazionale di Firenze, Palazzo del Bargello* (Florence, 1971), nos. 2–13, 15, 17, 18, 21, 24, 25, 27, 34, 39, 44–46, 48–52, 54, 57, 58.

5. Spallanzani (note 3), pp. 111–126; idem, "Ceramiche nelle raccolte Medicee," *Le arti del principato Mediceo* (Florence, 1980), pp. 78, 80, 81, 84, 86.

6. G. B. Passeri, *Istorie delle pitture in maiolica fatta in Pesaro* (Venice, 1758), chap. 13; A. del Vita, "Le maioliche nel Museo Civico di Bologna: III. Le Maioliche Metaurensi," *Dedalo* 5 (1924–1925), pp. 171, 182, n. 15; Rackham 1940, no. 846 (as noted in G. Conti, "La maiolica nel Museo del Bargello," *Faenza* 55, no. 3/4 [1969], p. 61, n. 9); see also C. D. E. Fortnum, *A Descriptive Catalogue of the Maiolica . . . in the South Kensington Museum* (London, 1873), p. 321; O. von Falke, *Majolika* (Berlin, 1907), pp. 11–13; Spallanzani (note 3), pp. 111, 112.

7. Rackham 1940, vols. 1, no. 846; 2, pl. 133.

8. Rackham 1959, no. 432, pls. 202–203.

9. Falke (note 6), fig. 40; this work was destroyed in 1944.

10. Bellini and Conti 1964, p. 152.

11. E. Molinier, *La collection Spitzer* (Paris, 1892), nos. 53, 54, pl. 13.

12. Giacomotti 1974, pp. 358–361, no. 1081. The loose, sketchy quality of this work's painted decoration is typical, however, of the Patanazzi workshop of Urbino (circa 1580–1625). Moreover, on the rim of each of the three lobes one finds the device of the Ferrarese duke Alfonso II d'Este: a flaming pyre with his motto *Ardet aeternum* (it burns eternally) inscribed on a scroll, which suggests that it was part of a service executed by the Patanazzi workshop on the occasion of the duke's marriage to Margarita Gonzaga in 1579. Since the Patanazzis copied the glaze decoration of grotesques on a white ground developed by the earlier Fontana workshop, it would not be surprising if they had also copied the Fontana maiolica shapes.

13. Wilson 1987, no. 241 (as "probably Urbino, circa 1570–80"). According to Wilson, this basin is linked by style and subject matter to the Fontana workshop pieces. He has stated that the swan-mold form of the British Museum example, which is similar or identical to that of the Getty Museum's basin, is the same as that used for the Louvre piece attributed to the Patanazzi workshop (p. 153). It is most likely that this form originated or was made popular in the more innovative Fontana workshop and was later copied by the Patanazzi.

35 Tabletop

By Francesco Saverio II Maria Grue (1731–1799)
Naples, circa 1760
H: 3.2 cm (1¼ in.); Diam: 59.7 cm (23½ in.)
86.DE.533

THIS MAIOLICA TABLETOP IS PAINTED WITH FOUR elaborate Rococo cartouches interspersed with landscape scenes of birds and hares in their natural habitat, intertwining vegetation, and floral and fruit swags in a palette typical of the Grue workshop: ocher, yellow, purple, light and dark grayish blue, black, and several shades of green—including grayish green, yellowish green, and olive green—on a creamy white ground. The cartouches—composed of scrolls, shells, acanthuses, and vegetal motifs—enclose Moorish and European hunting scenes after engravings by Antonio Tempesta.[1] The reverse is unglazed.

This work is signed twice with the monogram of Francesco Saverio II Maria Grue (also known simply as Saverio): *SG* on the horse's haunch in the scene of Europeans hunting a deer, and *FSG* on the horse's haunch in the scene of Moors hunting ostriches. It is also inscribed in two cartouches on the obverse: *FLAVA CERES TENUS SPICIS REDEMITA CAPILLOS* (blond Ceres, whose hair is enwreathed with grain), referring to the Roman goddess who is protectress of agriculture and of all fruits of the earth, and *FORTUNAE SUAE QUISQUE FABER* (each man is the maker of his own fortune), an antique proverb.

Saverio was the last member of the renowned Grue family—long connected with the manufacture of painted maiolica at Castelli, in the Italian Abruzzi region—to have played an important role in maiolica production. Born in Naples, he moved with his parents to Castelli at the age of four and remained there for a number of years before moving back sometime before 1749.[2] In 1758 he applied to enter the royal porcelain factory at Capodimonte, but the factory's manager refused his application on the grounds that the technique of miniature painting on porcelain was different from that on maiolica, the medium to which he was accustomed.[3] Saverio finally entered the royal porcelain factory, at that time under Ferdinand IV,[4] and appears as director of the *gabinetto di pittura* (painting studio) in 1773 and as director of the *tornanti* (ceramists who worked on the potter's wheel) in 1794.[5]

In porcelain Saverio executed statuettes, small busts, and reliefs painted in a refined style inspired by Pompeian figures and ornament. On maiolica objects such as this tabletop, however, he painted mainly landscape and genre scenes in a loose, almost sketchy style emphasizing the "rustic" quality of the medium. The decorative cartouches and intertwined vegetal motifs on the tabletop exemplify the eighteenth-century Rococo emphasis on freely handled naturalistic motifs and fanciful curvilinear forms. The charming and delicate pastoral scenes as well as the depictions of exotic subject matter such as Moors hunting elephants and ostriches are also typical of eighteenth-century Rococo. According to a chronology of style established by L. Moccia, this tabletop, executed during Saverio's stay at the royal porcelain factory, falls within his third period of production, which is typified by predominantly "French" subjects rendered in a delicate palette on a white ground.[6] One scholar has suggested that Saverio's mature style was formed as the artist, inspired by his travels abroad, attempted to decorate maiolica with the delicate designs more typical of porcelain.[7]

Maiolica plaques, favored by the Grue family, were developed as supremely pictorial objects from an originally functional plate form. Saverio Grue's tabletop is particularly innovative since it is an adaptation of the circular maiolica plaque to serve a functional purpose. Although no other tabletops by him are known, two plaques decorated with classical scenes are in a private collection, Pescara;[8] a plate by the artist in the Victoria and Albert Museum, London (inv. 241-1876), is decorated, like this tabletop, with a scenic landscape in which distant figures are occupied with activities of country life.[9]

MARKS AND INSCRIPTIONS: On obverse, in two cartouches, *FLAVA CERES TENUS SPICIS REDEMITA CAPILLOS* and *FORTUNAE SUAE QUISQUE FABER*; on horse's haunch in scene of Europeans hunting a deer, *SG*; on horse's haunch in scene of Moors hunting ostriches, *FSG*.

PROVENANCE: Earl of Warwick, Warwickshire; sold, Sotheby's, London, March 4, 1986, lot 24; [Robert Williams, London].

EXHIBITIONS: None.

BIBLIOGRAPHY: J. Guillaumin, "Majoliques tardives: A prospecter," *Connaissance des arts*, no. 419 (1987), p. 12, fig. 4.

CONDITION: Several chips and glaze faults.

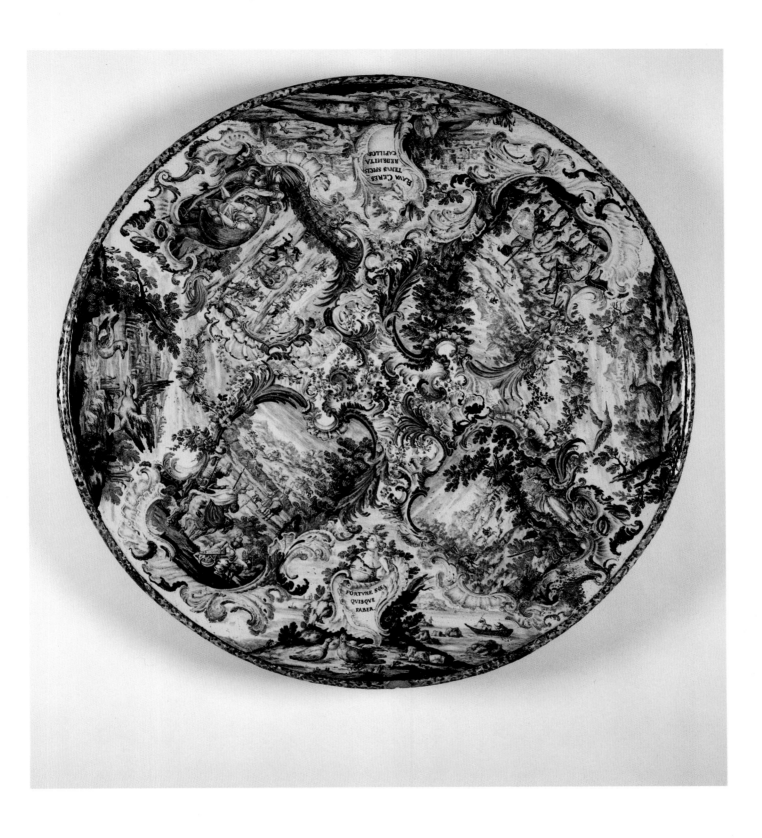

No. 35, detail

No. 35, detail

No. 35, detail

No. 35, detail

ANTONIO TEMPESTA (Italian, 1555–1630). *Deer Hunt*; *Ostrich Hunt*; *Elephant Hunt*; *Elephant Hunt*, 1598. From Hunting Scenes III. Engravings, each 9.7 × 13.7 cm (3¹³/₁₆ × 5⅜ in.). London, British Museum. Photos courtesy Trustees of the British Museum.

1. The two figures in the foreground of Saverio's deer hunt scene are based on the two figures in the foreground of Tempesta's *Deer Hunt*, from Hunting Scenes III (W. L. Strauss, ed., *The Illustrated Bartsch*, vol. 37 [formerly vol. 17, pt. 4] [New York, 1984], no. 1115 [166]); the cartouche displaying an ostrich hunt is based on Tempesta's engraving *Ostrich Hunt*, from the same series (no. 1108 [166]); the elephant hunt scene is a conflation of two separate engravings entitled *Elephant Hunt*, also from Hunting Scenes III (nos. 1110 [166], 1114 [166]). Although the source has yet to be identified, it is likely that the deer hunt in the background of this cartouche is based on another Tempesta engraving. The final cartouche scene, a boar hunt, is also likely to be based on one or more Tempesta hunt engravings (boar hunts were a favorite subject of the engraver). For a discussion of Tempesta engravings as sources for a Sèvres plaque and a plate attributed to Candeloro Cappelletti of Castelli, see B. Jestaz, "Les modèles de la majolique historiée," *Gazette des beaux-arts* 81 (February 1973), pp. 117–118, figs. 19–22; for an examination of iconographic sources for Castelli maiolica, including Tempesta engravings, see F. Moro, "Alcune fonti iconografiche delle maioliche dei Castelli d'A-

bruzzo," *Rassegna di studi e di notizie: Castello Sforzesco* 9, no. 8 (1981), pp. 399–440.
2. L. Moccia, *Le antiche maioliche di Castelli d'Abruzzo* (Rome, 1968), p. 24.
3. C. Minieri-Riccio, *Gli artefici* (Naples, 1878), p. 26, cited in A. W. Frothingham, *Capodimonte and Buen Retiro Porcelains* (New York, 1955), p. 50, n. 2.
4. The Bourbon Capodimonte factory closed in 1759, and the royal factory reopened in Buen Retiro, Madrid, under Charles III a year later. Charles' son, Ferdinand IV, opened a royal porcelain factory in 1771 in the Reale Villa di Portici.
5. U. Thieme and F. Becker, *Allgemeines Lexikon der bildenden Künstler*, vol. 15 (Leipzig, 1907), p. 124; other sources indicate that Saverio became director of the *tornanti* in 1796 (Moccia [note 2], p. 24).
6. Moccia (note 2), pp. 24–25.
7. S. Levy, *Maioliche settecentesche*, vol. 2 (Milan, 1964), pp. 62–63.
8. Ibid., pls. 80, 81.
9. A. González-Palacios, ed., *Antiquariato* (Milan, 1981), p. 657, pl. 2; Rackham 1940, vols. 1, pp. 382–383, no. 1152; 2, pl. 184.

36 *Pilgrim Flask* (Fiasca da Pellegrino)

Soft-paste porcelain
Florence; circa 1575–1587
H: 26.4 cm (10⅜ in.); Diam (at lip): 4 cm (1⁹⁄₁₆ in.); max.
W: 20 cm (7⅞ in.)
86.DE.630

NOT OF TIN-GLAZED EARTHENWARE, THIS FLASK IS instead one of the earliest examples of porcelain produced in Europe.[1] It is nevertheless closely related to Renaissance maiolica in that it borrows its decorative idioms and continues the tradition of ceramic production as an art form initiated by the maiolica masters of the early Renaissance. By the late sixteenth century maiolica wares had begun to decline in popularity among the affluent, and in response to the continuing demand for novelty, porcelain came to dominate the market for luxurious ceramics.

This flask is one of the exceedingly scarce wares produced in the Medici porcelain factory; roughly sixty of these objects remain today. Characteristic of these Medici porcelain wares are the signs of their experimental nature: the white clay base often displays a pink or gray cast; the glaze is frequently blurred, with small bubbles or a wide crackle; and the clay body sometimes sagged out of shape when the object was fired. The Museum's flask is an exceptionally beautiful piece, since it displays the finest qualities of Medici porcelain, including a well-formed, translucent white body decorated with clear designs in blue underglaze evidencing a restrained and sensitive touch.

This flask most likely served as a display piece. The applied side loops, certainly never used to suspend the object from a pilgrim's shoulder, assume the form of grotesque masks, reflecting the influence of contemporaneous maiolica wares (see no. 32). The blue arabesques and the stylized floral embellishment including rose, carnation, tulip, and palmette motifs are derived from Turkish Iznik ware dating from about 1500.[2]

The most powerful influence for the glaze decoration of this flask, however, came from Chinese blue-and-white porcelain of the early Ming dynasty (1368–1644). This translucent Ming porcelain was a particular favorite in Italy, partly because it appeared to unite characteristics of both pottery (sturdiness, colorfulness) and glass (refinement, translucency), two crafts Italian artists had mastered by the late fifteenth century.[3] Indeed Italian maiolica ceramists were sufficiently aware of these

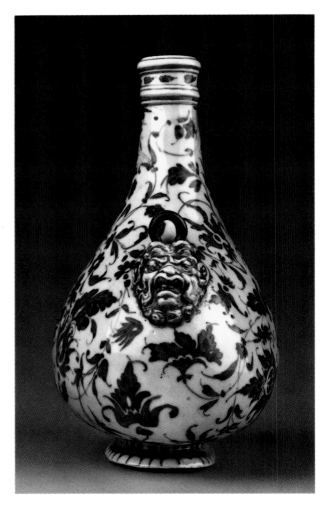

No. 36, alternate view

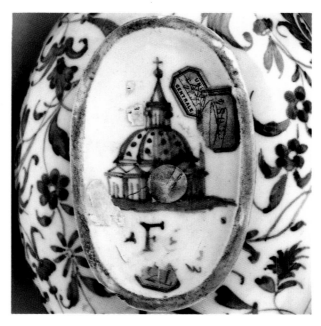

No. 36, underside

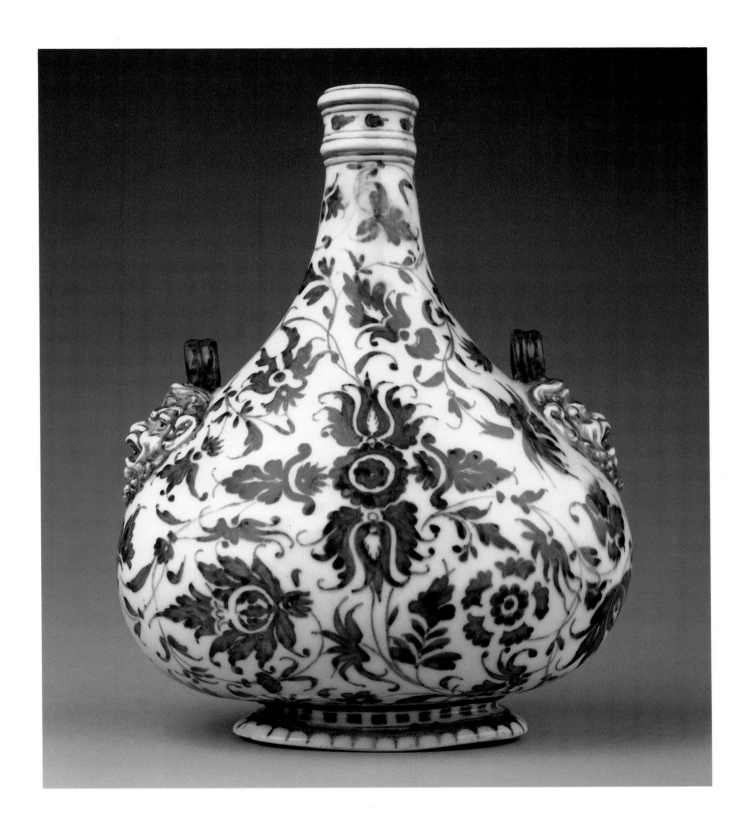

Chinese wares to attempt to imitate them in their *alla porcellana* earthenware decoration (see, for example, no. 21).

In the late fifteenth and early sixteenth centuries Venetian potters endeavored to manufacture porcelain, but the rare examples that remain appear to be nothing more than a *porcellana contrefatta* (counterfeit porcelain) of opaque white *lattimo* glass painted with enamel colors.[4] Contemporary sources suggest that Ferrarese potters produced porcelain in the 1560s and 1570s, although none of these vessels have been identified, and a recipe of 1583 from Ferrara in the Modena archives identifies the "porcelain" material as made of the same white tin glaze and fine clay that were used to make earthenware maiolica.[5]

After he had purchased the Palazzo Pitti in 1550, Grand Duke Cosimo I de' Medici built workshops behind it to encourage the recondite arts of tapestry weaving, crystal carving, *pietra dura* mosaic, and porcelain production. Bernardo Buontalenti was apparently the supervisor for most of the grand duke's artistic ventures, although Giorgio Vasari, writing of Buontalenti in 1568, predicted that he "will be making vessels of porcelain in a short time," indicating that none yet existed. Only after the grand duke's death in 1574 was porcelain finally produced in the Boboli Garden workshops under the patronage of his son, Francesco I. In 1575 Andrea Gussoni, a Venetian ambassador to Florence, wrote that Francesco had rediscovered the method of making porcelain and that a "Levantine" (elsewhere referred to as "a Greek who had traveled to the Indies") helped indicate how to produce it.[6] This porcelain production apparently continued for a few decades following Francesco's death in 1587, after which, surprisingly, almost a century passed before soft-paste porcelain was revived at Rouen—by Louis Poterat in 1673—and later at Saint-Cloud.[7]

One finds the largest collections of Medici porcelain in the Victoria and Albert Museum, London (nine pieces); the Musée National de Céramique, Sèvres (eight pieces); the British Museum, London (four pieces); and the Metropolitan Museum of Art, New York (four pieces).[8] Only three other Medici porcelain pilgrim flasks are known to exist: two are in the Musée du Louvre, Paris, and display typically Chinese-influenced landscape decoration; one is in the Victoria and Albert Museum, London, with *a candelieri* grotesque decoration and, like the present work, applied masks for the lateral loops. Only the Getty Museum's flask displays the Medici porcelain factory mark of a cathedral dome and the letter *F* (for Francesco I de' Medici) on the underside. Here, moreover, the cathedral-dome mark is particularly large and beautifully painted, with exceptional attention

to detail. The other flasks are unmarked, although the underside of one of the Louvre flasks (inv. OA 3103) is inscribed with the word *prova* (trial), indicating that it was probably an early experimental piece.[9]

MARKS AND INSCRIPTIONS: On underside, the dome of Santa Maria del Fiore accompanied by *F*; a mark resembling *3* scratched under the glaze and painted with blue glaze; on rim, three hatch marks(?) inscribed before glaze firing.

PROVENANCE: William Spence, Florence, until 1857; purchased by Alessandro Foresi in 1857; subsequently sold to Giovanni Freppa, Florence, and then to Eugène Piot, Paris (sold, Paris, March 19, 1860, lot 82, to Alphonse de Rothschild); Baron Alphonse de Rothschild, Paris; Baron Edouard de Rothschild, Paris; Baron Guy and Baroness Marie-Hélène de Rothschild, Paris.

EXHIBITIONS: *Exposition rétrospective du Trocadéro*, Paris, 1878.

BIBLIOGRAPHY: A. Jacquemart, "La porcelaine des Médicis," *Gazette des beaux-arts* 3 (December 1859), p. 276; A. Jacquemart and E. Le Blant, *Histoire artistique, industrielle et commerciale de la porcelaine* (Paris, 1862), p. 644, no. 5; A. Foresi, *Sulle porcellane medicee* (Florence, 1869), pp. 15ff., 29 (erroneously lists Baron Gustave de Rothschild, Paris, as owner), reprint from *Piovani Arlotto* (July 1859); H. Darcel, "Les faïences françaises et les porcelaines au Trocadéro," *Gazette des beaux-arts* 18 (November 1878), p. 762; M. le Baron Davillier, *Les origines de la porcelaine en Europe* (Paris, 1882), pp. 39–41, 114–115, no. 29; C. de Grollier, *Manuel de l'amateur de porcelaine* (Paris, 1914), no. 2309; S. de Ricci, "La porcelaine des Medicis," in *Faenza, Museo Internazionale delle Ceramiche: L'opera d'un decennio, 1908–1918* (1918), p. 29, no. 22 (also states erroneously that flask belonged to Baron Gustave de Rothschild and was passed to his son, Robert); G. Liverani, *Catalogo delle porcellane dei Medici* (Faenza, 1936), p. 31, no. 28; A. Lane, *Italian Porcelain* (London, 1954), p. 5, pl. 3c; C. le Corbeiller, "A Medici Porcelain Pilgrim Flask," *GettyMusJ* 16 (1988).

CONDITION: A small chip on the rim of the foot, which occurred after the bisque firing but before glaze had been applied. (That the ceramists found no need to mend or redo the chipped body is proof that they were well satisfied with such a successfully formed and fired, albeit blemished, object in this experimental medium.)

1. For a concise discussion of the history and development of Medici porcelain and its appeal in sixteenth-century Italy, see R. Lightbown, "L'esotismo," in G. Bollati and P. Fossati, eds., *Storia dell'arte italiana*, pt. 3, vol. 3 (Turin, 1981), pp. 458–465.

2. See, for example, Rackham 1959, pls. 20–96; C. Fiocco et al., *Storia dell'arte ceramica* (Bologna, 1986), pp. 66–69; G. Savage and H. Newman, *An Illustrated History of Ceramics* (London, 1985), p. 159.

3. For an examination of the Medicis' love for and extensive collections of Eastern, especially Chinese, ceramics, see M. Spallanzani, "Ceramiche nelle raccolte Medicee," in *Le arte del principato Mediceo* (Florence, 1980), pp. 73–94; according to the documents published there, the Medicis' collection of Chinese ceramics far exceeded their collection of native (Faentine and Urbinate) ware.

4. G. Lorenzetti, "Una fiaschetta veneziana di vetro 'lattimo' dei primi del secolo XVI," *Dedalo* 1 (1920), p. 248; R. Schmidt, *Das Glas* (Berlin, 1922), fig. 56.

5. Lane 1954, pp. 2–3.

6. Ibid., p. 3.

7. A curious addendum to Medici porcelain production before the late seventeenth century consists of two small bowls in the Victoria and Albert Museum, London, inscribed *I.G.P.F. 1627* and *G.G.P.F. 1638*, and a small bowl in Vienna inscribed *I.G. 1629* (ibid., pp. 6–7, figs. 4a–b). Possibly executed in Padua, these unusual bowls display qualities—whiteness, thinness, hardness, and translucency—that are very similar to those of porcelain. Whether these works are simply very thin examples of high-quality maiolica or other early experiments in porcelain has yet to be established. Their floral decoration and hard, white bodies, however, were undoubtedly influenced by Near and Far Eastern models.

8. Most of the Medici porcelain objects known to exist are reproduced in G. Cora and A. Fanfani, *La porcellana dei Medici* (Milan, 1986).

9. Other Medici porcelain marks include *F* surrounded by the letters *M. M. D. E. II*, for "Franciscus Medicis Magnus Dux Etruriae Secundus" (on a ewer in the Louvre), and six balls inscribed *F M M E D II*, for "Franciscus Medicis Magnus Etruriae Dux Secundus" (on a plate in the Metropolitan Museum of Art and on a large ewer in the Baron Elie de Rothschild collection, Paris).

No. 2 (85.DE.441)

No. 22 (84.DE.110)

No. 23 (84.DE.111)

No. 31 (84.DE.118)

No. 30 (84.DE.117)

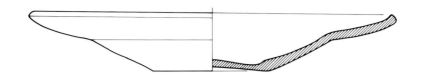

No. 15 (84.DE.103)

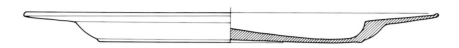

No. 26 (84.DE.113)

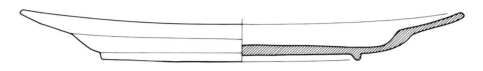

No. 33 (84.DE.120)

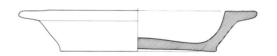

No. 4 (84.DE.94)

No. 20 (84.DE.108)

No. 18 (84.DE.106)

No. 21 (84.DE.109)

No. 19 (84.DE.107)

No. 29 (84.DE.116)

No. 34 (86.DE.539)

No. 27 (84.DE.114)